DIGITAL PHOTOGRAPHY EXPERT

Black
AND
White

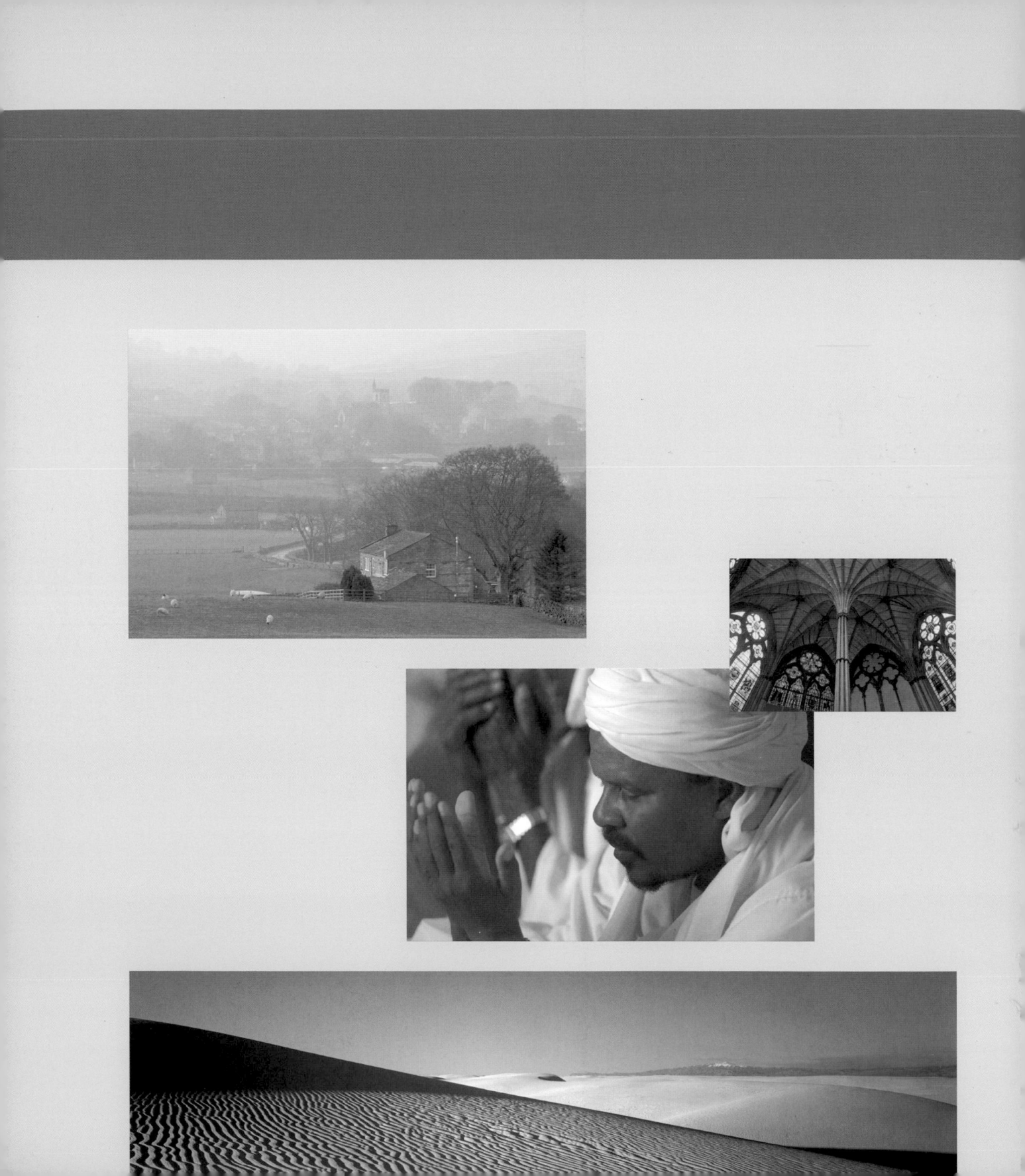

DIGITAL PHOTOGRAPHY EXPERT

Black
AND
White

MICHAEL FREEMAN

ILEX

First published in the United Kingdom in 2005 by

I L E X

3 St Andrews Place
Lewes
East Sussex
BN7 1UP
www.ilex-press.com

Text © 2005 The Ilex Press Limited
Images © Michael Freeman

This book was conceived by

I L E X

Cambridge
England

ILEX Editorial, Lewes:
Publisher: Alastair Campbell
Executive Publisher: Sophie Collins
Creative Director: Peter Bridgewater
Managing Editor: Tom Mugridge
Editor: Adam Juniper
Art Director: Tony Seddon
Designer: Ginny Zeal
Junior Designer: Jane Waterhouse

ILEX Research, Cambridge:
Development Art Director: Graham Davis
Technical Art Editor: Nicholas Rowland

British Library Cataloguing-in-Publication Data
A catalogue record for this book is available from
the British Library

ISBN 1-904705-57-X

Printed and bound in China

For more information on this title please visit:
www.web-linked.com/pcoluk

Contents

Introduction

Digital black and white represents one of the most intriguing reversals of fortune in photography. While it is certainly true that black and white has in any case enjoyed a revival as a craftsman's and artist's medium of expression, doing it digitally opens a powerful new toolbox of controls. This is more than convenient. It radically alters the process of shooting and thinking about shooting. As we will see, black-and-white photography has always maintained a strong element of craftsmanship, and when successful this has been a marriage of the technical and creative that was largely absent in colour film photography until recently. In the companion volume to this book, *Colour*, I've approached this issue from the opposite perspective, that of the colourist. Here, we take a long, and I hope in many ways a fresh, look at the special, formal place of black and white in photography.

Between digital and film, the major difference in process is the point at which the photographer's eye and imagination make the translation of a scene in colour to an image in black and white. In film photography, that had to occur at the time of shooting, which effectively meant anticipating the image in black and white before raising the camera. With digital photography, the situation is a little more complex, because although for creative reasons it's important to think in black and white when shooting, the image is actually converted to black and white long after, when it is finished on the computer. Some cameras offer the option of image capture in black and white, but apart from the possible advantage of being able to see the monochrome image immediately on the camera's LCD screen, this is not usually a good idea. It allows none of the important tonal controls that make digital black-and-white photography so flexible and creative. In normal digital shooting, therefore, the conversion from colour to black and white happens late in the process, and under conditions in which you can take your time and can experiment. This even makes it possible to decide late whether a colour image might work better in black and white, although clearly the ideal path is to see and organize the image in the way it will finally appear. As the beginning of Chapter 1 shows, the graphics of black-and-white imagery have different dynamics from those in colour.

Historically, the place of black and white is assured. It dominated the first century of photography, and what a number of photographers see as its essential purity has kept it a medium for serious expression. Digital technology enhances its role in two important ways. One is the ease of printing, without the need for a dedicated darkroom with chemical baths – and black and white has always been a printer's medium. The other is the range of entirely new opportunities it presents for controlling the tonalities in the finished image. No less skill is required, but the means are now more readily available. It is these that we will explore in the pages that follow.

The language of **Mono**

Creatively, it was a fortunate limitation that photography began in black and white. Technically, this was all that was possible when, in 1826, Nicéphore Niépce became the first person to fix an image permanently. He used a light-sensitive coating that hardened on exposure, allowing the areas that received little light to be washed away. So, as we can see, photography started as an invention that relied on quantity of light, not wavelength (which determines colour).

This was certainly a restriction in terms of photography's ability to reproduce scenes, so why was it fortunate? The palette was restricted, but this had the effect of confirming photography as a creative medium in its own right. Quite apart from the huge conceptual difference between capturing a photographic image from life and constructing an image through painting or draftsmanship, the single scale from black to white made the jump from reality to interpretation a definite one. Colour photography became possible as early as 1903 with the invention of the Autochrome process, and by the 1960s had become commonplace, yet black and white didn't disappear and wasn't seen as inferior. Rather it acquired an even more particular identity. Essential to shooting in black and white is the ethos of 'less is more', in which the loss of color positively helps to focus attention on other relationships in the image. Removing the component of hue focuses attention more closely on the intricacies of modulation of tonal shades, and there is an element of rigour – that of a formal discipline that often gets lost in the emotional and cultural associations of colour. Indeed, until very recently black and white has been central to the development of photography as an art, and as a means of communication. It allows photographers the freedom to select from the full-on richness of the colourful world, to make personal choices and express their individuality.

What we could call the language of black-and-white photography, therefore, is strongly oriented to the graphic qualities of proportion, line, shape, form, and texture, and in a way this recapitulates the Renaissance view of art. Writers on painting, such as Cristoforo Landino, were accustomed to separating the elements of painting into, for example, *rilievo* (modelling in the round), *compositione* (composition), *disegno* (linear design), and *colore* (colour). The skills of draftsmanship, in working with line, shape, and volume, were considered to be different in principle from the handling of colour, even though all were combined in an oil painting. Fast forward to photography, and we find that the very real separation that occurred because of the early process has persisted, at least for photographers who find it creatively liberating to put all their energy into imaging without colour. In particular, a large part of the pleasure of black and white is dealing in subtle distinctions, and we can see this, for example, in high-quality printing. For most monochrome photographers this is the ultimate objective, and as we will see, being able to discern detail in shadows and highlights is one of the hallmarks of excellence.

Different concerns

Switching between colour and black-and-white photography calls for a shift in our way of seeing, with important changes in the graphic priorities for the image in question.

▼ **Portraiture**
The dynamics of expression, and the always compelling focus of the eyes (to which the viewer's own are drawn) make portraits less dependent on color. Nevertheless, choosing the appropriate tone for the skin is an issue.

As photography in general has moved from completely black and white to mainly colour, there has been a major shift over many years in the perception of what a photograph is. When black and white was universal, everyone understood that the image was an interpretation of a scene into a very specific medium, dominated by tones. What colour photography has done is to convince us that taking a picture is capturing reality in two dimensions – an illusion, of course, but an effective one. This is not a criticism of color photography, but we could say that black and white sharpens the faculty of constructing an image from a full, moving, three-dimensional occasion.

Practically, and from the point of view of composing and organizing the image, the priorities are necessarily different between colour and black and white. This of course is assuming that the photographer is trying to get the most out of the medium – colour sensibility from the colour image or tonal quality from the black and white. In both cases we can take it as read that the basic issues of accuracy and optimization have already been taken care of, including exposure, focus and shutter speed.

With colour, the concerns are dominated by the elusiveness and subtlety of defining the several million colours that the eye can appreciate. Adjusting the exposure affects not only the brightness and 'correctness' of the image, but also alters individual colours. For example, with increasing exposure, red becomes pink, while with decreasing exposure, yellow becomes ochre – different colours

entirely to our eyes. In a high-contrast scene, this often means choosing between colours. Then there is the less easy-to-define overall colour character for the image, made up of the relationships between hues and colour cast, which gives an indication of style at first glance. The relationships between individual colours are responsible for perceptual and subjective impressions of contrast, harmony, and discord. Overall saturation, now in the digital age, is so much easier to choose than it ever was with film. This calls for more decisions on a scale from a colorful and rich rendering of the image, to a restrained, understated palette.

Against this list for colour photography, the creative priorities for and black and white have greater scope and yet are more restricted. The absence of colour focuses attention on specific dynamics, partly because black and white prints tend to be judged more critically in terms of tone and subtle renderings of highlights and shadows, and partly because the formal graphic qualities of shape, line, form, mass, and textural rendering are made more apparent. Finally, an issue that is now more important than ever in digital photography is that of which tones of grey best represent the original colours of a scene. As we'll see in the next chapter, digital post-production gives an infinite choice, and this new freedom takes over from the rather limited filtering that was possible with black and white film. The new technology, its possibilities, and to a certain extent its ubiquity among users, make it important to think about the visual 'weight' of colours in every scene.

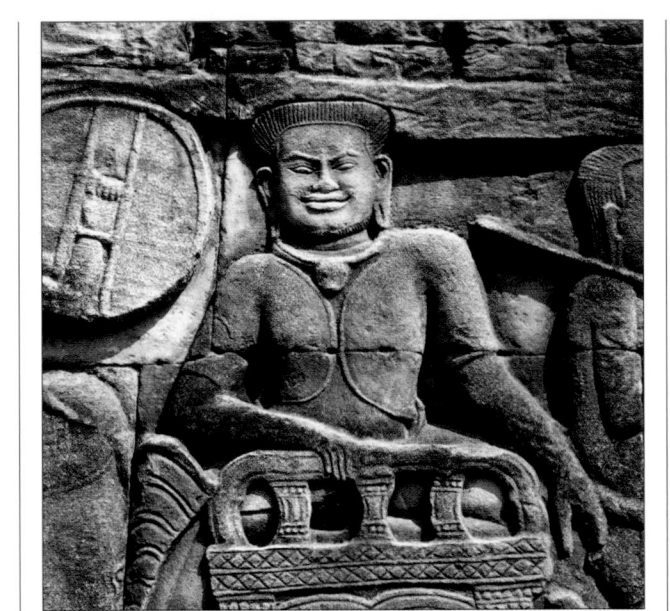

▲ Bas-relief
Texture is a great strength of black and white. By finding the best light, the photographer can give the image a tactile dimension. In this case, the angle of the sun brings the stone alive.

▼ Silhouette
Shooting into the light creates the chance to play with the dynamic range, and high contrast is another image quality at which black and white excels. Texture from reflections plays a role.

Contrasting creative concerns

Black and white	Colour
Contrast	Colour effect of exposure
Key	Colour style
Geometry	Colour relationships
Volume	Colour intensity
Texture	Colour into tone

Case study: **visualizing in mono**

The reality of what works as an image in monochrome, rather than in colour, is complex. It depends on an interplay of content – the subject matter in front of the camera – the photographer's intention, and the all-important ability of being able to think in black and white: what one of the great technical black-and-white photographers of the 20th century, Ansel Adams, called 'visualization'. With content, there is a push-pull effect between subjects that have the makings of a black-and-white image through offering strong geometry, form, and texture, and those that clearly have a colour component that attracts the eye through its richness or subtlety, or relationships between hues. Here and on the following pages is a set of colour originals and their translation into black and white. Some work better than others, some lose through translation, and some simply work in a different but equally valid way.

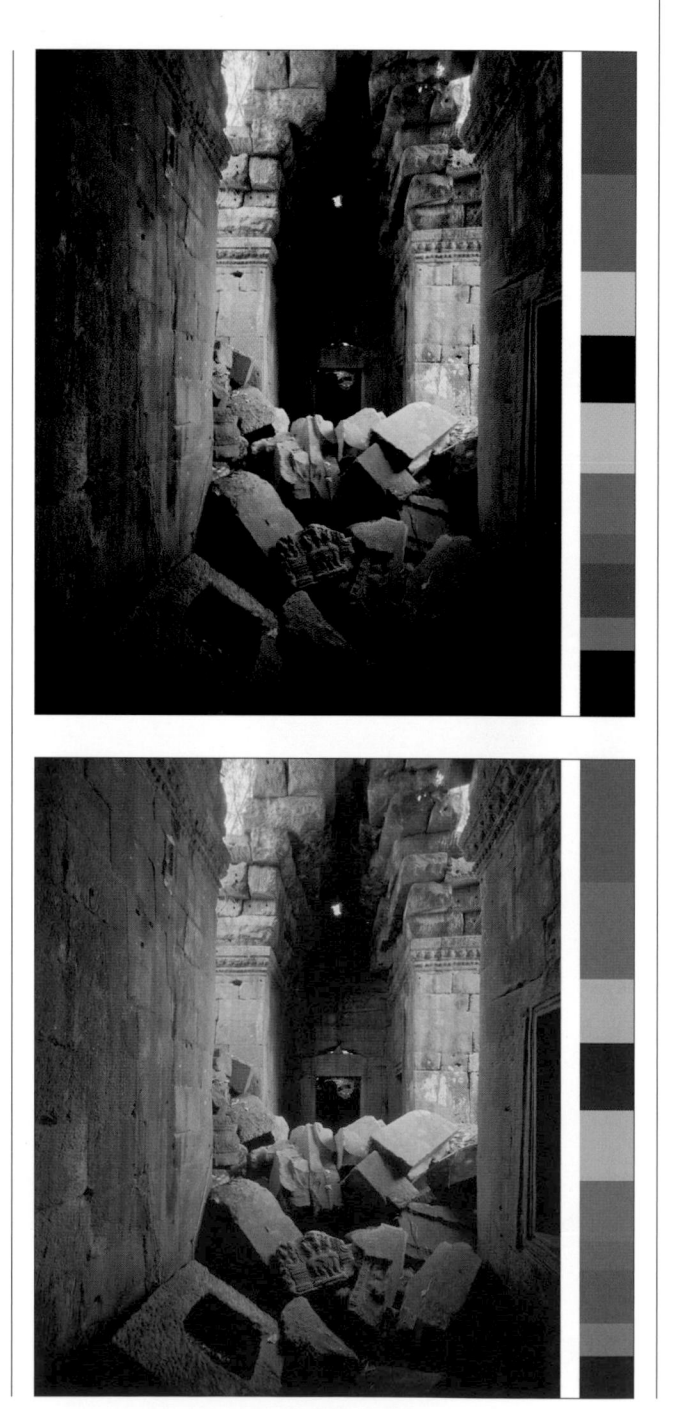

◀ Ancient stones

The theme of this interior of a ruined Khmer temple is variations on colour, but in black and white it becomes an exploration of shadows.

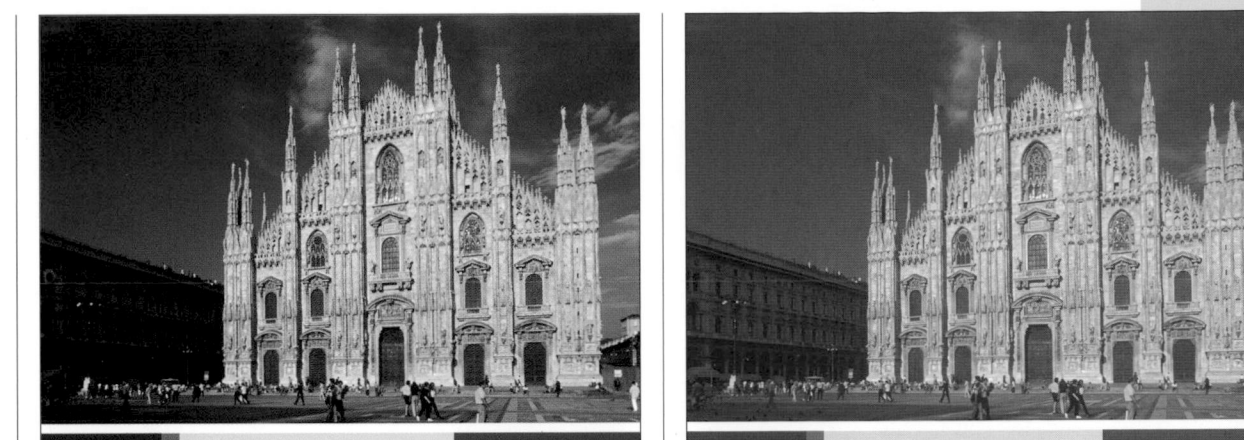

▲ Duomo

This shot of the facade of this famous church in Milan is in colour, bright but with a touch of the postcard. In black and white the sky no longer detracts attention from the form.

▲◀ Tibetan streets

The colour is clearly what caught the eye in this scene of prostration at the monastery of Tashilunpho, and without the distinction of the red, the figure of the man all but disappears.

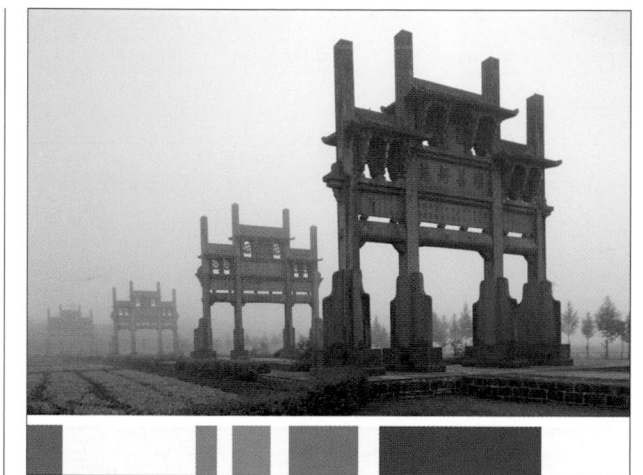

Chinese arches

This row of ancient ancestral arches in China had little colour to begin with, and was easy to visualize in black and white. In both, the modulation of tones with distance is key.

Shibuya, Tokyo

In colour, this well-known location in downtown Tokyo is suffused with blue at dusk. In black and white there is the suggestion that the scene is more colourful than it really is.

Ginza

The three elements – sign, couple, and bamboo – are equally treated in colour and in black and white, the difference being whether the green of the bamboo is considered important or not.

Hair salon

The clear contrast of tones makes this scene read equally well in colour and black and white, but with different appeals – the red accent against cool blue-green in one case, and the delicate shading in the other.

Neon lips

This neon display works better than might be imagined in black and white. Naturally the sensuality of colour is lost, but sharp and legible tonal contrast remains.

Case study: **the complexity of landscape**

Landscape was one of the earliest, and remains one of the most enduring, subjects for monochrome photography. Although there was in the beginning no choice in the matter – practical colour did not become available until 1903 with the invention of the Autochrome process (about which more later) – other factors came into play to keep this subject popular among photographers who preferred black and white. Landscape is rich in detail at a variety of scales, from sweeping overviews to macro. It is also strongly dependent on the change of light for its appearance, and light is more critical to black and white than it is to colour. Thirdly, landscape is an endlessly accessible subject that conveniently does not move – much. While light and detail are also concerns for colour photography, they can often be subjugated by the presence of colour, which alone can justify an image.

▶ **Newspaper rock**

The panoramic format of this image of a petroglyph site in New Mexico is used to emphasize foreground detail. It is a classic technique, conveying a huge range of detail using a wide-angle lens close to a significant foreground, at the same time using the composition to relate this to the distance. Thus, the eye travels between ancient petroglyphs on the rocks and the far horizon.

Lava beds

This image, of old lava beds, illustrates the idea of relationships, which adds another layer of complexity to landscape as a subject. In this case, the relationship is a simple graphic one between clouds and rock, which gives a structure to the tonality of the image – a narrow band of strong, dark texture, and a broader band of textureless sky, separated by a strip of white clouds.

Contrast

On a broad scale, the contrast between dark and light is what gives overall definition to an image in black and white, and helps to separate outlines and shapes.

The contrast between all kinds of qualities in an image, from the content to the process, plays a huge creative role. In lighting, for example, just think of *chiaroscuro*, the alternation of light and shade, as in a spotlit face emerging from the dark background of a room. Or the soft, smooth texture of a baby's skin against a wrinkled, much older hand, or even the silhouette (the ultimate in tonal contrast). Many of these contrasts are represented by sharply different areas of tone, and this is one of black and white's most powerful tools for creating images that are instantly striking.

Contrast problems, when they exist, are always to do with high contrast, meaning a range of brightness in the scene that is higher than the sensor can record in one exposure. Low contrast hardly ever presents any difficulties, because if you want to increase it in an image, there are some very simple procedures for expanding the range in Photoshop. This is yet one more instance of how digital photography has altered the priorities in image capture, leaving special developing techniques behind. It is another good reason to shoot, whenever possible, in a higher bit-depth, so that good tonal depth is available to you in editing. High contrast, nevertheless, is a real issue, and more so at the moment in digital photography than it was for film. The inherently different process of digital image capture has encouraged more awareness of film behaviour, and whereas the whole business of characteristic curves used to be of purely academic interest for most photographers, it does now matter.

Sun and shadow

Bright late afternoon sun shining through the doorway of an old Mexican church creates inevitably high contrast. Keeping the face of the man light enough to be visible is a second, but important, consideration.

Buddha in roots

Over centuries, roots have enfolded the head of a broken statue. The soft lighting helps the view, but is too flat and needs improvement. The histogram reveals that the full range is not being used, with gaps left and right. Closing these up will be the first step, either by dragging the sliders inward or by using the Auto option.

Levels

Channel: Gray

Input Levels: 0 1.00 255

Output Levels: 0 255

OK
Cancel
Load...
Save...
Auto
Options...

☑ Preview

The characteristic curve

Plotting the tones captured against the amount of light to which the sensor is exposed – output to input, in other words – gives a line on a graph that can be read as a signature of the recording medium, film or sensor. It's a curve that represents the way that film or that sensor behaves, hence 'characteristic curve'. Film has a distinctive shape of curve that tails off at both ends, shadows and highlights. What this indicates is that film still manages to record something even when the light reaching it is very little or excessive. You could call it forgiving – it tolerates underexposure and overexposure, and no film more so than black and white negative. Digital sensors do not. Their curves – their response – are linear. A straight line, with no tolerance. In practice, this means that they overexpose easily, and once a photo-site has been over exposed, it registers pure, useless white. Put another way, digital sensors handle high-contrast scenes poorly. There are some solutions, and new ones in the pipeline, so this will not always be a problem, but for now care must be taken when shooting. The sensible rule is to expose for the highlights, to just below the point at which they are blown out. The camera's highlight warning display is an essential tool.

Scene	ratio	ƒstops
Sunlight to shadow illumination only (grey card)	8:1	3
Sunlight to shadow in an quite-contrasty scene (pale skin in sunlight to vegetation in shadow)	1,000:1	10
Sunlight to shadow in a very contrasty scene (white paint in sunlight to black paint in shadow)	1,600-2,500:1	about 11
Open sky to shadow on an overcast day illumination only (grey card)	4:1	2
Open sky to shadow on an overcast day in an average landscape scene	2:1	1

Recording medium	ratio	ƒstops
Sensor of average digital compact camera, low sensitivity (ISO 100-200) setting	256:1	8
Sensor of typical DSLR camera, low sensitivity (ISO 100-200) setting	512:1	9
Sensor of typical DSLR camera, high sensitivity (ISO 1000) setting	128:1	7
Human eye fixed on a single point	100:1	6 _
Human eye taking in an entire scene	30,000:1	15
Typical black and white negative film	2,000:1	11
Typical CRT monitor	300:1	8
Typical active matrix monitor	400:1	8 1/2
Glossy paper	128-256:1	7-8
Matt paper	32:1	5

Notes

1. The range in ƒstops is the number of intervals, one less than the number captured.

2. The dynamic range of sensors is less at higher ISOs, giving higher contrast, as it is with silver-halide films (faster films have a smaller range, and so are more contrasty).

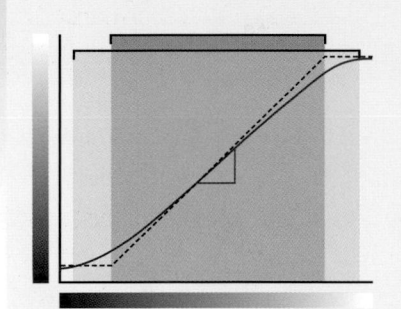

▲ **Full range**
Setting the black point and white point stretches the tones across the full dynamic range, increasing the contrast.

▽ **Curve**
Within the range just set, mid-tone contrast is now increased in the Curves dialog by applying a classic S-shape. A third point at the highlight end keeps the brightest parts of the image light.

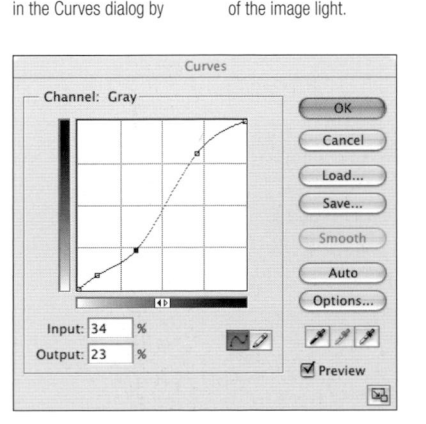

Case study: **silhouette**

The extreme of contrast is when the primary subject is treated as a pure, featureless black shape, relying on outline for its recognition. Detail within the silhouette is often completely unnecessary, although an occasional indication can hint at depth and volume. What the eye usually demands from a silhouette, however, is that it contains a rich, deep black, as the examples here illustrate. The exception to this is in a misty or foggy atmosphere with shapes seen at a distance. In all cases, the graphic appeal is simplicity. What silhouetted images lack in subtlety, they gain in instant effect.

◄ **Storks**
The camera position was chosen carefully but quickly so that just a sliver of the sun showed between a bird and the branch. Keeping the star-like flare distinct was the exposure key: essentially underexposing the rest of the image.

▲ **Carrying thatching**
Two girls in a hill-tribe village in northern Thailand. The appeal of this shot lies in its initial strangeness, but for it to work the viewer needs to be given some clue. This comes from timing – the raised feet as the girls cross the rise – and from leaving a hint of shadow detail.

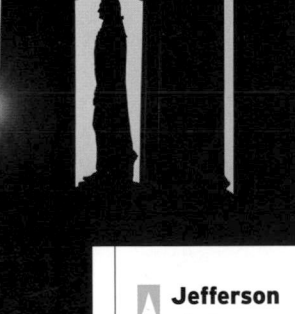

Clarity from the camera angle

Because recognition in a silhouette depends on outline, the angle of view is often important. Many subjects register more clearly at one angle than at others.

▲ Jefferson statue

A silhouetted telephoto shot of the statue of Thomas Jefferson, in the Jefferson Memorial in Washington DC, converted to black and white without adjustment. The silhouette is almost but not fully black, while the sky is unnecessarily dark.

▲ Extreme silhouette

The image can be improved using the Levels dialog. Dragging the white point slider to make the sky (the clump of values at the right) white, and setting the black point inside the darkest values, ensures a perfect silhouette.

The essential graphic qualities

Restricting the palette to eliminate the complex perceptual effect of colour has the effect of concentrating attention on the graphic elements of line, shape, form, and texture.

Without colour, photographs automatically acquire formality of composition and tone. Irrespective of the content, the image depends for its form on the closely linked compositional elements of line and shape, and on the modulation of tone between dark and light. Not only are these graphic qualities of more importance for a monochrome image than for one in colour, but also they define the character of the photograph. If the photographer chooses to emphasize one of these qualities skilfully, it can become as much the subject of the image as the physical object or scene. Each of the three examples here is essentially an exploration of one graphic element - texture, volume, or light.

Line and shape are a function of the kind of large-scale contrast that defines edges, and in black and white these are automatically more prominent than in colour. How these edges divide the frame, interact with each other, and guide the eye depends on composition, and they are at their most definite in a silhouetted image. Edges enclose shapes, and these become distinct when they sit comfortably within the frame, without breaking its edges or corners.

The form of an object is a more complex quality than its shape, because it is essentially a quality of three dimensions, not two. While shape is very much a graphic and two-dimensional quality, as in a two-tone silhouetted image, form is plastic and three-dimensional, needing a lighting technique that reveals roundness and depth. Conveying volume is in many ways easier in black and white than in colour, but it calls for close attention to the

▲ Play of light
The imperfections in old glass window panes create a fluid, shifting effect as the sunlight shines through them onto a chest of drawers. The image is almost, but not quite, abstract.

way light falls on a subject. The most reliable technique is to use a carefully graded modulation of light and shade. This means, essentially, directional lighting that throws distinct shadows, and from an angle that gives a reasonable balance between light and shade. Lighting from the front casts

few shadows and so is much less effective at this than from the side. There are many variables, including the precise angle of the light, the diffusion or concentration of the light source(s), and the relationship, if any, between object and background.

Texture is the rendering of a surface, with infinite variety from smooth and shiny to rough and gritty. In a black-and-white photograph it is the interaction between the physical qualities of an object's 'skin' and the way in which light falls on it. Not only is choosing the angle of lighting the key to conveying volume, but also it changes the appearance of the detailed structure of surface, and so has an effect on the tactile impression. Roughened surfaces, such as the stone in the bas-relief close-up here, typically come alive under cross-lighting that skims across them. Because texture is a quality of the detail in a subject, the closer the view, the more important it becomes.

Given the right circumstances, light itself can be the subject of a photograph. While it can never be entirely divorced from the objects and surfaces on which it falls, provided these give just enough clues to help the viewer locate the image in the real world, the play of light – its modulation – can be beautifully captured in monochrome. Provided that the effect does not depend on colour contrast to work, black and white is perfect because it keeps attention on tone.

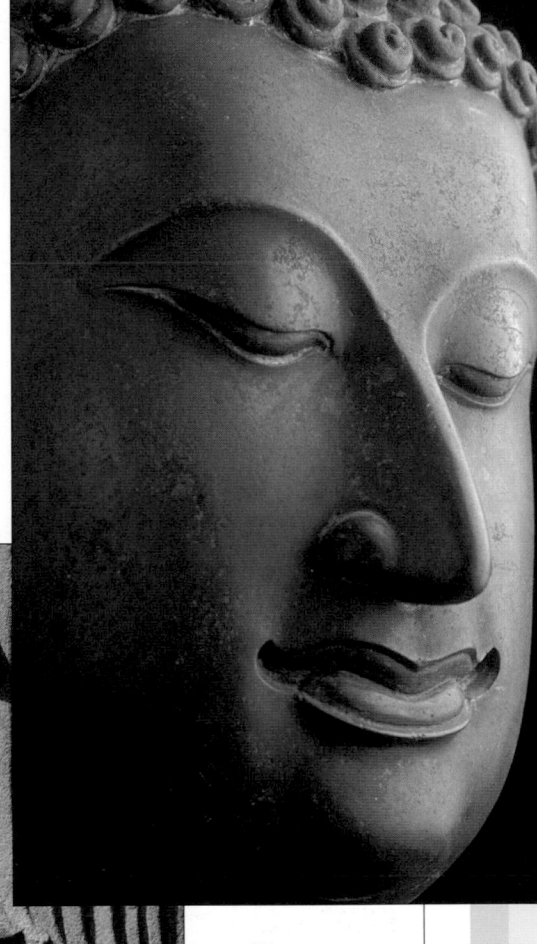

▷ **Form**
In this studio-lit shot of a basalt Buddha statue, shape (outline) is sacrificed for form (volume), achieved by a single diffuse area light at an angle that reveals the rounded form of the face to shade into darkness.

▷ **Texture**
A deity carved in sandstone and photographed close enough to show the fine detail of the stonemason's work and the granular texture of the stone itself. The acute angle of the sunlight to the carving, almost at right angles to the camera axis, makes this possible.

Case study: **the problem of skies**

In landscape photography, which includes architecture as well as nature, the sky and ground often form two distinct zones in the image, and do not always coexist happily. The problem is that of tonal range, because the average brightness of a sky can be several f-stops higher than that of the terrain below. It's not an issue unique to black and white, but because so much attention is focused on the tonal scale in a monochrome print, deficiencies are that much more apparent. With colour an irrelevance, the value of a blue sky is moot, while clouds can be a rich subject for exploration. The key is to work within the tonal range of the sky, and this often means digitally selecting the sky. This is really no more than a more precise version of 'burning in' under a traditional enlarger, using your hands or a shaped card. In this shot of Angkor Wat, the sky, with its diverging lines of late afternoon cloud, is pleasant enough, but relies very much on colour.

The first step is to take a quick look at the individual RGB channels for an indication of which carries the richest sky tones. As the sky in the original is blue, the blue channel lightens it almost out of existence, and unsurprisingly the red channel is the most useful. Even so, this is only the starting point, and in order to work independently on the sky, with no adjustment of the temple, it needs to be selected. Being so much paler than the stone, it is easily selected with the Magic Wand tool, and then it is simply a matter of experimenting with the Curves dialog to make it darker and more interesting.

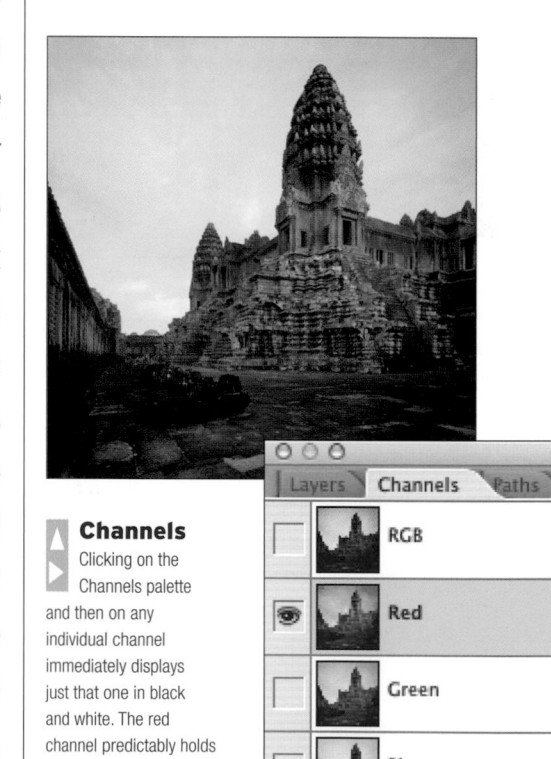

Channels
Clicking on the Channels palette and then on any individual channel immediately displays just that one in black and white. The red channel predictably holds most of the tonal information of the sky.

Split Channels
The Split Channels command from the palette's drop-down menu irreversibly breaks down the image into three, from which we select the red.

Refined adjustment
Clicking on the upper corners of the sky indicates where on the curve they lie, and dragging this upper part of the curve back to the right gives a more realistic rendering.

Select sky
Using the Magic Wand tool at a tolerance setting of 20, the sky is selected by Shift-clicking repeatedly. This adds newly clicked areas to the selection.

Save selection
When complete, the selected sky area is saved as an Alpha channel.

First adjustment
In the Curves dialog, dragging the centre strongly to the left darkens the sky distinctly and well, although the upper part, which in the original was the most strongly blue, is too dark.

Colour into **greyscale**

If there is a single key to understanding black and white it is in the translation from the full colour of the real world. Black and white is not a medium rooted in realism, but its source is the normally coloured world. Traditional shooting skills included the ability to 'see' in the mind's eye how a scene full of colour could translate into an image dominated by tone and line and shape, and a specialized aspect of this was to recognize how each colour would appear - whether light or mid-tone or dark. Film photographers with time on their hands could then use colored filters to manipulate the shade of grey in which a hue would be reproduced. In practice, this became very much the province of the large-format landscape and architectural photographer, as this was a type of shooting that demanded from the outset a great deal of time. The camera had to be on a tripod, camera adjustments were slow, and viewing was inconvenient. The attitude of an Ansel Adams or a Brett Weston helped, and indeed, Adams wrote at length about the manipulation of tones with coloured filters. Without this deliberate and exacting mentality, however, Wratten filters were a pain. Until Polaroid came along to provide a preview of the shot, one could only guess at the effect, helped of course by experience. More than that, filters added to the exposure needed, especially in the case of deep reds, greens, and blues, which gave strong effects.

Digital black and white has largely overturned this. Indeed, it is impossible to overstate the significance of digital tools in creating black and white images. There are many, including layers, masks, channels, and curves, and the permutations when using them together, are virtually endless. At the heart of all this, however, is the ability to manipulate the three independent colour channels, red, green, and blue, so as to control—again, with infinite choice—the tonal value of all the colours in a scene. This is entirely new, and its potential is only now being explored. There are so many ways of manipulating the tones into which colours can be converted that they merit their own, important chapter.

In this context, one of the most significant image-editing tools ever devised is the channel mixer available in Photoshop. New digital tools are, of course, continually being developed, not least because they help to justify ever newer versions of software. They all have uses, but only occasionally does one come along that can alter the way in which photographers plan their shooting. Channel mixing is one of these few. Essentially, it allows you to select the proportions of the RGB channels used to create a monochrome image from colour. This features very heavily in the following chapter, for good reason. It is not merely an improvement over the traditional colour filter set used with black-and-white film. It is a sea change in black-and-white photography. The possibilities are explored here, but it calls for a completely new way of thinking about black and white, both aesthetically and technically. How photographers learn to use this relatively new procedure will have important effects on the art of photography.

Basic colour conversion

The simplest digital tools for converting colour images into black and white in a single step aim for a result that accords with our innate sense of the brightness of colours.

By default, there are two simple methods of turning a colour image into monochrome, and both of them are available as standard in Photoshop. One is the removal of colour from each of the three RGB channels, called desaturation. The other is a one-step conversion of the three-channel image into a single greyscale-channel image – a mode change, in other words. They are almost, but not quite, the same in effect, and it is both instructive and useful to try both out for yourself on different images, and compare the results.

Saturation is the amount of chroma in an image, the intensity or richness of hues, and is one of the three elements in the HSB (Hue, Saturation,

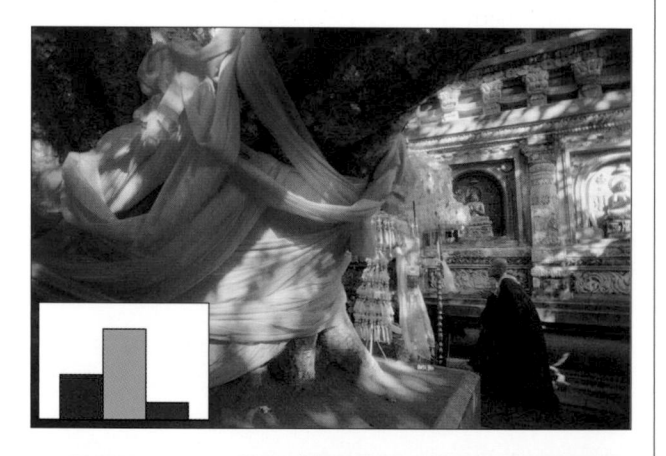

▶ **Grayscale**
The Photoshop command that collapses the three color channels into one grayscale channel emphasizes green and diminishes blue. In the event, the low blue outweighs the high green to make the orange distinctly light.

▲ **Original**
Saffron cloth around the tree at Bodh Gaya, India, where the Buddha achieved enlightenment. The orange will react to the channel proportions used for conversion.

◀ **Desaturate**
The Photoshop Desaturate command gives equal weight to all three channels, here rendering the orange cloth noticeably darker than above. Desaturation is also available as an adjustable control in the Hue/Saturation dialog.

Hue/Saturation

Edit: Master

Hue: 0

Saturation: –100

Lightness: 0

OK
Cancel
Load...
Save...

Colorize
Preview

Brightness) colour model (valuable in image editing because it closely follows the way we perceive colour). The usual editing tool for adjusting it is a slider in the *Image > Adjustments > Hue/Saturation* dialog. Dragging the slider to the left reduces the intensity of all hues until, at far left, minus 100%, there is no hue – no colour whatsoever – visible. This is how the Desaturate command (under *Image > Adjustment > Desaturate*) works, by fully desaturating each channel. The image remains RGB but appears in monochrome.

Greyscale conversion uses a different principle. It combines the three RGB channels into one single channel without hue, but in doing so does not necessarily combine them equally. Photoshop's default conversion algorithm (under *Image > Mode > Grayscale*) combines them in the following proportions: Red 30%, Green 59% and Blue 11%. This conversion intent is designed to give a black-and-white result that looks natural to the eye – an effect that most people would consider to be normal, were they to give it any consideration at all. (Incidentally, this conversion reduces the number of channels from three to one, and so achieves a commensurate reduction in file size).

We can go further into this. An equally balanced conversion would be 33% for each channel (to maintain a normal level of brightness, the total should be 100%), but the Photoshop version favours green and diminishes hue. The combination keeps flesh tones looking natural, and these on balance are probably the most important for most people (though it works less well on some non-white skin tones). This procedure is a first hint of what is possible in the rich, complex, and largely new world of digital conversion from colour to monochrome. The fact that the three channels can be combined in different ways has enormous implications, as will become apparent. Indeed, because you can combine them to taste, you are obliged to think about the proportions.

Original
In this scene of the Yorkshire Dales, yellow-green is the dominant colour, but there is also a slight blue cast to the shadows. The equal-channel conversion produces an image with moderate contrast.

Grayscale
The default 59% green lightens the fields, while the 11% blue deepens the shadows, to give a distinctly more contrasty monochrome rendering.

Work on a copy or Save As a Copy

There are many procedures for making radical alterations to a digital image, but one essential is to make sure that you do not overwrite the original. The most sensible working method is to make immediate backups, in which case this is not an issue. But if you decide to make black-and-white conversions before backing up the original, then first make a duplicate file, or in Photoshop Save As a Copy before you begin work. Over-caution prevents overwriting!

The traditional filter set

Long experience of translating the world of colour into monochrome provided film photographers with the means to alter the brightness of individual hues.

Wratten filters

Kodak's gelatin Wratten filters are manufactured by dissolving organic dyes in gelatin, then coating this solution onto prepared glass to solidify. Following this, the gelatin is stripped off the glass support and coated with lacquer. Although fragile and easily marked, the very thinness of a traditional filter makes it optically very clear.

For film photography where the shot could be set up - as in landscape, architectural, and portrait photography, rather than reportage—a set of coloured filters evolved to give photographers some control over how bright different colours would appear to be in black and white. For the normal run of photography this takes too long to decide upon and implement, but when fine image quality and the precise delineation of different areas of the print is important, the tonal filtering of colour becomes a special and valuable skill.

The principle is straightforward - that of using a strongly coloured filter over the lens to block the light from certain colours in the scene. A green filter, for example, obviously passes green light without hindrance (which is why the filter itself looks green). More importantly, however, it acts as a barrier to opposite colours. One of the keys to colour theory for which Isaac Newton was largely responsible (at the same time as demonstrating the colour spectrum) is the arrangement of these hues into a colour circle. As shown on pages 36-37, there is an important relationship between colours that face each other across the circle. They are complementary and opposite. A filter of one colour will block the light from its complementary, rendering it dark, even black. The opposite of green is a variety of red, and as the test series of colour circles on page 71 demonstrates, viewing the circle through a green filter makes the reds appear darker than they would in ordinary white light.

In nature, at least on the larger scale of landscape, colours are rarely pure and intense, so there is little practical use in having a full set of filters in many varieties of hue and strength, quite apart from the complications of handling them. The traditional filter set, even for photographers who made full use of this technique, rarely contained more than a few, and the standard ones were drawn from Kodak's Wratten series, as shown here. Choosing and using them was (and is) by no means simple. They demanded experience in knowing what the results would look like; an adjustment for the density of the filter; and judgment in how light the filtered colour should appear, and how dark the opposite colours. As the table shows, there was a small number of basic predictable effects, from darkening skies to minimizing freckles, and these are explored in more detail later.

For the few digital cameras that offer black-and-white image capture as an alternative to full colour, these traditional filters work in the same way as they do with black-and-white film. They also work, of course, with regular RGB digital image capture, but this is pointless and time-consuming given that the same results, with all the benefits of other software tools, and of course the ability to undo, can be achieved by manipulating channels in post-production – the subject of the following pages.

Filters

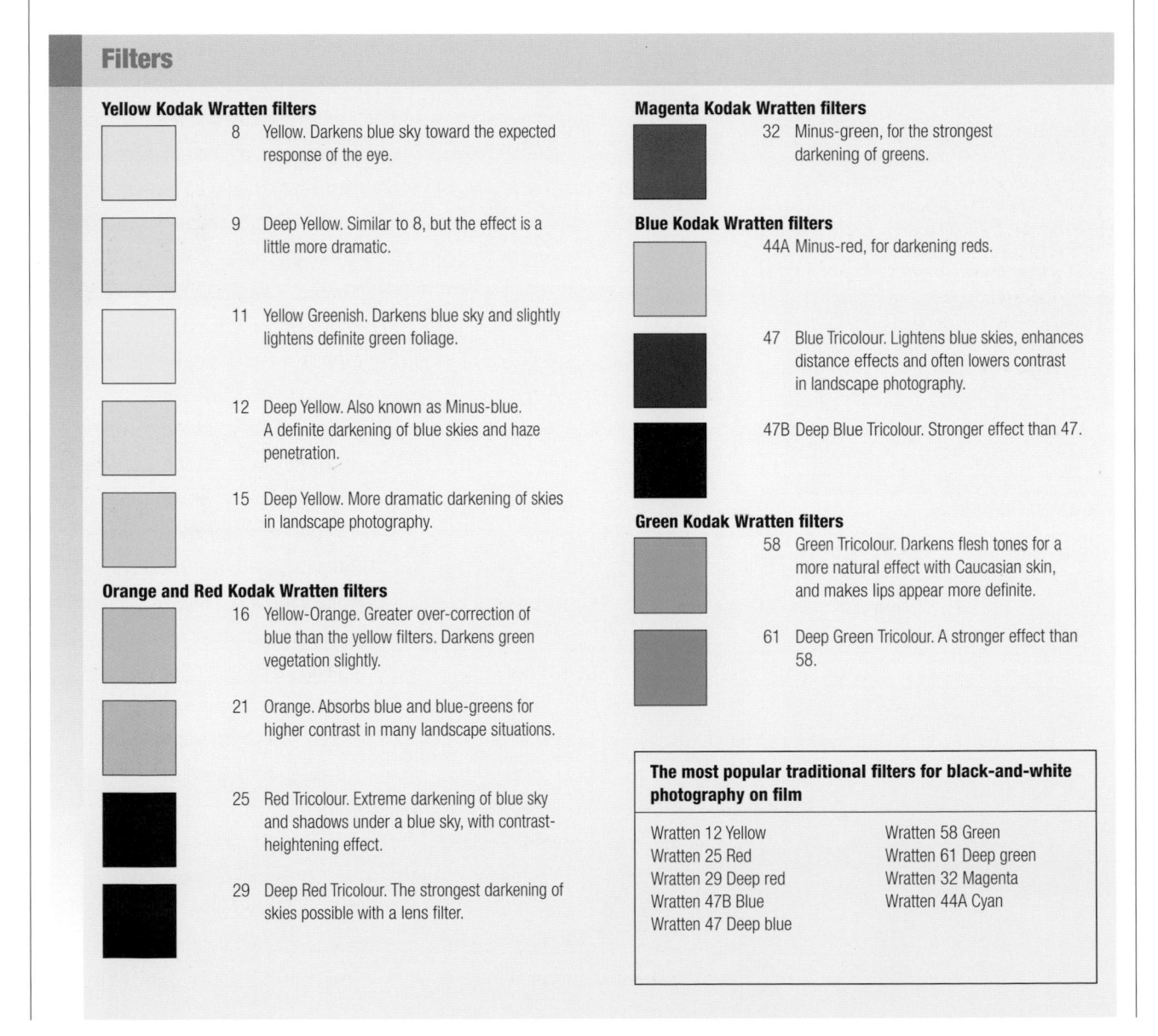

Yellow Kodak Wratten filters

8 Yellow. Darkens blue sky toward the expected response of the eye.

9 Deep Yellow. Similar to 8, but the effect is a little more dramatic.

11 Yellow Greenish. Darkens blue sky and slightly lightens definite green foliage.

12 Deep Yellow. Also known as Minus-blue. A definite darkening of blue skies and haze penetration.

15 Deep Yellow. More dramatic darkening of skies in landscape photography.

Orange and Red Kodak Wratten filters

16 Yellow-Orange. Greater over-correction of blue than the yellow filters. Darkens green vegetation slightly.

21 Orange. Absorbs blue and blue-greens for higher contrast in many landscape situations.

25 Red Tricolour. Extreme darkening of blue sky and shadows under a blue sky, with contrast-heightening effect.

29 Deep Red Tricolour. The strongest darkening of skies possible with a lens filter.

Magenta Kodak Wratten filters

32 Minus-green, for the strongest darkening of greens.

Blue Kodak Wratten filters

44A Minus-red, for darkening reds.

47 Blue Tricolour. Lightens blue skies, enhances distance effects and often lowers contrast in landscape photography.

47B Deep Blue Tricolour. Stronger effect than 47.

Green Kodak Wratten filters

58 Green Tricolour. Darkens flesh tones for a more natural effect with Caucasian skin, and makes lips appear more definite.

61 Deep Green Tricolour. A stronger effect than 58.

The most popular traditional filters for black-and-white photography on film

Wratten 12 Yellow	Wratten 58 Green
Wratten 25 Red	Wratten 61 Deep green
Wratten 29 Deep red	Wratten 32 Magenta
Wratten 47B Blue	Wratten 44A Cyan
Wratten 47 Deep blue	

Using channels

The three RGB channels in a digital photographic image each display a unique tonal version in black and white – the starting point for complete control over the final conversion.

Channels get right to the heart of black and white, because each one is monochrome. Open any RGB image in Photoshop and click, one by one, on the Red, Green, and Blue channels in the Channels palette. Depending on how colourful the original image was, they will differ from each other quite noticeably. This is the digital equivalent of using black-and-white film with strongly coloured filters over the lens (see pages 30–31).

Looking at the red channel is like shooting through a deep red filter, adjusting of course for the exposure. Like a filter, the red channel passes so much of the light from a red object, like the balconies of the Japanese pagoda shown here, that it appears very bright. Colours that contain very little red, such as a deep blue sky, hardly register at all in the red channel, and so appear dark.

Extracting a single channel

In shots with strong colour elements, the three RGB channels will look quite different, and may even impart an unexpected atmosphere. From this colour image of Daisho-in temple on the sacred Japanese island of Myajima, the red channel predictably brings a harsh contrast, but the blue channel delivers a soft, misty view.

This has obvious creative uses. The three channels offer different, but perfectly valid, conversions from colour to black and white. Extracting one is a simple two-step affair, as shown. There are further possibilities, too. Convert to CMYK and click on these new channels individually. Or delete one channel. The tonal relationships within the image shift with each move.

But selecting individual channels is just the start, because they can be blended—in monochrome—in any combination at all. The ideal tool for this is within Photoshop, the Channel Mixer accessed under *Image > Adjustments*. For black-and-white imagery, check the Monochrome box in the dialog window, then experiment with the channel sliders. 100% Red, with 0% Blue and Green, is the equivalent of looking at the Red channel on its own. An equal 33% for each channel is the same as a straightforward desaturation without bias. Other combinations favour different colours, and merit experiment on an image-by-image basis. In order to keep a sensible overall tonal balance, neither too dark nor too bright, the percentages should add up to +100%. Nevertheless, some startling effects are possible by straying deliberately from this while using the Constant slider to compensate for the brightness. This fourth slider adjusts the values of the output, from solid black at far left to pure white at far right. As the three channel sliders each cover a 200% range, this leaves a lot of room for dramatic effects.

Channel mixing

Using the Channel Mixer in Photoshop, with the Monochrome option ticked, gives total control over the proportions of the three primary colours – up to 200% in either direction, positive to the right and negative to the left. The Constant slider usefully allows you to compensate for difference in brightness when using such extreme settings, as in two of these examples.

Default black and white

The two most basic ways of extracting a monochrome image from a full-colour original are to convert to greyscale (*Image > Mode > Greyscale*) and to desaturate (*Image > Adjustments > Desaturate*). The effect is the same, but with desaturate you retain the three colour channels. Each of the three channels is affected equally.

Aids to help conversion

Visualizing the effect of different proportions in the three colour channels is not intuitive, but two Photoshop techniques can help.

Digital cameras and colour monitor displays work in the tricolour RGB system, by combining red, green, and blue, as indeed does colour film. The principle goes back more than a century to the discovery that all viewable colours can be created by mixing just three, and it is highly practical for digital imaging. Nevertheless, human perception does not 'read' colour images in this way, but rather by the HSB method. So, prior to making a conversion from color to black and white, it helps to be able to have some kind of preview of your overall direction. The most readily available preview is the individual channels themselves. These are, naturally, monochrome, and are extreme black and white versions of the image – one of them containing only the red tones, another only green, and the third just blue. While it is simple enough to go to the Channels palette and click on one of the three (this automatically turns off the other two channels), even more useful is channel splitting. We use this technique a great deal, and it is as well to be familiar with it.

The Split Channels command breaks up the image into its component channels (the basic R, G, B and any Alpha channels). Unusually for Photoshop, this isn't reversible. If you want to maintain the color view, first make a

Ubehebe Crater
In preparation for black-and-white conversion, the brown tones on the distance will be important, and it will help to know how they are made up from red, green, and blue on average.

Average blur
The Average choice under Blur makes a single colour from everything enclosed by the marquee.

Make selection
A square sample area is chosen with the Rectangular Marquee tool (though you could use an alternative shape if you needed an average from that).

duplicate, then open that and perform Split Channels on it. The channels are automatically names with the suffix .[Color], thus [filename].Red, [filename].Green and [filename].Blue. Before moving on to Channel Mixing, this channel splitting gives a good, definite indication of where the brightest and darkest monochrome tones will lie, and which colours help higher or lower contrast.

Another technique that we make use of here for precise control during channel mixing is colour analysis by averaging values over an area. The Info palette remains the single most valuable tool for precision analysis, and normally is always left open on the desktop. However, the sampling area under the cursor - which generates the RGB values - is confined to a choice of three. These are a point sample (single pixel), 3 x 3 pixel average, and 5 x 5 pixel average. The RGB values are important to know before adjusting the Channel Mixer because they indicate the proportions—and these are exactly what you will make changes to. The technique here is to make a selection, usually a rectangle or circle, and then apply an averaging filter to this. The Blur Average filter (*Filter > Blur > Average*), displays the average of all the colour values in the selection. Take and note the reading, then undo.

Splitting channels

A scene in northern Thailand. A copy is made (Split Channels is irreversible). The splits are predictably different. Blue lightens the sky and darkens everything else; Green lightens the foliage; Red lightens the foliage even more because the original was shot at sunset.

The sample

With the Info palette in view, running the dropper over the square shows the RGB composition. Any bias can now be adjusted during channel mixing. Undo the Average Blur before continuing.

Individual channels

A simple and effective way of achieving distinctly different tonal renderings of colour in monochrome is to separate the individual colour channels.

A standard RGB digital image is made up of three channels, each carrying the information from a distinct wavelength. The tricolor method of reproducing the full spectrum of color is at the heart not only of photography but of human vision, and goes back to the discovery in 1872 by James Clark Maxwell that the eye perceives colour by means of just three pigments in the retina - red, green, and blue. Colour film uses the same principle, as do the sensors in digital cameras – and colour monitors for that matter. The most

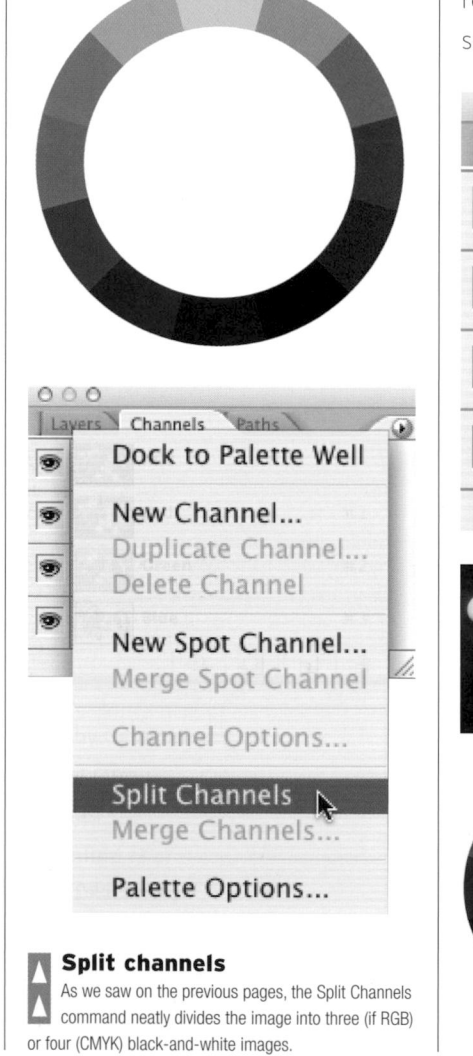

RGB channels
In a standard colour image from the camera, the full color (top) is made up of red, green, and blue channels, seen split into their monochrome versions below.

Split channels
As we saw on the previous pages, the Split Channels command neatly divides the image into three (if RGB) or four (CMYK) black-and-white images.

Red Green Blue

common image mode is RGB. The Split Channels technique is the simplest way of making the conversion, and if compared with a standard Greyscale conversion, you can see the difference that individual channels make.

The scale of this difference, of course, depends on how pure and how distinct the colours of the original are. For the example below, we've taken an extreme of four—a red and a green pepper, and lemons, on a blue plastic background. These are complicated slightly by difference in brightness as well as hue; the peppers and background are close to each other, but yellow is inherently much brighter than any other colour. There is no such thing as a dark yellow; it simply becomes another colour, such as ochre.

Using channels is the equivalent of using strongly coloured traditional lens filters. The red channel passes the red component of the image, so that this is light in tone. At the same time, it blocks other hues in proportion to how different they are from red. The most distinctly opposite color from red is cyan, with blue close by. Hence the red channel in this example brightens one of the peppers, darkens the other somewhat, and strongly darkens the background. Equivalent changes happen with the green and blue channels. To make this clearer, I've included a standard 12-zone colour circle with the hues arranged so that they oppose each other across the circle.

One other colour mode offers three different tonal interpretations, although not in the way you might expect. CMYK is used for offset printing, and while it is normally avoided by photographers because of its smaller colour gamut than RGB (and because digital photographs are RGB to begin with), it has three colour channels with extreme effects, and black (K). However, while intuitively you might imagine that these channels, once split, would lighten cyan, magenta, and yellow respectively, because of the different construction of a CMYK image file, they darken these colours. In practice, as the colour circles show, the cyan channel behaves like an exaggerated version of the red channel, magenta a slightly strengthened version of green, and yellow as a strong blue.

CMYK channels

Converting the image to CMYK mode makes it possible to split it into the complementary colour channels cyan, magenta, and yellow. The black (K) channel is normally of no use for this exercise.

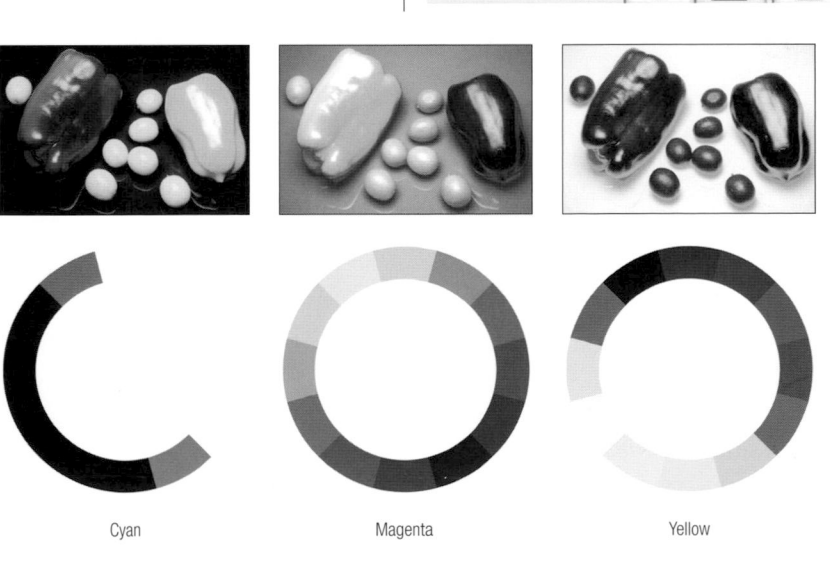

Cyan Magenta Yellow

Practical channel mixing

The most powerful and flexible way to control channels is to mix them as percentages with monochrome as the output, using Photoshop's Channel Mixer.

The principle of channel mixing is simple enough, but the implications are considerable. A set of sliders allows you to choose the percentages of each channel used in the final output, no more, no less. Simply click the Monochrome check box before starting. The range of adjustment extends not just from 0% to 100%, but down to minus 100% as well. This makes some extreme, even bizarre, effects possible. Average brightness normally depends on keeping the sum of the three percentages in RGB at 100%, but a fourth slider – Constant - controls brightness so that even extreme adjustments can be kept at a reasonable tonality. It can be adjusted to compensate, since otherwise combined RGB percentages higher than 100% will give a lighter image, lower percentages darker. Use with caution though: at the extremes the contrast may be unusually high or low.

In practice, the four sliders give a huge choice and experimentation tends to be most people's approach. The examples here give an idea of what is

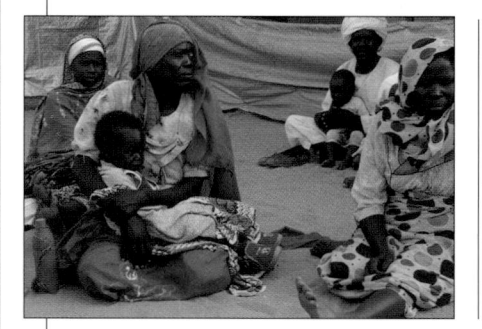

▲ Colour original

This picture of Sudanese women and children is a useful example thanks to its strong and varied colours; there are neutral areas (the background), and dark, medium, and light shades.

▶ A variety of mixes

Five different mixes of the three channels illustrate at a glance how powerful this control is. Mix (1) has the default equal values for all three (equivalent to Desaturate). Mix (2) is the opening setting for the mixer (100% red). Mix (3) is the default Grayscale Mode conversion. Mixes (4) and (5) aim for the darkest and lightest renderings possible of the orange garment.

possible, though it can help to go through the procedure outlined on the previous pages, and see how the image looks channel by channel to get a sense of what direction to aim for. The essential point is that channel mixing gives total control over the spectral response of a black-and-white image. As the Extremes box illustrates, even unlikely and unnatural translations are possible, such as a black yellow and a white red.

The example here, of Sudanese women in their traditionally colourful robes, was chosen with care, because it contains two distinct sets of colours – neutrals and strong hues. The near-neutrals are the grey tarpaulin background, the white clothing, and the skin tones, which are actually a dark brown (a median value of Red 80, Green 50, Blue 35). These change very little whatever permutations of the channels are selected, but they do provide a valuable guide to optimal brightness of the image. One of the issues with channel mixing is that it can alter overall contrast and brightness to extremes. Clearly, there are few reasons for clipping either highlights or shadows, and it is usual to keep an eye on both the lightest and darkest areas to make sure that they remain readable. Yet there is still often plenty of room for placing the mid-tones high or low, and this is not always easy to judge. The Histogram palette helps.

Interactive histogram

As an aid to alerting you to clipped highlights and shadows, and to indicate the position of the mid-tones, keep the Histogram palette open, preferably the expanded view with all channels showing, and uncached refresh. The original histogram will be in grey, and any changes you make with the channel sliders will display instantly in black (easier to read than the 'Show Channels in Color' option).

Using an adjustment layer

Many of the image alterations commonly performed in converting to black and white and manipulating tones can be made in the form of adjustment layers.

Photoshop's adjustment layers are usually promoted for their ability to work non-permanent changes on an image—they sit over the original and can always be revisited and adjusted over and over again. Arguably more important is that they allow constant feedback to complex changes that are not easy to predict, as is very much the case with channel mixing. As should be evident by now, and certainly after the several examples throughout this chapter, channel mixing is absolutely the method of choice for converting colour to black and white, but it adds a layer of complexity to the entire procedure, which also includes setting black and white points and adjusting Curves. One of the difficulties with channel mixing is that it is yet another permutation, and because it is performed as part of a sequence, you may need to retrace your steps to see its effects on a different Curves or Levels adjustment.

Adjustment layers go part of the way to alleviating this. Opening a Channel Mixer layer (*Layers > New Adjustment Layer > Channel Mixer*) allows exactly the same adjustments as if you performed them directly on the image, but they reside in their own (disposable) layer. If, having mixed the channels in a particular order, you then activate the underlying image (Background), any changes you make here will immediately be translated into a black and white mix.

So, for instance, you can raise or lower the saturation on the Background image and watch the effect filtered through the Channel Mixer. These other adjustments can, of course, themselves be made via adjustment layers.

Original
This view of a volcanic crater lake in Indonesia has one distinct colour only – green – with just a hint of blue in the sky. We'll use three adjustment layers to convert it. The first step, from the choice of a dozen adjustment layers, is Levels, for a basic optimization.

◀ Black/white points
The first step is to set the black and white points, as usual in optimizing. Here there is no real need to check the effect visually, and using the Auto command in Levels works perfectly.

▶ Resulting histogram
The resulting histogram shows the values spread fully across the range.

Because the channel mixing is the stage at which the colour image is converted to grryscale, the Channel Mixer adjustment layer always needs to sit on top of the layer stack, which could reasonably contain, for instance, a Levels layer, Curves layer, and Hue/Adjustment layer. And more. Double-clicking on the layer thumbnail brings up the dialog window for any adjustment layer and allows you to continue making changes.

And the disadvantages of using adjustment layers? None really, but as you'll notice from the rest of the book, I rarely use them in practice, and the reason is simply that I prefer to make the decisions and move on, rather than leave an image with a stack of changeable options. In a professional image workflow, there is often not enough time to keep going back and tweaking unfinished business (though clearly you must keep a copy of the original unconverted file). Obviously, this does not need to apply to a more personal, leisurely way of working. The interactive nature of adjustment layers, on the other hand, is definitely an advantage while assessing the effects of different procedures on the final conversion to black and white.

The ready-attached layer mask

Open a Channel Mixer adjustment layer and you will see from the Layers palette that it already has a layer mask. Having made the mix of channels, the image as it appears will be in black and white, but by choosing a paintbrush with the foreground color set to default black, you can paint onto the mask in order to remove the black-and-white conversion. Do this selectively and you can make a partly colored/partly monochrome image, as if hand-painted (see also pages 52 and 142).

Mono
The result of the three operations is this monochrome rendering. However, studying it, I think I would like to light up the lake even more.

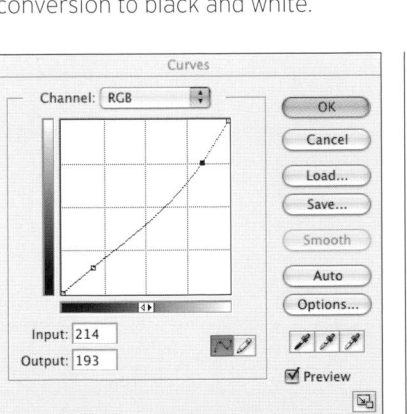

Curves layer
The second step is to adjust the mid-tones within the range. To place more visual emphasis on the crater, the brightness of the clouds is reduced by dragging the upper quadrant right, while holding the dark areas in their original tones with a second point at lower left.

Channel Mixer layer
A third layer is added under the previous two for channel mixing. Making the adjustments interactively, the aim is to lighten the green so that the lake 'glows', slightly reduce the blue in the sky, and make up the tonal difference with the red slider.

A fourth layer
Rather than interfere with the channel mix already created, we can adjust the green of the lake easily by adding a Hue/Saturation layer and increasing the green saturation. Effectively this increases the effect of the channel mixing.

Case study: **appropriate proportions**

In this reasonably straightforward example, a Shaker village in New England with autumn colours, it's clear that channel mixing has enough difference in hue to work on. The focus of attention is the complex of buildings, which are close to neutral, with white wooden walls and close-to-black roofing. In other words, there is no reason for them to be much affected by what we do with the channels – we need only ensure that the overall tonality from walls to roof remains unchanged. Using a desaturated version as a guide, I can work toward a more pleasing black-and-white conversion. The aim is to be true to the overall impression of fiery leaves. Also, I'm happy to have a more thundery impression from the sky, even if it is not exactly realistic and lacks a sense of 'lift' behind the buildings. The final result, as always, is one person's interpretation and not in any sense 'correct'.

Colour original
This autumn view of Shaker buildings in New England is so successful in colour that ordinarily I would not try a black-and-white conversion. Nevertheless, for the purposes of the exercise it offers a challenge because it works by virtue of a combination of lighting and colour.

Default desaturation
For reference, this is the default conversion from the Desaturate command, which gives equal values for all three channels. My immediate impression is that the sky is too light, the grass slightly dull, but worst of all, the rich glow from the tree has been lost.

Channel Mixer

Output Channel: Gray

Source Channels

Red: +76 %

Green: +12 %

Blue: +12 %

Constant: 0 %

☑ Monochrome

OK
Cancel
Load...
Save...
☑ Preview

Raised red

Raising red to 76% while lowering green and blue equally to 12% gives a perceptually more true result, but I still think it could be improved.

Final

So, a very high red value with a low blue value achieves the bright leaves, and the effect on the grass is to deepen the shadows, by contrast making the lit areas of green appear brighter. Given this, there's no need to adjust the green channel.

Channel Mixer

Output Channel: Gray

Source Channels

Red: +112 %

Green: 0 %

Blue: -22 %

Constant: 0 %

☑ Monochrome

OK
Cancel
Load...
Save...
☑ Preview

Case study: **mixing to extremes**

With all three channel sliders capable of being adjusted upward and downward by 200% – an overall range of 400% – tones of individual colours can be altered far beyond any realistic interpretation. The occasions for needing to do this are few, but in these two examples I wanted to see how close to white (and later black) it would be possible to shift one specific hue in a photograph. In theory, any hue can be rendered at any level on the tonal range, from 0 to 255, but the difficulty is keeping the rest of the scene within range. Strong movements of one slider need to be balanced by opposite movements of either or both of the others. Analyzing the RGB values of the target hue makes it easier to decide what the proportions of the mix should be.

Goathland
In the case of this preserved railway station in the north of England, the target hue is the orange of the safety vests. Even at a glance, it is clear that the colors of most of the scene are weakly saturated; greys, dull greens, and browns predominate. Even strong channel mixing is unlikely to have much effect on these, so it should be easy to concentrate on altering the orange.

Default conversion
As a reference, we first make a standard Photoshop Grayscale conversion and save this as a copy. This renders the orange as a medium-light grey (25%), the same as the surface of the platform.

▶ RGB analysis

The vests, in this overcast light, are a consistent strong color, well saturated. Running the cursor over them with the Info palette visible shows the RGB values, which predictably favour red. In fact, the green is a little more than half the value of the red, and the blue a little more than half the value of the green.

R 220
G 140
B 80

◀ Bright orange

To render the orange to its maximum greyscale value, the technique used is to follow the original RGB proportions. The colour with the highest value is set to maximum – that is, red to 200% – and the other two are arranged approximately in proportion to balance. With one value at 200%, it is inevitable that the others will be at minus values, and these are judged by eye so that the neutrals in the scene match the rendering in the standard Grayscale conversion. Two by-products are that the dark red of the bridge becomes light, and that the steam from the locomotive, bluish in the original, disappears.

▲ Dark orange

Now we attempt the reverse values, applying the same principle. The lowest of the RGB values is blue, so that slider is set to its maximum, and the other two are arranged in approximate proportions to balance. Again, the effect is judged by eye, and the overall neutrality of the scene helps a great deal. The steam, which is complementary in colour to the safety vests, is now as light as it can reasonably be.

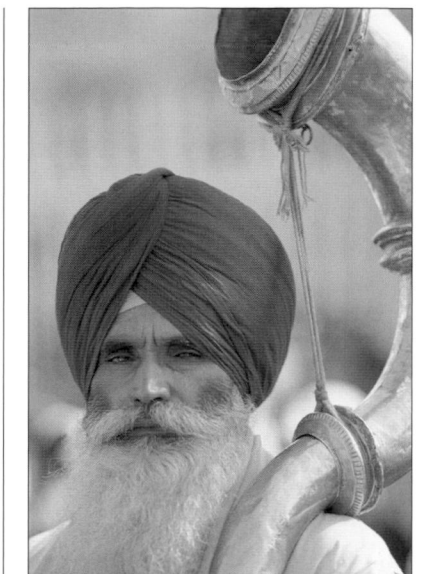

Sikh turban

The objective here is to render the blue turban at extremes of lightness and darkness. The image lacks the predominant neutrals of the railway station, which allows more flexibility in adjustments, but also means that there is no obvious guide to the overall exposure. What may not be completely obvious is that the skin tones have a distinct red component, and so will be affected by channel mixing.

Grayscale

For reference, we make a standard Grayscale version. With its characteristically low blue value, this keeps the turban quite dark.

Colour analysis

There are three distinct colour areas: the turban, the orange scarf, and the yellowish brass of the horn. The target colour is naturally strong in the blue channel, but the scarf is almost its exact opposite, and so during channel mixing will move in the reverse tonal direction.

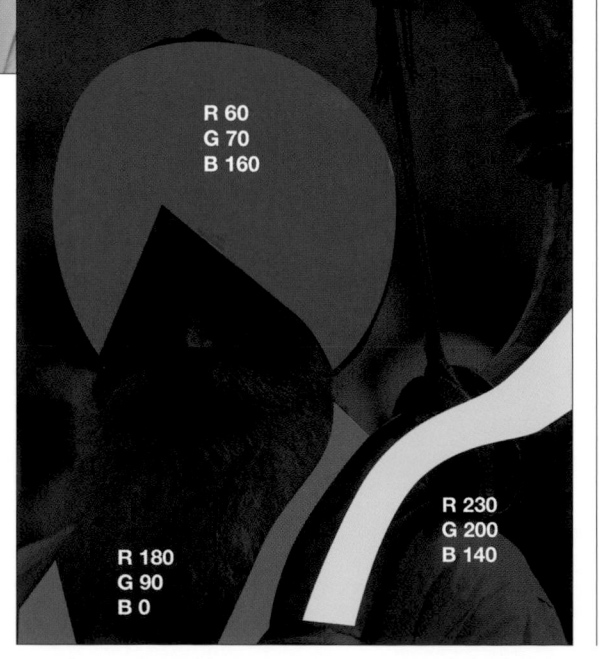

R 60
G 70
B 160

R 180
G 90
B 0

R 230
G 200
B 140

Bright blue

With blue as the target colour, we set the blue channel to 200%, and adjust the red and green to more or less the same proportions in the minus sector of the scale, at levels that maintain the brightest parts of the turban at white. The problem is that the skin tones, which even though not fully saturated are nevertheless complementary to the turban, are now rendered too dark. There is no way of avoiding this simply through channel mixing. One answer would be to make a moderate channel mix on an underlying background layer, and this extreme mix on a duplicate layer, and then erase the face from the upper layer.

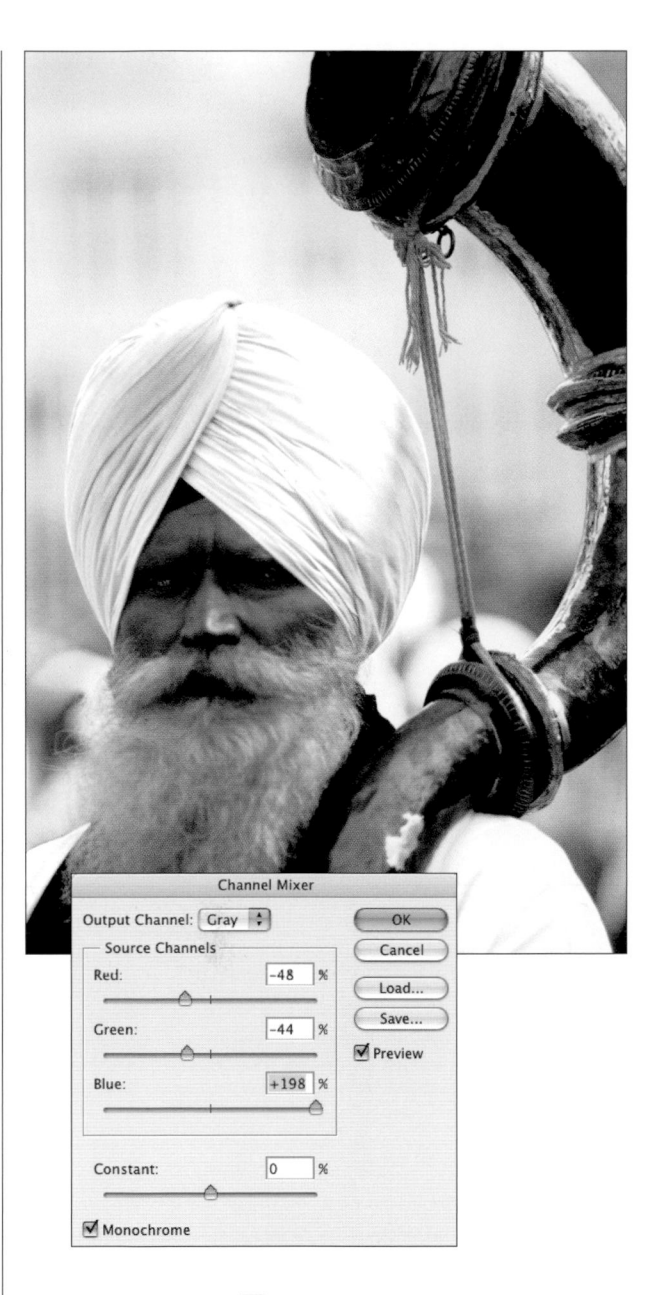

Channel Mixer

Output Channel: Gray

Source Channels

Red: −48 %

Green: −44 %

Blue: +198 %

Constant: 0 %

☑ Monochrome

OK
Cancel
Load...
Save...
☑ Preview

Channel Mixer

Output Channel: Gray

Source Channels

Red: +94 %

Green: +66 %

Blue: −44 %

Constant: 0 %

☑ Monochrome

OK
Cancel
Load...
Save...
☑ Preview

Dark blue

Darkening is an easier proposition, as the default conversion is already in that direction. In fact, we can reach pure black in the shadows of the turban well before 200% on the blue slider. By trial and error, these settings give the darkest blue with moderate clipping of the yellow highlights. As with the bright-turban version, a manually brushed-out layer composite is an improvement and avoids any clipping.

Hue adjustment

Now that the tonal translation of colours into black and white is infinitely adjustable, shifting hues across the spectrum can have a profound effect.

As if all the colour-to-monochrome adjustments already described were not enough, here is yet another that gives strong, global changes that are difficult to predict. The Hue/Saturation dialog under *Image > Adjustments* uses the HSB colour model that corresponds very closely to the way we intuitively think about colour. Hue relates to wavelength and to the names we give to colours (as in red, yellow, cyan, and so on), Saturation is the intensity of the colour effect (or chroma), and Lightness is self-explanatory. Whatever method of conversion to black and white is used, whether basic Photoshop Grayscale, or Desaturate, or the Channel Mixer, the effect depends on the proportions of red, green, and blue. Any changes that you make via Hue/Saturation will obviously affect the outcome, and none more so than the Hue slider, which in its basic function shifts all the colours around the spectrum.

The scaling of the Hue slider is by degree, with red at 0°/360°, and all the hues arranged notionally in a circle so that their complementaries are 180° opposite. The opposite of red is blue-green (that is, cyan), and its hue angle, therefore, is 180°. By moving the slider strongly, red can become green, or indeed any other hue, and all the other colours move by the same amount. In a colour image, the most by which this slider is used under normal circumstances is a very few degrees, usually to counter a color cast. Any

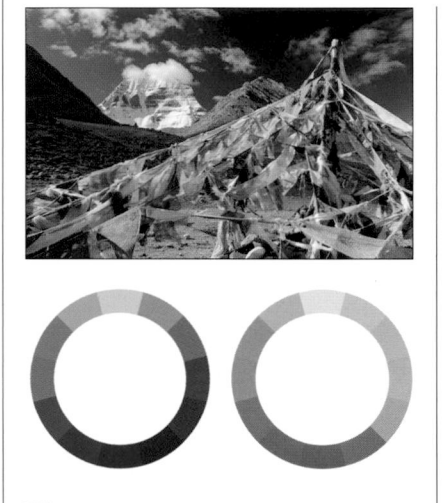

Colour original
The original has some noteworthy characteristics, which will strongly affect the outcome. The sky is an intense blue but the landscape is almost completely neutral. As before, here we have our standard colour circle to see the effects of three positions of the hue slider, each differing by 90 degrees (0 and 360 are identical). For comparison, this is the default Grayscale conversion.

A strong red channel mix
We begin with a Channel Mixer Adjustment Layer, which opens with a default mix of +100 red, which we keep because it gives a dramatic sky.

Add hue adjustment layer
Next we open a Hue/Saturation Adjustment Layer below.

more and the image simply looks oddly coloured without any good reason. In black and white, however, tonal shifts do not elicit the same reaction, particularly if the viewer has no colour reference for comparison. The main effect is a redistribution of contrast within the image.

Just as in the normal 'colour' use of the Hue slider, there are refinements to this global and rather crude shifting of hues. Instead of working with the Master selection (all hues), choose one from the drop-down menu to restrict the range of the spectrum over which you are going to make changes. This done, a set of four sliders appears below on the main spectrum bar to indicate the range of hues that will be affected. These can be dragged around to alter the range. The two inner vertical bars define the range between them of 100% alteration, while the two outer triangular sliders set the limits of the fall-off of alteration, which is feathered for a natural effect.

The effect of these hue adjustments is powerful and potentially useful on a black-and-white image. The real problem, of course, is fitting such a strong adjustment method into all the others that you might want to use. The permutations are too many to visualise easily. This is where adjustment layers become particularly useful. Create a Channel Mixer Adjustment Layer on top, and choose any reasonable mix. Then open a Hue/Saturation Adjustment Layer below it, and work the Hue slider as described. The tonal shifts in the monochrome image are instantly viewable.

Hue angle +270
Plus 270 degrees of hue angle. The most evenly distributed scale of tones in monochrome. Only the purple stands out darkly.

Hue angle +180
Plus 180 degrees of hue angle. Yellow's evident brightness disappears from the monochrome circle.

Hue angle +90
Plus 90 degrees of hue angle. Turns the yellow-to-red arc into close variations of green, and a monochrome conversion that divides the circle almost in half.

Hue angle +100
Shifting the angle positively 100 degrees turns the blue sky to magenta, so lightening it dramatically in monochrome with the same channel mix of +100 red. Note that the landscape is unaffected, but the flags are. The coloured version is how the hue shift would look without the channel mixing conversion.

Hue angle -120
Moving the hue slider in the opposite, negative direction by 120 degrees turns the blue sky green, with a correspondingly less strong effect in monochrome.

Channels into layers

By creating a three-layer image from the three RGB colour channels, you can perform most of the effects of a Channel Mixer through adjusting the opacity.

This rather more complex and time-consuming Photoshop technique, suggested by John Paul Caponigro, has the advantage that the tonal values of the three channels can be combined interactively using layer commands. Adding layer masks to the upper two layers further enhances its scope, and although this is clearly not an everyday, every-image technique, it offers unprecedented flexibility. The principle is to convert each channel into a layer, and the simplest method is as follows.

Either use the Split Channels command to separate the channels into different documents, or simply click on each channel one at a time in the Channels palette. If the latter, click on the Red channel first; this hides the others. Select All, then Copy, and then choose *New* from the *File* menu, but change the Color Mode from Grayscale to RGB Color. As you have just loaded the channel into the clipboard, Photoshop will automatically use the same size of file for the new document. Then Paste. The black-and-white image representing the Red channel will appear as the new layer. Flatten the image so that this becomes the background of the new document, which you can save and name. Repeat this process with the other channels: Green and Blue if the original was an RGB file. The same procedure works with CMYK and four channels.

As created, only the upper layer will be visible, but as layer compositing offers so many choices through different commands, there are a huge number of

Colour original

A highly colourful interior in Hong Kong gives plenty of opportunities for combining channels, each of which will have a marked effect on the contrasting hues. From here select one of the channels by clicking on it – in this case red. Now Select All (Cmd+A) to select the whole image, then Copy.

New file

Create a new image file (automatically the same size because of the Copy command), and Paste into it.

permutations for combining the different tonal interpretations of these channels-become-layers. The combination of layers is quite different in principle from channel mixing. In the latter, simple percentages determine the proportions of each that will be visible, but layers behave just as their name suggests – the combination appears as if you were looking down through them from above. So, if the top layer has an opacity of 100% (at the 'Normal' blending mode), this will be the only part of the image visible. Reducing its opacity allows something of the layer beneath to show through. The bottom layer needs to be at full 100% opacity, but varying the percentages of the upper two controls the mix. Not only that, but the order of the three layers also affects the appearance. Most blending modes are too extreme to be practical, and the tendency is to increase contrast, but depending on the image's tonal structure, the Darken and Lighten options can be useful in reducing overall contrast – the former darkens areas where the overlying layer is darker than the one beneath, the latter lightens in the same manner.

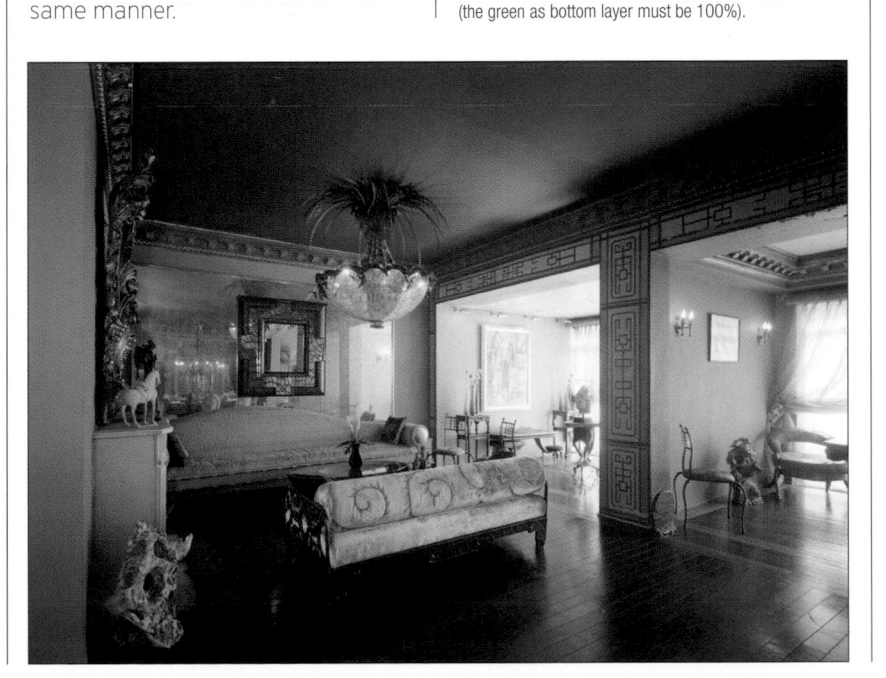

Version 1
With the layer stack in this order, and opacities in descending order of 10% (blue), 20% (green), and 100% (red), this is the result.

Version 2
To lighten the ceiling and give extra tone to the almost washed-out far window bay, the layers are reordered by dragging. Then, the red layer is lightened by reducing its opacity and the blue darkened to 100% (the green as bottom layer must be 100%).

Flatten and repeat
Flattening is optional, but reduces the file size. Repeat the process for the other two channels, resulting in a three-layer file. For identification, name the layers. You can now vary the layers' opacities to taste.

Layer masks

When using channels-into-layers, adding a mask to each layer adds an even greater degree of control by allowing selective removal.

Yet another argument for controlling the tonality in a black-and-white conversion by turning the channels into layers is selective retouching. Channel mixing, powerful though it is, works across the entire image. If you want to selectively apply one mix to a particular area of the image and another mix to the rest, the solution is slightly cumbersome – preparing two mixes, layering one over the other and erasing (see page 66). Layer masks used with layers that have been copied from channels, as described on the previous pages, offer a more elegant solution, but still with a hands-on painting-and-erasing capability.

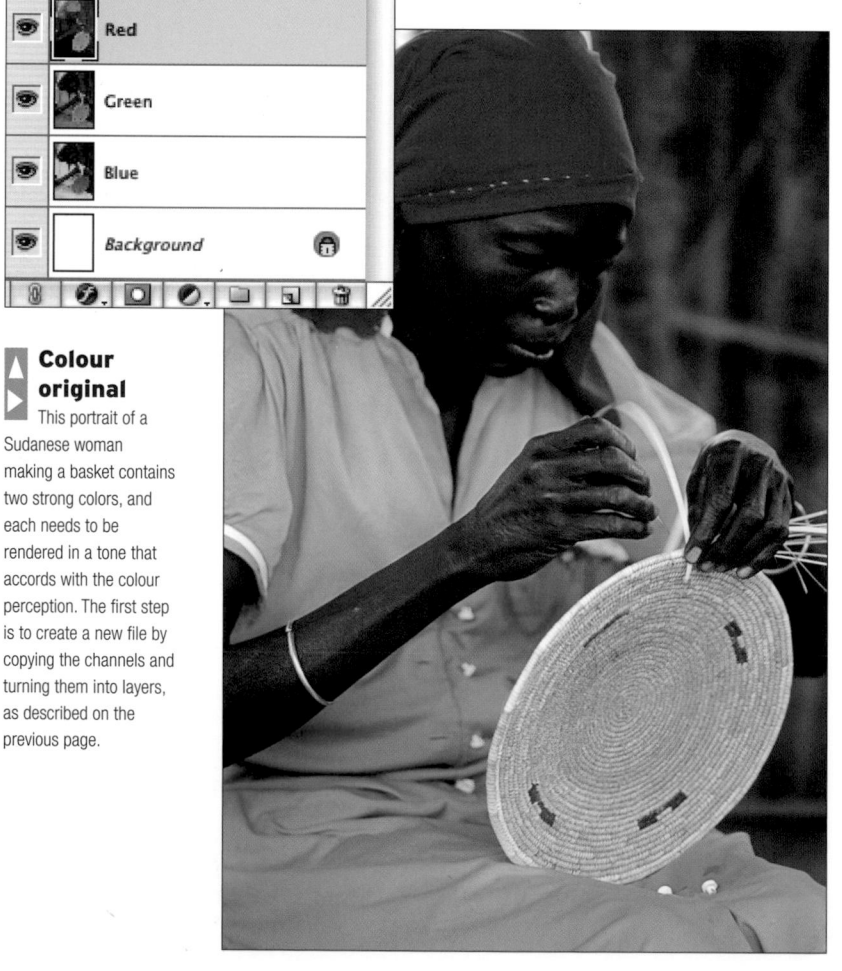

Masks determine what is revealed or hidden from an image, and a Layer Mask is simply a greyscale image attached to a particular layer. White reveals the entire layer – that is, it is opaque – while black hides everything. So, painting with a black brush on a white layer mask has the same effect as erasing parts of the layer to allow the lower layer to show through. Shades of grey allow varying proportions of the lower layer to show through.

You can create a layer mask by selecting the target layer, then, from the menu clicking *Layer > Add Layer Mask* and then choose either Reveal All or Hide All. The mask appears in the Layers palette alongside the thumbnail of the layer. Alternatively, there is a New Layer Mask button at the bottom of the Layers palette.

Its uses are extensive. You might have assembled a layer combination

▲ Colour original
This portrait of a Sudanese woman making a basket contains two strong colors, and each needs to be rendered in a tone that accords with the colour perception. The first step is to create a new file by copying the channels and turning them into layers, as described on the previous page.

with blue on top, red below, and green at the bottom, and adjusted the opacities to work for most of a landscape image. Yet suppose that you wanted to darken the blue areas of the sky further. With this technique, the solution would be to paint in black over the sky area of the upper layer, effectively removing it from what was once the blue channel. This reveals the darker rendering of the sky from the red layer. And painting with a brush is not the only way of retouching – another option is to use the gradient tool for a smooth transition across the layer mask.

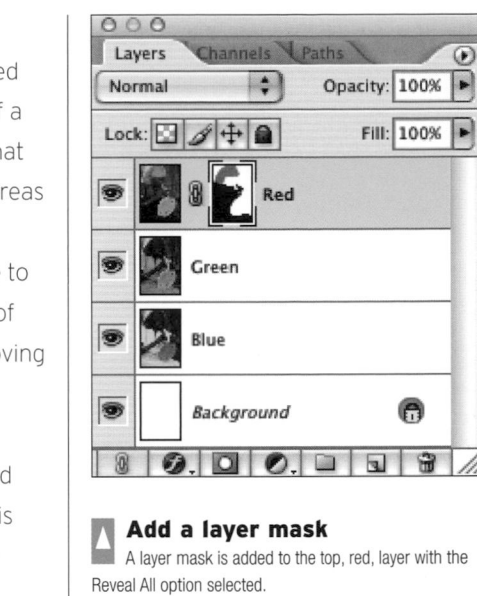

▲ Add a layer mask

A layer mask is added to the top, red, layer with the Reveal All option selected.

▲ Brush over dress

Once you've added the layer mask, using the Brush tool at 100% opacity, work over the dress and scarf. The almost-neutral dark skin is virtually unaffected, allowing broad brush strokes.

▶ Partly restore headscarf

The headscarf is now over-darkened. To bring it back a little, set the eraser to 50% and brush over just this part.

Using and displaying layer masks

To activate the mask so that you can paint on it, click its thumbnail in the Layers palette. A paintbrush appears on the left to show that it is ready for painting.

To view the layer mask in the main image window, Option/Alt-click the layer mask thumbnail. The mask now appears over the image. Return to the normal view of the image by clicking in the same way.

To disable a layer mask, Shift-click its thumbnail, or go to *Layer > Disable Layer Mask*.

To enable it again, Shift-click the thumbnail once more, or go to *Layer > Enable Layer Mask*.

To alter the appearance of a Layer Mask in the same way as you would Photoshop's Quick Mask Mode (for instance, display it in red and at a percentage opacity), first display the layer mask as above, and then double-click its thumbnail. The Layer Mask Display Options dialog appears. Alternatively, double-click the masks' thumbnails in the Channels palette.

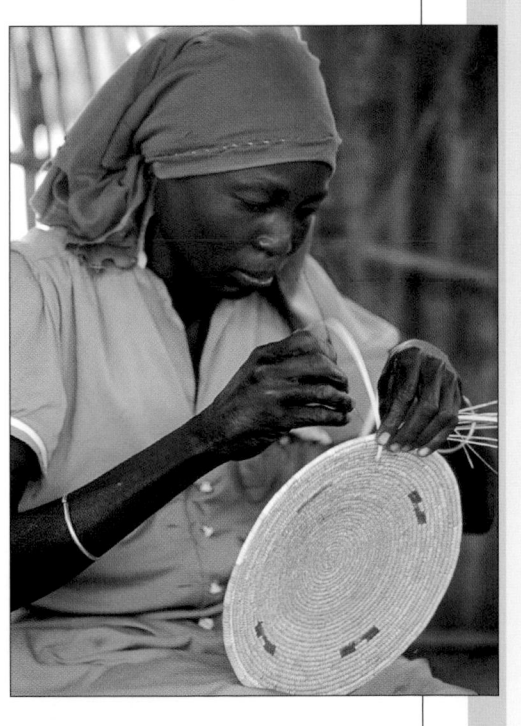

▲ Retouched version

The final version has colours that are more as the eye perceives, or at least expects, with a pale dress and a darker headscarf that still contrasts with the skin.

Third-party converters

A small number of specialist software companies provide dedicated methods of converting colour to black and white.

As we've seen, there are powerful tools for making both subtle and extreme conversions to black and white. This does, however, demand a commitment to understanding the software fully. Channel mixing in particular is not completely intuitive, not least because it was designed for a variety of tasks, not just photographic conversions.

This is where third-party software comes in. There are plug-ins for almost every conceivable imaging function, and black-and-white conversion is no exception. Plug-ins operate from within an application, in this case Photoshop. They exist for two reasons: some because they offer procedures not available (yet) in Photoshop, and others because they present the procedures in a more convenient way. Most black and white converter plug-ins fit into the latter category, although some have original algorithms, such as conversions based on how specific silver halide materials perform.

Here are three examples. One of the most comprehensive is the Black and White Studio plug-in from PowerRetouche, part of a larger suite of imaging software, much of it geared toward photography. It is notable for offering various approaches to black-and-white conversion that largely follow the procedures and materials available in conventional film photography. To this end, the spectral sensitivities of several films, as well as the behaviours of multigrade printing papers, have been analyzed and made available as conversion options. The controls are grouped into four sets – Lens, Film, Print, and Zones – which give a film-photographer's methodology.

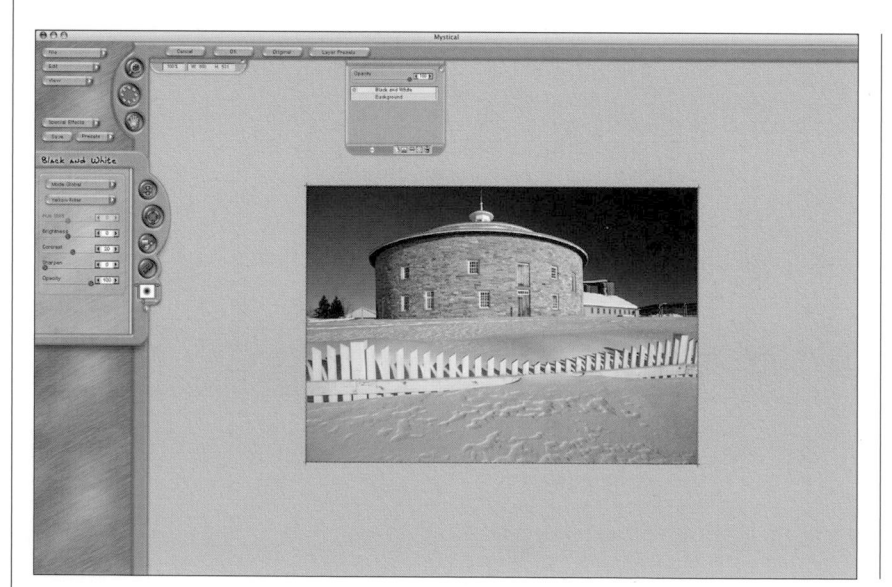

▲ Mystical Tint, Tone and Color
Applied to a colour original of a round Shaker barn in snow, the Black and White filter is one of several in this suite (also known as MTTC).

Of course, as digital black-and-white conversion is procedurally quite different from film black and white photography, the different sets of controls are essentially alternatives rather than a sequence to be applied to any one

image. The Lens filters give the tonal conversion that you would expect from coloured filters over the lens (see page 30); the Film controls use sliders to adjust wavelengths, together with presets for specific black-and-white emulsions; the Print set offers the classic darkroom print techniques including multigrade, highlight and shadow correction, and exposure; while the Zones controls adjust contrast, brightness, and balance across three zones (not related to the Zone System).

Also part of a suite is B/W Conversion from nik Multimedia's Color Efex Pro, the filter procedures of which are optimized for photography. The conversion process from colour has been refined to three parameters, each represented by a slider. One controls the strength of the effect, a second determines which part of the spectrum is used, and the third allows you to adjust the overall brightness (which is affected by relative importance of whichever colour is being lightened or darkened).

Mystical Tint, Tone and Color from AutoFX Software also has a black-and-white converter that uses sliders to apply coloured filter, brightness and contrast controls, as well as sharpen and opacity of effect. Notably, it offers both a 'global' mode that applies the effect to the entire image and a brush mode that is useful for partial black-and-white effects (see page 142).

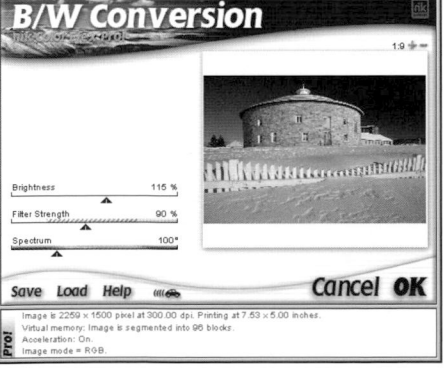

◀ nik Color Efex Pro

B/W Conversion in nik Multimedia Color Efex Pro.

▲▶ Black and White Studio

This plug-in from PowerRetouche offers three methods of conversion: Film, Print and Zones. The first two are analogous to film types and darkroom printing respectively; the third allows the tonal range to be subdivided in any proportion (shown here at bottom is the mask for one zone, indicating affected areas).

Case study: **drama in the red channel**

In traditional black-and-white film photography, a red filter over the lens is the simple way to achieve an intense, high-contrast tonality in outdoor scenes with strong sunlight and a blue sky. It is also easy to go to extremes, and the degree of drama is a matter of taste. Ansel Adams was critical of what he called the 'lunar' quality in images that overdid this red-filtering effect. In this example, however, I wanted exactly that lunar quality of stark otherworldliness, as if there were no atmosphere at all. The view lends itself to this treatment: the summit of a bleak, still-active volcano in the Andes, close to sunset with long shadows. This is by way of an experiment, to see how far we can go in creating a dramatic version. Of course, as the original is in colour and we are working in post-production, this is only one of many possible versions.

Colour original

The full-colour image fulfills the criteria needed for a strong red channel mix on a landscape – the sunlight is strong, visibility good and without haze, and although there is no clear sky visible, it is deep blue behind the camera and so reflected distinctly in the low clouds in the middle distance, and all-importantly in the shadows. Moreover, the altitude is high and there is a high UV content to the light. There is also a distinct and attractive colour-temperature contrast between the sunlit and shadowed areas, as we would expect.

Default conversion

As usual, we first make and save a default Grayscale conversion. The channel mix is, as we already know (see page 28), red 30%, green 59% and blue 11%, and so the balance is average on red but with much more emphasis on green than we are going to make with our new channel mix.

▲ Strong red

As it happens, the default channel mix when the dialog window opens is 100% red, 0% green and blue, and this is in exactly the direction that I want. The contrast is higher, but as the histogram indicates, there is no clipping at either end of the scale. The centre foreground rocks and the ridged mound just beyond are key indicators—I'm trying to increase the local contrast in this area, as measured by the brightness of the sunlit sides and the darkness of the shadows. The upper part of the image, occupied by bluish clouds, is also darkened.

▼ Maximum red

Now I want to see how far we can take the red filtration, for the maximum lunar quality. As an increasing red channel bias has the effect of increasing contrast in this scene, the limit will be the point at which highlights and shadows are clipped. The danger highlight that needs to be preserved is the left part of the toxic steam from one of the volcano's fumaroles. That must be held, but we can exercise some choice over the shadows. By experiment, this combination, with red at 160%, is the maximum. Apart from the starkness of this new version of the image, notice also how the overall composition is strengthened by having a broad, diagonal, dark band separating the brighter areas at upper left and lower right.

Case study: **yellow's compromise**

Again drawing on the experience of black-and-white film photography, the single most widely used lens filter for outdoor shooting is yellow. As with red, it needs direct sunlight and a clear sky to have its typical effect, as it acts on blue. Its popularity with film lies in the characteristic of a silver-halide emulsion to be over-sensitive to blue and UV light.

A yellow filter typically restores the perceptual darkness of a blue sky and its reflections. The huge tonal control possible with digital imaging makes much of this rationale moot, but there remains the popular photographic issue of sky contrast between clear blue and clouds; a distinction preferred by most. Yellow offers a reasonable, rather than an extreme, treatment of skies. Neither red nor yellow are exact complementaries of blue, by the way, but they are close enough to have a distinct stopping effect. The blue of sky light in any case varies from a hue angle of about 190° to 220°.

▶ **Acoma**
This image was shot under near-ideal conditions in New Mexico in clear winter weather – an ancient native-American pueblo built on top of a sandstone mesa. The local rock has a warm, yellowish tone, which contrasts with the clear deep blue of the sky.

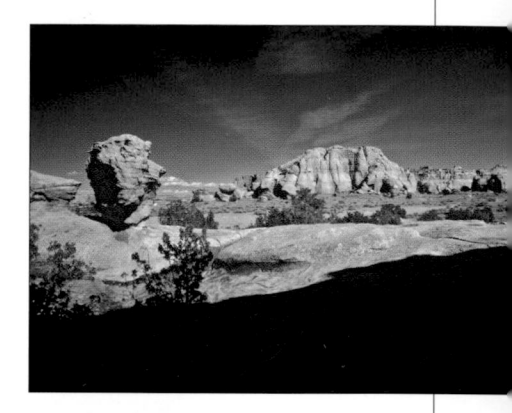

◀ **Split-channel preview**
A quick channel split (performed on a copy as it is an irreversible action) has the value of showing the extremes that we want to avoid. Remember that here we are looking for a reasonable, balanced contrast, and certainly don't want to lose detail in the extensive shadows. Red is extreme in one direction, blue in another, and the differences are obvious. The green channel is quite interesting.

Red Channel

Green Channel

Blue Channel

| 45% 55% | 50% 50% | 55% 45% | 60% 40% | 90% 10% |

Degrees of yellow

In the traditional Wratten filter set (see page 30), there is more than one yellow. Here, digitally, we've constructed a set of filters that vary from greenish to reddish. With additive colour mixing, yellow is the product of red and green. This was done with channel mixing, and as the percentages demonstrate, around the standard yellow mix of equal red and green, small percentage differences make noticeable changes to the perceived hue. Notice, however, that the monochrome effect is not so strong perceptually – more a subtle distinction in contrast.

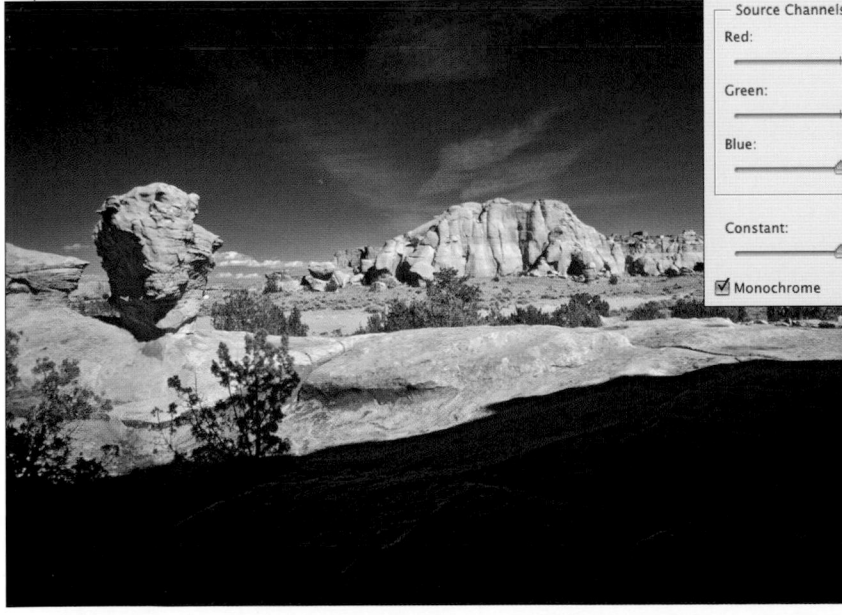

A spectral yellow mix

50% each of red and green gives a pure yellow measured on the spectrum, and this is the final mix chosen here. The blue sky is quite dark, and sufficient to show the wispy clouds – an important factor. The rocks are bright but without clipping, and the foreground shaded area is rich and dark with good contrast.

Case study: **blue's atmospheric depth**

Still with landscape photography, because of the overriding effect of blue skylight and atmosphere, let's now look at a treatment that's the complete opposite of red and yellow filtration.

Desaturated

Grayscale

Five basic versions

As the image overall is not strongly saturated, we can't expect great differences between the two standard conversions and between the channels. These standard conversions in Photoshop are Grayscale, Desaturate, and the three channels from the Split Channels command. Certainly the differences are mild if we examine the distance, but notice that the blue-channel version is darker in the foreground — too dark if the farm buildings are intended to be the principal subject.

Landscape with atmosphere

A slight mist hangs over this Yorkshire valley of Wensleydale, as the dew evaporates in the early morning sunshine. The strong, punchy treatment would be to counteract the paleness in the blue-tinged distance with an orange or red 'filtration', but a more sensitive approach might be to emphasize the aerial perspective for a better sense of depth and atmosphere. As the UV content in the air helps to make the distance blue, this is likely to be a case for the blue channel.

Examine the channel histograms

Opening the full channel-by-channel histogram display in colour helps the analysis. The more prominent, broader spike toward the right of the blue channel's histogram (the lowest) is clear evidence of the pale haze. Let's now proceed to the next step.

Red, Green, and Blue Channels

Decide on an average area

As we can see, a single channel will not always automatically be optimized. We need to do some work, and the first step is to exercise judgment as to which parts of the scene ought to be an average 50% grey. The stone wall of the building nearest to the camera seems a likely candidate, and using the Average Filter method described on page 34, we analyze it. At 75% it is a mid-shadow value, and too low for taste.

Decide on the lightening

With a section of the wall still averaged, it is easy to decide on the amount of lightening necessary. In Levels, simply drag the mid-point slider over to the spike that represents the marquee value. In doing this, however, I change my mind about making this area mid-grey. It seems a little too bright. Maybe 60% would be better. Take a note of the new Input value for the mid-point: 1.49.

Lighten the image

The Input value measured in the previous step, 1.49, is then applied to the entire image. This brings the building, trees, and grass of the middle distance to values that look normal. The distant haze is now distinctly brightened, so that the scene acquires a luminous quality absent in the earlier black-and-white versions.

Case study: **luminous green foliage**

As with all tonal conversion filtration, the colour used brightens objects of its own colour and darkens the complementary, which in the case of green is magenta. This makes green a useful tool when dealing with skin tones and make-up such as lipstick; we will come to this shortly. For now, however, we consider the green channel in terms of what it does to its own colour, which is prominent in nature as foliage. One caveat here is that normally green vegetation is much less saturated than most people would expect. We subconsciously tend to use our imagination a little too much when we see trees and grass. In this example, however, I've chosen a scene that does happen to have an unusually high saturation of green – new grass in the Yorkshire Dales, under a cloudy sky (good for saturated colour because there are no specular reflections from the blades of grass).

▶ Hikers and green fields

The original image (which actually works very well in colour, so this is more of an exercise) contains a variety of greens, differing in brightness and saturation. Using the Average Filter technique described on page 34, I've prepared samples from the four zones. The old stone barn is grey, which gives us an easy standard for any brightness adjustments, although there is, in fact, a tinge of blue to it, as we'll see when we make some extreme changes.

▶ Grayscale for reference

As a yardstick, the standard Grayscale conversion gives a black-and-white image that is already biased toward green (RGB 30% 59% 11%), although viewed alongside the colour original, it disappointingly lacks the expected brightness. The human eye is especially sensitive to green wavelengths, and this is what we want to convey here in black and white.

◀▼ Default channel mix

As we know by now, the default mix when the Channel Mixer dialog opens is 100% red – inappropriate for what we want here, but a useful demonstration of how much this image needs the opposite.

Channel Mixer

Output Channel: Gray ▾

Source Channels

Red: +100 %

Green: 0 %

Blue: 0 %

Constant: 0 %

☑ Monochrome

OK
Cancel
Load...
Save...
☑ Preview

◀▼ Stronger green

We can go further to lighten the greens. 150% in the green channel, countered by negative values in the other two, and a slight adjustment to the Constant slider brings the conversion to more or less how I see it in colour.

Channel Mixer

Output Channel: Gray ▾

Source Channels

Red: -40 %

Green: +150 %

Blue: -40 %

Constant: 0 %

☑ Monochrome

OK
Cancel
Load...
Save...
☑ Preview

◀▼ Green mix

Choosing 100% green in the Channel Mixer and 0% each for red and blue is the equivalent of simply taking the green channel. The effect is good, but only in the bright, strong field surrounding the barn. The other areas remain dull.

Channel Mixer

Output Channel: Gray ▾

Source Channels

Red: 0 %

Green: +100 %

Blue: 0 %

Constant: 0 %

☑ Monochrome

OK
Cancel
Load...
Save...
☑ Preview

◀▼ Contrast the hikers

The colour analysis shows the field with the hikers in contains more blue than red. The solution is to maximize the green, minimize the red and use the blue slider to adjust the overall brightness and contrast.

Channel Mixer

Output Channel: Gray ▾

Source Channels

Red: -200 %

Green: +200 %

Blue: +120 %

Constant: 0 %

☑ Monochrome

OK
Cancel
Load...
Save...
☑ Preview

Flesh tones, dark and light

Although we are not accustomed to thinking of skin as having definite colour, it does have a bias that affects its appearance in black and white.

As in other aspects of photography, anything to do with the human face evokes viewer reactions based on familiarity and expectation. What this means in practice is that when looking at a portrait photograph, we have a distinct sense of what is the right or wrong colour. This translates into black and white as a skin tone that is lighter or darker, and with less or more contrast. There is certainly a wider range of acceptable tones in black and white than there are hues in a colour photograph (where even a slight hint of green, for example, triggers a response of wrongness), but this is still narrower than the range for subjects such as the sky, plants, buildings. In other words, skin tones are a case for special consideration, the more so in black-and-white photography because they can be manipulated at will.

The main reason for this is that human perception is trained to 'read' faces: to recognize them, evaluate them, take information from them. If there is something out of the ordinary in the colour or tone, the first reaction is to wonder why and then imagine

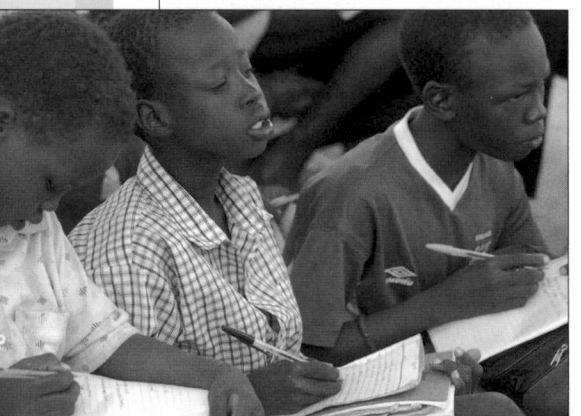

Dinka classroom
There are actually many colour casts of black skin; in this case, Dinka in Sudan, the lightening effect of 100% red in a channel mix (compared with default Grayscale) is moderate, but helps to reduce the contrast between skin and clothes.

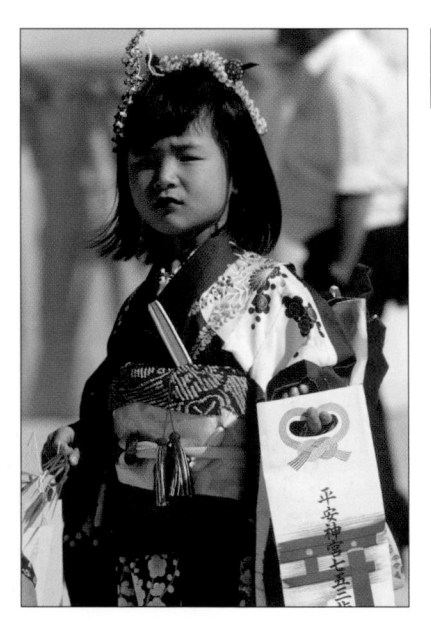

Japanese girl
From the original above, a red favouring mix with +76 red, +14 green and +10 blue.

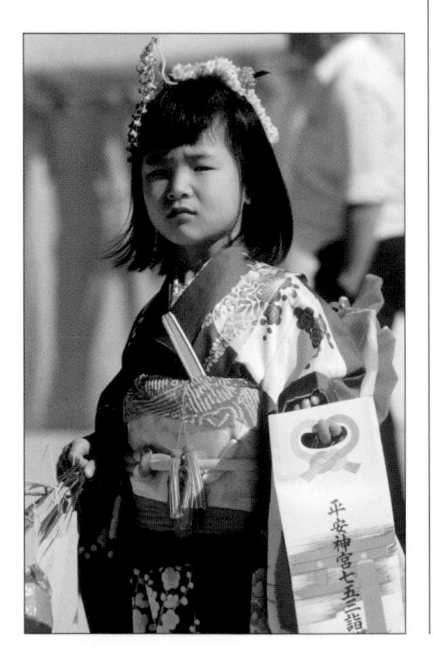

the cause. If a face that we expect to be pale appears dark, we might imagine excessive sunbathing is the cause. Darker still would simply be disturbing, because there would be no obvious explanation. Faces are special in this way. No other 'object' normally receives so much instant attention. Interestingly, the photography in black and white is rarely seen as the culprit. If a colour image has an overall colour cast it is assumed to be a photographic fault, but in black and white, as long as the overall brightness and contrast are within a normal range, individual tones are treated as part of the subject.

As in facial recognition, we are most familiar with, and have the strongest opinions about, the skin tones of our own ethnic group. Even within one ethnic group there are large differences from individual to individual, and it is important to avoid preconceptions. Nevertheless, in most skin there is a higher proportion of red than green or blue. In very pale and very dark skin, as in the white English children (right), the red bias is least, and tends to show more in the mid-to-dark tones. The Japanese girl has the lowest proportion of blue, and the distinctly brown face of the Pathan man has the most red. When using the Channel Mixer, you need to take each image on its merits – there is no blanket solution. The differences between equal-channel desaturation and default greyscale conversion are usually very slight.

▲▶ Pathan Man
This portrait of a Pathan tribesman has the highest proportion of red. Using the averaged samples technique (page 61) it is possible to see this, and the conversion has been made accordingly, with a red mix.

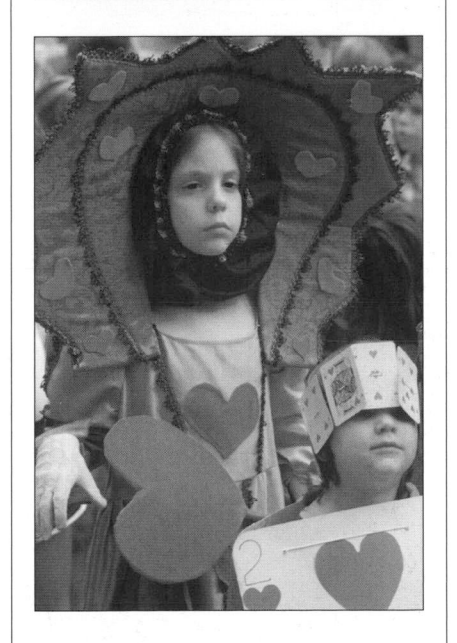

▲▲ Mad Hatter's Tea Party
Light Caucasian skin responds moderately to variations in the red channel, but the choice is a matter of taste – the lightening effect may cause the skin to look too pale.

Fine-tuning dark skin

Very dark skin, such as that of many sub-Saharan African people, generally needs a black-and-white conversion that emphasizes local contrast.

As we saw briefly on the previous pages, skin colour varies hugely. The terms 'white' and 'black' are completely inappropriate as a way of dealing technically with skin tones. Nevertheless, very dark skin needs a different tonal approach from very pale skin. In principle, we usually want to maintain a rich, dark treatment, while not losing detail in the shadows (which is easy to do). In practice, this often means raising the contrast in the darker part of the tonal range, as this example demonstrates. The portrait is of a girl from the west of Sudan, and while it is not possible to say that the skin colour is typical of sub-Saharan Africa, nor is it unusual.

If we make an RGB analysis, using the Average Filter on squares of skin, we can see that throughout, red is strongest on this face and blue weakest. However, note that the relative proportions alter with shadow, so that the

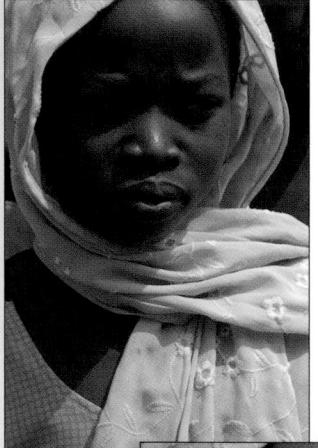

Colour original

In the original colour image, the face is half in shadow from a bright but fairly low sun. The overall colour is brown, so red is predictably quite high. The brightness levels measured with the HSB option in the Info palette are 40% for the brightest patch, 30% for the darker and 20% for the darkest.

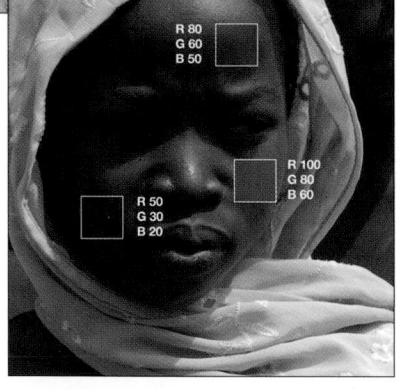

R 80
G 60
B 50

R 100
G 80
B 60

R 50
G 30
B 20

Default channel mix

Opening the Channel Mixer displays the default, which is 100% red, the dominant color in this instance. The overall brightness of the face is satisfactory, but it lacks contrast.

Proportionate mix

Referring back to the colour patches and their RGB values, the channel mix is adjusted roughly in proportion to the values, with red strongest and green weakest. There is a slight improvement in contrast, and no clipping of the highlights, but the face still lacks local contrast.

Channel Mixer

Output Channel: Gray

OK
Cancel
Load...
Save...
☑ Preview

Source Channels

Red: +78 %

Green: +30 %

Blue: -6 %

Constant: +4 %

☑ Monochrome

shaded areas have a slightly higher red component than those in sunlight. This will affect the contrast when we convert to black and white. Be aware, though, that black skin from some ethnic groups can have much less red. If neutral and very dark, it will also pick up environmental reflections - much more so than pale Caucasian skin - and under a strong skylight this can even give a bluish appearance.

Moving to the Channel Mixer, the choice of the favoured channel is determined less by a need to lighten or darken overall, than by contrast. With the exception of a few specular highlights (in this example on the forehead, the tip of the nose and the lips), all the values are in the lower half of the tonal range. One of the effects of this is to give a rather flat appearance, and the key issue is usually reaching sufficient contrast. In the steps shown here, it was possible to produce a satisfactory result by adjusting the channel sliders so that they followed the initial RGB values, but a better result was a more extreme mix to boost contrast in the face. Unfortunately, the bright shawl could not survive this treatment, so we resorted to a composite - not elegant, and by no means always necessary, but it created the effect that was wanted.

Compositing
The only solution is to composite the face from the high-contrast mix with the clothes from the proportionate mix. The former is pasted as a layer over the latter, and brushed out where needed with the eraser.

Mixing for contrast
Ignoring for the time being the effect on the clothes, the mix is adjusted for high contrast in the skin tones, which by trial and error is average red and high green. The result is good, but the shawl values are blown out.

Fine-tuning light skin

Pale skin usually benefits from the opposite approach to that just demonstrated for dark skin – namely less local contrast and texture.

The distribution of tones over a light-skinned face is quite different from that on dark skin, and the convention is for a reasonably high-key effect, with the exception of the mouth, eyes, and eyebrows. In practice, these features tend to be more prominent, so, as here, need special attention. The very term 'light skin', of course, covers a wide range, and there are ethnic variations, differences caused by complexion (florid, pallid, freckles) and, importantly, by make-up.

If the intention is an attractive result, then it's essential to pay close attention to small details, like variations in pigmentation. It's not fair to call these blemishes, but from the point of view of 'beauty photography', reducing or removing them is almost always considered an improvement. I'm being careful here to connect this to intention, because in reportage faces are usually better left as they are, while the treatments discussed here are designed to give a result that is pleasing to the sitter in a portrait situation. I've deliberately chosen a freckled face. The freckles obviously have a higher red component than the surrounding skin, so that they are in danger of becoming too prominent but equally can be suppressed through channel mixing.

▲ Colour original

The combination of complexion, eye make-up and dress makes this a colourful image that will, because of this, respond quite strongly to any changes in the channel mix. Note that the pink cheeks will probably respond even more to variations in the red channel than will the freckles.

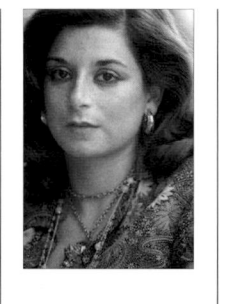

▲ Default greyscale

The default Photoshop Grayscale conversion, because it favours green, gives more prominence than we want to the freckles, and cheeks that are rather too dark.

◀ Make duplicate layers

Because it is likely that we will have to adjust different parts of the portrait separately, the first step in making adjustments is to create a couple of duplicate layers. These can be composited later.

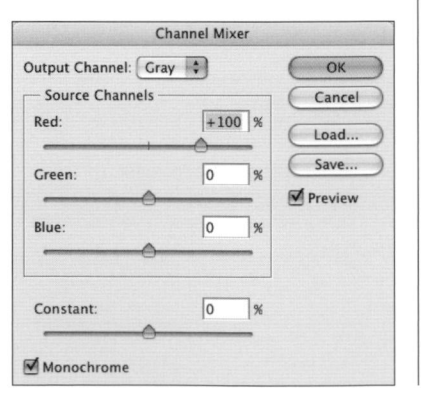

▲ Red extreme

The default channel mix of 100% red is a starting point. As expected, it lightens the overall skin tone and reduces the freckles. On the downside, the mouth now lacks definition because its red lipstick has also been lightened, the eyes have become unnaturally dark, and the hair highlights too bright. This mix is applied to the bottom, background layer. Note that, in this case, we do not want to remove the freckles completely, simply keep them more subdued.

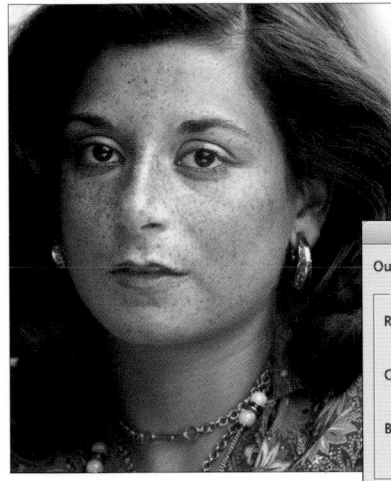

Blue extreme

The blue channel is the least commonly used for portraits, but for information let's see what it does here. Apart from a bizarre treatment of the complexion it does, as we might guess, brighten the eyes – and this is something we need. It is applied to the top duplicate layer, but then turned off so that we can work on the middle layer.

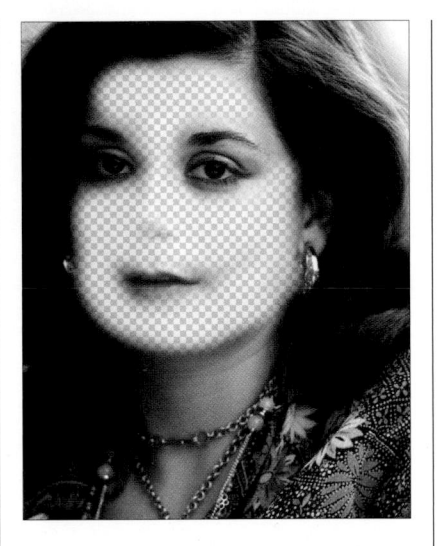

First composite

Now working on the lower two layers of the three, the skin areas of the upper layer (balanced mix between red and green) are erased with a soft brush.

A balance of red and green

Bearing in mind that we can make partial use of the extreme red and extreme blue mixes, we take the middle layer of the three and give it a channel mix that is adapted from the default greyscale, but with all blue removed.

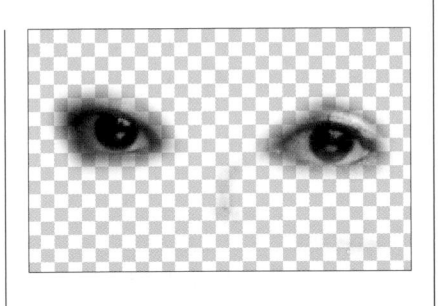

Second composite

Finally, we turn on the top layer (blue mix), and erase all of this apart from the eyes, which are at their brightest in this channel.

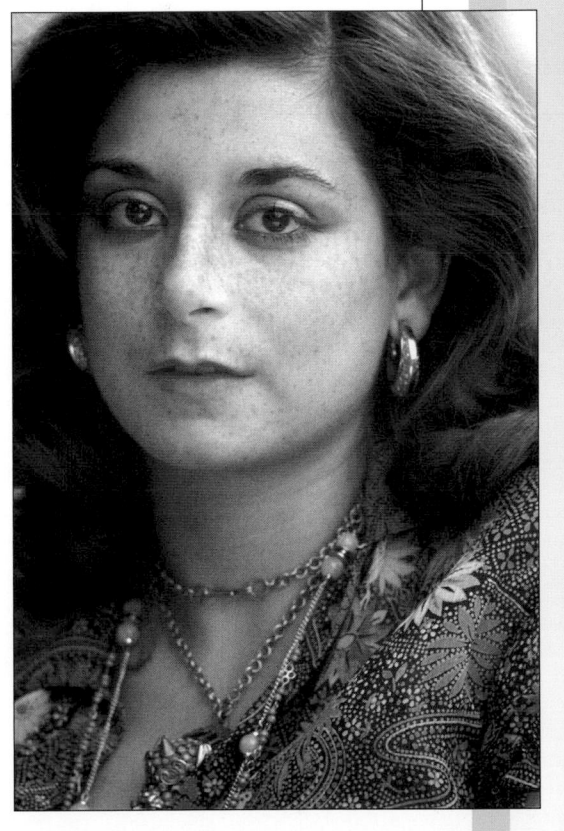

Thinking colour

Because digital imaging provides the means to choose how colours translate into black and white, there is now even greater need to first judge the colours in a scene.

Paradoxically, digital black-and-white photography demands a thoughtful appreciation of the dynamics of colour. Despite the need to concentrate creative attention on the special features of black and white, including tonality, line, shape, contrast and so on, many of the potential relationships between parts of a scene are in colour. Digital conversion to black and white can, as we have just seen, handle these relationships, which makes it important to understand how they work.

Colour is a complex component in all images. How it finally enters our consciousness is through a mixture of the physics of light, the physiology of the eye and brain, and the psychology of perception and association. Let's take green as an example. It is recognized as 'green' because it occupies that particular position on the visible spectrum (in the middle frequencies), but it is also, for the human eye, a familiar and quite prominent colour. It is familiar through vegetation and nature, which is to say chlorophyll, and moreover carries a wealth of largely positive associations that include growth, freshness, youth, and by extension, 'go' in traffic lights and other signs. Yet it

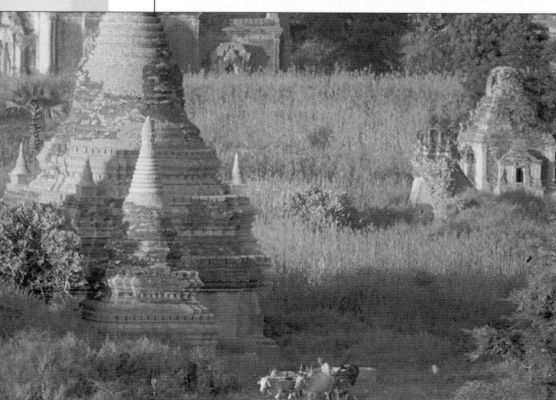

Pagan
The dominant colours in this scene are apparent – reddish brick and green grass. The conversion issue, of course, is whether the brickwork should be lighter than the grass, or vice versa. Because the general colour impression is that the stupas 'stand out' from the fields, my choice would be lighter brickwork.

Japanese room
This startlingly modern interior in bright hues is clearly a shot made for colour. If it were in black and white, the actual colours would be un-guessable, so the aim is simply to create a contrast in tone.

carries all these effects and associations without being inherently bright or dark. An average green has approximately the same perceptual brightness as an average red, more than blue, and less than yellow.

There are two fundamental ways of treating colour in black and white. One is simply looking at the contrast between hues, ignoring any associations. The other is to acknowledge the familiarity and expectation of certain colours. In the image to the left we know that the grass should be green and the brick stupas (probably) red-brown, but the interior shot is impossible to imagine from the mono version. This distinction is important as, since the advent of digital photography, individual hues can be converted to any degree of brightness or darkness. If the viewer knows that an object is green, for instance, there are upper and lower limits to how bright or dark it can be rendered in black and white and still look sensible. If there are no expectations, it's not an issue, and you can concentrate on establishing a suitable contrast with neighbouring colours instead.

Thinking in color is an important preparation for thinking in black and white, not least because it allows you to filter out those elements in a scene that make it appeal as a colour image. There is always a choice between these two forms of photography, and with digital capture you can go on exercising that choice all the way through. The choice is personal, because, while certain kinds of image are logical candidates for one treatment or the other, the creative judgment is an individual expression. It would be easy to say that a near-monochrome colour image would be better in black and white, but the very subtlety and chromatic restraint might be a part of its appeal. Equally, an image with an intense colour accent may simply make a different kind of photograph in black and white, exploring other tonal relationships.

Viewing the color circle

One useful preparatory exercise that gives an immediate idea of the effect of coloured filters or colour channels on different hues is to 'view' the colour circle in coloured light. Using Photoshop's Photo Filter (*Image > Adjustments > Photo Filter*) at 100% density and with Preserve Luminosity switched off, apply in turn the following colours: deep red, deep yellow, deep emerald, and deep blue. The overall colour casts are distracting, but even so, you can see the changes in brightness between these five different versions. With the deep blue filter, for example, the bluish zone on the circle becomes brighter while the yellow-orange-red – directly opposite and the complementaries – become darker. Compare this with the deep red-filtered version.

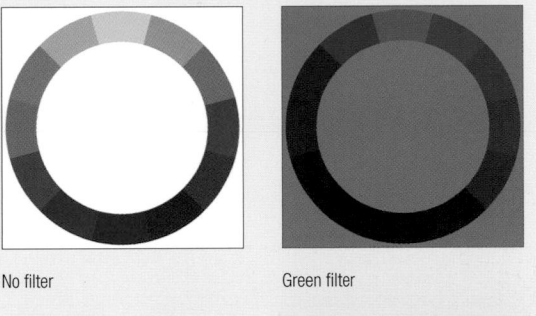

No filter Green filter

Yellow filter Red filter

Blue filter Blue filter

Colour's perceptual weight

How we read a colour image depends on several factors, including psychological associations, and these need to be considered when translating into black and white.

Although the idea of using strongly coloured filters to manipulate the lightness and darkness of different colours has been well known for a long time, and often features in writing on photography, very few photographers made much use of it before digital. As previously explained, a yellow filter over the lens was about as far as it went. The reasons are not hard to find: effort and unpredictability. While a full set of filters in primary and secondary colours could give huge control, it involved considerable fiddling about, and worse, the exposure had to be recalculated. Moreover, it needed experience and some guesswork to predict the effect; simply viewing the scene through the filter was more disorienting than informative.

Digital control over the tones of colours is so wide-ranging, however, that the brightness of any hue, from yellow to violet, can be allocated to any point on the tonal scale. An almost-black yellow may look bizarre, but it is possible. This kind of choice is new, and makes it both important and interesting to evaluate how colours ought to look in black and white. This is by no means simple, and depends on much more than the positions of colours in the spectrum. The starting point may well be

Colour original
A Peruvian woman with her pack llama. The accompanying illustration shows the colour relationships (black and white being colours in this sense). The orange cloth and red hat catch the eye, and even compete for attention with the action.

Interest
This simplified monochrome schematic reveals the areas of interest in the image.

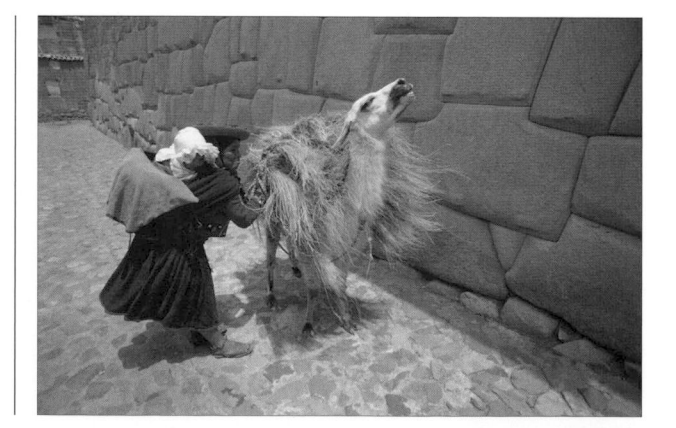

Orange midtone
If we decide that the interest in this image is because of the content, there is little point in favouring the colours. Here, therefore, the bright orange has been rendered as a mid-tone.

▶ **Sunset red**
A view of Monument Valley. In colour, the main point of the shot is, as the illustration makes clear, the blocks of color, diminishing in size with distance. These clearly stand right out.

▶ **Schematic**
The apparent areas of interest in this image are all red.

the 'white-light' appearance (which is essentially what a 'Desaturate' or 'Convert to greyscale' command does), but more important is how colours are perceived and expected to be. Yellow, already mentioned, is relatively simple. Our eyes see it as the brightest hue of all, and there is no naturally dark version – to do that would be to change it from being 'yellow' as we call it to something like 'ochre'. Red, however, is more problematic. Pure red is one of the richest, strongest colors in our experience, and has been through history and across cultures, hence its use in display and in signage, especially to alert attention. In short, red stands out. Yet this is because of its hue, its 'redness', not, as in the case of yellow, its brightness. If you completely desaturate pure red, you have a mid-gray. Unfortunately, you also have mid-grey by desaturating green. You may need, therefore to sacrifice or exaggerate one colour.

Hence the importance of colour relationships. Ideally, before using channel mixing or other digital tools to manipulate the tonal relationships in converting an image to greyscale, you should first evaluate the relative importance of each colour. And the relationships between colours change from image to image, which makes it impossible to apply a single standard. There is, instead, a set of influences: brightness, perceptual intensity, the extent to which a hue advances or recedes, psychological associations, and the level of interest of the subject. These combine to give a perceptual weight for each colour, and one of the purposes of altering the tonal relationships in greyscale is to try and match this.

▲ **Default**
With all channels equal (as in Desaturate), the black-and-white conversion is quite disappointing. The reason, of course, is that the reds, though rich, are also dark.

▽ **Favouring red**
This red-favoured channel mix restores the masses of red rock to their expected prominence, lightening them greatly.

Environmental reflections

Often overlooked, but of real importance in outdoor photography in sunlight, and especially with landscapes, are the tonal effects of reflected colours in shadows.

Environmental reflections, from vegetation, walls, rock faces, water, and sky, play an important role in the shadow areas of landscape and other outdoor photography, even though they are not usually obvious to the eye. The colour of such reflections can occasionally be very striking when seen in colour, and it's an easy but wrong assumption to think that the effect does not really apply to black-and-white photography. In fact, using channel controls to adjust the spectral response can have a powerful effect on shadows.

There is a very real difference between the way surfaces reflect direct sunlight and the way they reflect light in shadow, but because our eyes adapt easily and quickly from one level of brightness to another and from one colour cast to another, we don't normally appreciate this. As we already saw, the typical range of brightness for an averagely bright object (a grey card, in

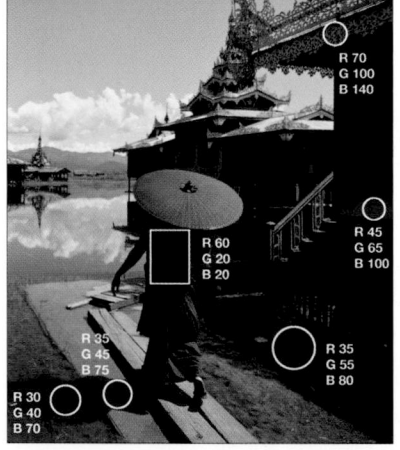

A lake in Burma
Bright sun, blue sky, and still water make for a huge amount of blue in reflections and shadows. In addition, however, there is the red of the monk's robe and its shadows. Averaged samples (see pages 34–35) show the measured values. In the monochrome version we'll aim to make an exaggerated comparison between blue and red channels.

Lightening reds
Using just the red channel, the appearance of the monk is much improved, but at the expense of the other shadows. Neither version is perfect, and this is a case for considering selective retouching.

other words) between normally bright sunlight and shadow is about 8:1, a difference of 3 ƒ-stops, but this range increases dramatically when different surfaces are taken into account. A scene that contains bright Caucasian skin in sunlight and deep shadow in woodland can be as high as 2,000:1, or 11 ƒ-stops, which is considerably beyond the capabilities of a normal digital camera sensor. The strength of sunlight, therefore, is such that its colour temperature overwhelms any environmental reflections.

In shade, it's a different matter, and the more intense the sunlight and the clearer the air (as in mountains, for example), the greater the contrast between sunlit and shadow areas, and so the greater the effect of reflections into the shadows. A bright green hedgerow will have virtually no colour effect on something close by in sunlight, but it will add a green cast into neighbouring shadows. And of all the environmental reflections, none has a more striking role than the sky. A completely clear sky creates overall blue shadows, while a bright cumulus cloud drifting overhead can rapidly dilute this colour with its white reflection. This has important implications in black-and-white photography when you use channel mixing or filtration, because not only does it give you control over how much shadow detail is revealed in the image, it also allows you to choose the overall contrast of a landscape scene.

Basically, adjusting the blue response will usually brighten or darken shadows independently of the rest of the scene. And the reason for this is that most landscapes, and cityscapes for that matter, actually contain very little intrinsic blue. Apart from the sky, blue is not a common colour in nature. Adjusting it, therefore, usually means affecting sky reflections, on water, highly reflective surfaces, and in shadow.

◀ Lightening reflections

An exaggerated comparison between blue and red channels. In this version, using just the blue channel opens up the shadows very well, although the clouds are washed out. But note that the red shadows under the parasol have turned inky black.

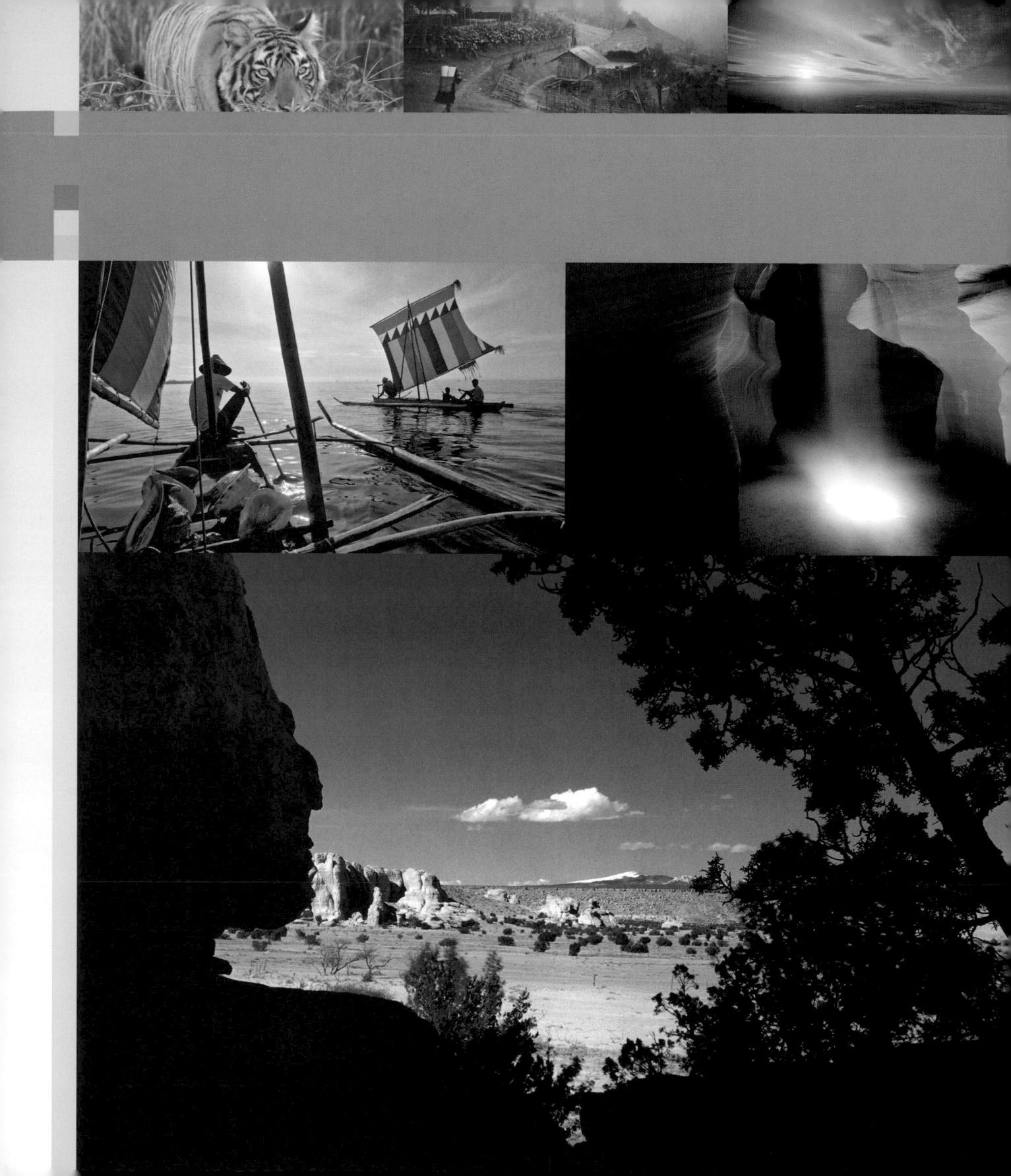

Digital **Black** and **White**

Having established the relative tonal values between the colours in the original scene, the major editing stage is to optimize the black-and-white photograph. This is the basic and essential sequence of the image workflow, and while it is clearly a part of post-production, taking place on the computer rather than in the camera, it is more akin to processing. Depending on how you choose to shoot – JPEG, TIFF or Raw – the actual sequence and the amount of work involved will vary, but essentially, the aim of all of this is to make the best of the image as shot. This is where digital photography has created a new way of thinking about image quality. There is now a range of well-established software techniques to deal with every aspect of this, from setting the limits of the tonal range to precise enlargement that intelligently manages artificial detail. Most of these can be worked from within any good image-editing application, of which the most widely used remains Adobe Photoshop, but there are also specialized programs dedicated to particular issues, such as combining the information from different exposures into a single tonal range. So, for some photographers, the optimizing workflow consists of two or three steps in one application, while for others, it involves moving from one application to another and can involve several stages.

Beyond optimizing, there is also the possibility of interpreting the image differently. In silver-halide black-and-white photography, for instance, the negative is capable of being printed in a variety of ways. It holds a number of potential positive images, and an experienced photographer or printer can assess it to appreciate its limits and possibilities. You might want a stark treatment with dense blacks, or perhaps a fully-toned image that lacks punch but reveals all, from shadows to highlights. These are subjective judgments that call on technical expertise in printing. Predictive skill is needed, because the accuracy of the printing plan is proved only by examining the dried silver print.

Digital black and white makes much more of this idea of the potential image, in three areas. The first is that there is usually more information available, particularly if you shoot in Raw format. When some photographers talk of a 'digital negative', this is what they are referring to, a computer file format that stores the image captured by the camera's sensor as closely as possible – a bank of data that can be processed in many different ways. Importantly, as digital rather than analogue, this data is separated – for example, the colour is stored in three channels that allow, as we saw in the last chapter, infinite tonal interpretation. Second, the processing tools are increasingly powerful, using ever more sophisticated algorithms to distribute the tones, from black to white, across the image. Third, all of the procedures between shooting and the finished print are handled as a single suite on the computer, and with the three key machines linked – camera (directly or via the memory card), computer, printer – the image workflow is straightforward and efficient.

Maximizing the range

Step one for most images is to set the tonal range so that the darkest details are almost black and the brightest almost white.

Most photographs tend to look their best when the very darkest tones are black and the absolute brightest are pure white. There is an aesthetic judgment here, and it would be foolish to say that this is any kind of rule. It's easy to think of types of image that work without these extremes, and one example is a misty landscape. Pale, soft, pastel, inky, obscure – these are all possible styles of imaging, and they do not cover the full range. Nevertheless, for reasons that are a mixture of technical and psychological, photographs that are normally conceived are better received when they have been expanded or contracted to fit the scale from black to white. You could argue that the lack of colour in a black-and-white image puts more pressure on getting the tonality right.

There are two stages to this. The first is to fit the tonal scale of the image appropriately to the full black-to-white scale. The second is to adjust the middle of the range, which is where, logically enough, most of the subject matter of most photographs lies. It's important to do them in this order, first setting the range, then manipulating the proportions in the middle. Here, let's

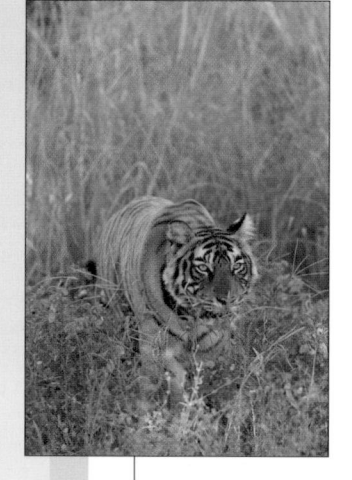

Tiger
The original in colour clearly lacks contrast, but this is an advantage in that it gives plenty of room for adjustment.

Mix
This channel mix aims for lightened brown stripes against a darker background, hence high red and low green channels.

Maximized contrast
The black and white point sliders are set to these points, with this improved result.

look at establishing the limits of black at one end and white at the other. The digital tool for viewing this is the histogram, available on the camera's LCD display and in Photoshop, and the tool for adjusting it is Levels (which is essentially a histogram that you can manipulate).

Looking at the examples here of an image as originally shot (then converted to greyscale) and as optimized to fit the full tonal range possible, it is easy to appreciate the improvement. However, viewing the first image alone, you might accept it as perfect, because our eyes accommodate easily to qualities such as contrast. There is no 'correctness' in this, but it does just tend to look better. The three methods for expanding the range are: first, dragging the black-point Input slider in toward the first group of pixels in the histogram, then doing the same with the white-point slider; second, clicking the black-point dropper and then clicking on the darkest shadow, followed by clicking the white-point dropper then the brightest highlight; third, clicking Auto in the Levels dialog, or else *Image > Adjustments > Auto Levels*.

Clipping check

To see whether, in adjusting Levels, you are in danger of going too far with either highlights or shadows, hold down the Alt key as you drag each slider. With the black-point slider the image will be pure white until you begin to clip the shadows, at which point you will see the lost pixels on the screen. With the white-point slider the effect is similar except that the clipped areas appear bright out of black.

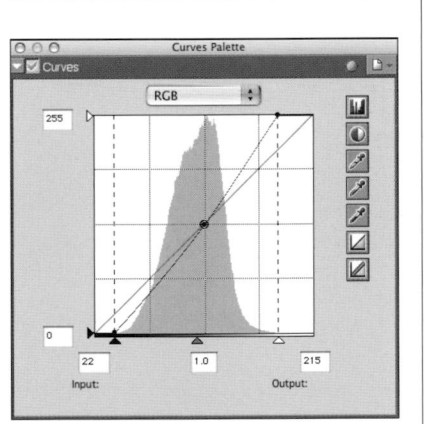

▲ Raw histogram progress
The gaps left and right show plenty of room for improvement (top). Then the black and white point sliders are moved in, but not completely (to allow for later fine-tuning). Finally the Mid-point slider is moved left to middle of range, to darken slightly (bottom).

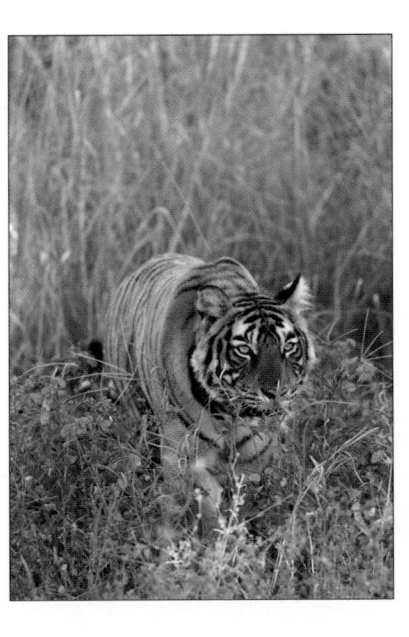

▲ Raw procedure
If shooting in Raw format, consider performing the basic levels adjustment in the Raw converter, which means in colour of course. However, rather than attempt to make an exact adjustment, leave some room on either side of the range and fine-tune it later, after converting to black and white. This is the adjusted image as it appears in Photoshop Levels.

Shadow detail

Technical excellence in a finished black-and-white image is often judged by the fine control of the very darkest tones, which should retain a good degree of separation.

Possibly more than in colour photography, details in the shadows are of critical importance in much black and white shooting. In a colour image, the prominent hues by definition occupy the mid-tones, and so even if super-saturated colours are not central to the picture, most attention tends to be focused on this central part of the tonal range. Black-and-white imagery depends more on separation of tone, and while the total tonal range, as we've just seen, is the first consideration when we optimize a digital image, the local ranges within the shadow, mid-tone, and highlight ranges also contribute to its success.

By tradition, whenever there are substantial areas in shadow, the separation of just-visible detail is regarded as an indicator of technical print excellence. This needs careful judgment, because too much shadow detail from enthusiastically opening up the darker areas creates an unrealistic, pale effect (something that is all too easy using the Photoshop Shadow/Highlight

Doing without the clues from colour

While we rarely think about it, visual recognition is greatly helped by colour. The test is when the differences between areas of pixels are very slight, as so often happens in deep shadows. Here, at left, recognition of shadow detail depends partly on the small, yet visible, differences in colour. Converted into monochrome, the image becomes more difficult to read, and requires tonal adjustment to restore clarity (this can be achieved using Photoshop's Shadow/Highlight adjustment, see right).

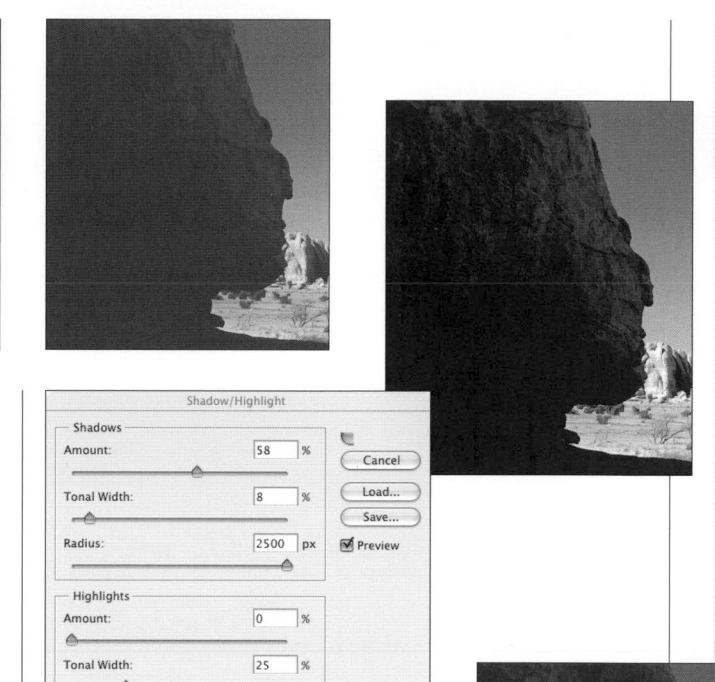

command, as explained on page 92). In a normal black-and-white image, there should be a touch of pure black somewhere, but not occupying a significant area. The tonal extent of the shadow areas varies according to judgment – there is no fixed number – but is often in the region of 15% to 20%. This translates in an 8-bit image to the bottom 40 or 50 levels of the 255 total.

Because digital sensors are linear, the 256 levels in an 8-bit image are not equally distributed across the tones recorded by the camera. It is doubly important to capture the maximum highlights (as we just saw on the previous pages) without clipping. It also reinforces the need to shoot at as high a bit depth as possible. Most cameras (typically SLRs) that have a Raw mode record 12 bits per channel in Raw rather than 8 bits (though the file will be treated as a 16-bit image in Photoshop). This has a major effect on the amount of information captured: 8 bits per channel (24 bits in total) results in 256 discrete tonal levels (28), but 12 bits (36 in total) produces 4096 (212). If we assume that an image has a shadow area taking up 20% of the total range, it might have as few as 20 levels devoted to these shadows in 8-bit, but 320 in 12-bit. There is clearly a huge quality advantage in shooting Raw if your camera has that capability, even if it does slow down post-production. And because black-and-white photographs stand to gain more from better discrimination in shadow detail, they have more of a need for Raw.

Retaining a hint of detail

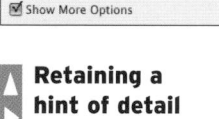

In this typically high-contrast daylight scene from New Mexico, it makes a critical difference to have a sense of volume and substance from the deeply shadowed foreground rock. With the tree, it provides a frame for the view beyond, but they shouldn't appear as a two-dimensional cut-out. The original (top) shows some detail, but lacks a well-defined black or white point. These have been created in Levels (bottom), but at the cost of losing shadow detail. The Highlight/Shadow command is ideal for adjusting this. In a first attempt (above), limiting the range and raising the amount brings out the detail well, but the final version (top right) is less extreme – success depends on giving just a hint of shadow detail. The high radius avoids haloing between sky and rock.

Preserving highlights

The converse of detail in the deep shadows is the degree of nuance that can be held in the lightest tones, approaching, though never quite reaching, pure white.

In the same way that preserving the subtle distinction between dark tones in the shadows is an indication of a rich and well-controlled image, holding the brightest tones is essential for high image quality. It is, however, rather more difficult, for both technical and perceptual reasons. Digitally, the chief technical problem is that a sensor responds to light in a linear fashion, without the trailing off of response that happens with film. The result is that it is all too easy to lose all detail from the highlights. This is important and bears some explaining (see below).

The way in which film responds to both excessive and insufficient exposure is actually a special case, and its lessening sensitivity is a benefit that generations of photographers have come to take for granted. Digital exposure needs more care, in particular to avoid blowing out the highlights. The camera's LCD display has two useful ways of showing this. One is in the histogram (if the values are squashed up against the right-hand edge, highlights are clipped); the other is flashing areas on the image that warn of over-exposure. The ironclad solution to preserving highlights is to expose to

Sensor developments

Manufacturers are constantly making in-camera improvements. One method, pioneered by Fujifilm, is to use two diodes in the photosite, a large one for basic sensing, and a small one that kicks in only when light levels are high. The results are combined. Another method, used by Nikon, is to build in preconditioning algorithms before the ADC (Analog-to-Digital Converter).

How highlights get clipped

Film and sensors behave differently in an important respect. Exposed to increasing amounts of light, film's response gradually slows. At the highlight end of the scale, twice as much light does not produce twice as bright a tone. This means that in the brightest areas, film usually still manages to record some slight differences in detail. A similar effect happens at the opposite (shadow) end of the scale, and the standard way of representing this effect is as a characteristic curve. The tailing off in the shadows is known as the toe and in the highlights as the shoulder. Practically, film has an exposure latitude because of this. The photosites in a sensor, however, behave in a less complicated, linear fashion. As more light falls on the photosite, the charge steadily increases, and when it reaches maximum, all detail is lost. A common analogy is a well filling up with water. On the 256-step digital scale of values, 255 is pure, useless white. When reached, the highlights have been 'clipped' and no detail can ever be recovered in post-production.

the level just below this warning, and, if at all possible, to shoot in Raw format. The extra bit-depth of Raw makes it easier to pull plenty of information out of the shadows. With a high-contrast scene, exposing to preserve the highlights will typically render the rest of the image darker on first appearance than you would like, but if you treat it as a 'raw' image for later adjustment – as a kind of digital negative – the finished result should be fine.

Average exposure

At first glance, the histogram for this shot of an ostrich taken with the average TTL meter setting looks good, but on closer examination, the white feathers below the neck have been clipped.

Under-exposed

Fortunately, the highlight warning was noticed for the first shot, and the exposure adjusted downwards for the rest. The histogram looks too dark at first glance, but in fact all the tones have been preserved.

Levels

In Photoshop, the histogram seems to have a lot of room for closure at right, but the thin line of the highlights goes all the way to 237. This is the best optimization.

Curves

Finally, a higher-contrast curve is applied for mid-tone contrast.

Targets for calibration

Just as colour targets act as an objective measure in digital colour photography, so a precise scale from black to white can help to calibrate a black-and-white image.

Although arguably less critical for black-and-white photography than for colour, for accuracy and consistency it helps to have some form of calibration for the camera. Digital black-and-white photography is, as we have seen, almost always captured in colour, and calibration makes for predictability when converting colours into greyscale tones. The basis of this is a known target, which is captured under even lighting, then processed with software that creates an ICC (International Color Consortium) profile. The software essentially reads the image of the target as captured, compares it to the known values, and produces a file that shifts the colour values to what they ought to be. Digital SLRs normally have default ('canned') profiles, already built in, which are automatically attached to their image files as they're made. Photoshop reads these profiles – again automatically – and for average shooting conditions is satisfactory. However,

Step One: photographing the target

1. Place the target so that it is evenly lit, and angled to avoid reflections.
2. All the camera settings should be at average or neutral. Select the appropriate white balance or create a preset white balance with a reference white or grey card.
3. Adjust the exposure so that the grayscale range is full but not total – as close as possible to the recommended values shown here.

| 243 | 207 | 169 | 131 | 98 | 52 |

GretagMacbeth ColorChecker Color Rendition Chart

Step Two: creating the profile

There is a choice of calibration software, and the one shown here as an example is inCamera, a Photoshop plug-in from PictoColor.

1. Use the following Color Settings so that no profiles are attached to the image:
2. Open the image and do not colour manage. That is, with an 'Embedded Profile Mismatch' warning, choose 'Discard the embedded profile (don't color manage)' and with a 'Missing Profile' warning, choose 'Leave as is (don't color manage)'.
3. Check that the greyscale values are as recommended. Adjust Levels and/or curves to bring them into line. If there is a strong colour bias, aim for the average of the three RGB values.
4. In the profile building software select the ColorChecker target and its reference file.
5. Align the grid by dragging the corners.
6. Save the profile in the appropriate folder as suggested by the software. This varies according to platform (Windows or Mac), operating system and Photoshop version.

for complete accuracy, particularly under specific lighting conditions, such as those in a studio, a profile calculated for your particular camera under these precise conditions is better.

The standard target for camera calibration is the GretagMacbeth ColorChecker, as shown here. This is a specially printed card containing 24 color patches that include neutrals, as well as primary and secondary hues, and 'memory' colours of the kind that occur most frequently in shooting situations, such as flesh tones, sky, and vegetation. For photographs that will ultimately be converted into black and white, the bottom scale on the ColorChecker is the most important, from 'white' to 'black'. The recommended average RGB values are shown here, on the 0-255 scale, and it's important to note that neither end of this greyscale is pure. By using the ColorChecker and a calibration program, you can ensure that the progression of tonal values from dark to light is properly balanced. The other useful accessory for balancing tones is a standard Gray Card. This is a card with a reflectance of 18%–a standard mid-tone (18% to match the non-linear response of the human eye to brightness). You can use it to establish mid-grey in any image.

Macbeth™ ColorChecker Color Rendition Chart

Step Three: applying the profile

With the ICC profile stored for the particular combination of camera and lighting conditions, you can then apply it to any of the images shot during this session (do not expect the profile to work in different, generic, situations). As a matter of colour management policy, you should already have Photoshop's Color Settings such that Adobe RGB (1988) is the working colour space in which images are normally opened.
1. Go to *Edit > Assign Profile…* and choose the one you just created from the list. (In some versions of Photoshop, the option may be under the *Image > Mode* menu.)
2. Following this, go to *Edit > Convert to Profile…* and choose the same profile. This is an important step, and one that's easily missed.

The zone system

This classic method of assigning tonal values ensures that the final print captures the essential details.

The Zone System was invented by Ansel Adams and Fred Archer in the late 1930s, and its aim was to be a commonsense application of sensitometry – a straightforward way of translating the range of brightness in a scene to the tonal range of a print, via the camera. Although developed for black-and-white film, it has a new lease of life with digital photography, precisely because you now have the best means of all to adjust tones. At the heart of the Zone System is the idea of dividing the greyscale of brightness, from darkest shadows to brightest highlights, into a set of zones. In the original, shown here, there are ten, identified by Roman numerals. 0 is solid black, IX is pure white, and V is mid-grey. Adams and Archer intended it to be a tool to 'liberate' photographers from technique and allow 'the realization of personal creative statements', and for anyone committed to the craft of photography and who enjoys a slow picture-taking process, this is still the best way to use it.

The idea is to first identify in the scene the important tones – important for you, that is. As it turns out, the three key zones are V, which is mid-grey, the same as a standard Gray Card, III, which is dark but significant shadow texture, and VII, which is significant highlight texture. The tonal values in a scene are assigned to this simple scale of ten, each one ƒ-stop apart. You first place the key tone in the Zone you want, such as a textured shadow in Zone III. As the Zones are one ƒ-stop apart, the other tones will naturally fall into their appropriate Zones. Zone V is the one constant – it is always mid-grey. Essentially, the Zone System is a way of assigning priorities to different parts of an image.

Different photographers have different ideas about how an image should look tonally, and the Zone System allows for this individuality. Used successfully, it will ensure that the print matches the way you see the scene, which may well be different from the way someone else would want it to appear. Another benefit of the Zone System is that it allows for the fact that the paper on which you print has a narrower range than the camera's dynamic range (and this in turn cannot capture the full range of brightness in a contrasty real-life scene).

▶ **Relating zones to print values**
Moving a scale around a print shows immediately which tones in the image match particular zones. In a medium-contrast scene like this, all the Zones are included. Mentally doing this helps to visualize the final print, which could in this case legitimately vary by at least one Zone – that is, one ƒ-stop.

Case study: **placing a tone**

The Zone System works best when you have the time to consider and measure the light values in different parts of the scene. From the outset this image of a Shaker village in New England, looking out over a rocking chair, was bound to present contrast issues. Without considering later adjustment, here were two possible interpretations. In the lighter version, the just-visible shadow area between the window and the door was placed in Zone II so that some detail would register. This, however, would have to be at the expense of losing highlight detail in the white picket fence outside, which would fall into Zone VIII. If, on the other hand, this fence detail were considered important, and so placed in Zone VII, the shadow detail left of the door would have to be sacrificed – or rather, dealt with later in image editing. In the event, this darker exposure was chosen in order to avoid the clipped highlights.

The zones

Zone 0
Solid, maximum black. 0,0,0 in RGB. No detail.

Zone I
Almost black, as in deep shadows. No discernible texture.

Zone II
First hint of texture in a shadow. Mysterious, only just visible.

Zone III
TEXTURED SHADOW. A key zone in many scenes and images. Texture and detail are clearly seen, such as the folds and weave of a dark fabric.

Zone IV
Typical shadow value, as in dark foliage, buildings, landscapes, faces.

Zone V
MID-TONE. The pivotal value. Average, mid-grey, an 18% grey card. Dark skin, light foliage.

Zone VI
Average Caucasian skin, concrete in overcast light.

Zone VII
TEXTURED BRIGHTS. Pale skin, light-toned and brightly lit concrete. Yellows, pinks and other obviously light colours.

Zone VIII
The last hint of texture, bright white.

Zone IX
Solid white, 255,255,255 in RGB. Acceptable for specular highlights only.

Adjusting tonal distribution

Step two, after the black points and white points have been set, is to optimize the brightness of the mid-tones.

Once the end-points of the tonal range have been set, you are free to experiment with the tonal distribution. It's important to remember the distinction between an overall lightening or darkening of the image and the altering of tones within a set range (see box). The only sensible procedure is to set the black and white points first, then adjust the tonal distribution.

The standard method is with the tone curve, using the Curves dialog. In other words, first Levels, then Curves. The RGB tone curve begins as a straight diagonal from black (0) at lower left to white (255) at upper right. The horizontal axis represents the starting, or Input, values, and the vertical axis the new, Output, values as you adjust the curve.

As long as you leave the end-points of the curve where they are, in the corners, the limits of the tonal range of the image will remain as you set them in Levels. They can be dragged away from the corners – the equivalent

▲ **Village in mist**
Levelled, and awaiting mid-tones adjustment.

▲ **Mid-point darkening**
Highlight advantage, but losses in the shadows.

▲ **Mid-point lighting**
Better shadows, but the centre sky washes out.

▲ **Lighten shadows**
The best so far, but no improvement on the original.

of altering the black and white points in Levels – but this tends to give extreme results. The grid, divided into four horizontally and vertically, is a useful guide. It makes three intersections along the curve: mid-point, mid-shadows and mid-highlights. The basic method of lightening or darkening the image without altering the black and white limits is to drag the mid-point right or left. This is the same as dragging the middle Input slider in Levels. The effect is to redistribute the middle tones of the image toward brighter or darker while pulling the other tones with them, to a greater or lesser degree in proportion to how close they are to mid-grey (or the point moved).

However, the tonal distribution can be altered in many more interesting ways. If you first click on the mid-highlights (the upper right intersection on the grid) instead of the mid-point, dragging will have a greater effect on the lighter tones than the darker. To take it to the next level, click on two points on the curve and move each independently. Dragging the mid-highlights left and the mid-shadows right gives an S-curve, increasing contrast. These two points dragged in the opposite directions results in a reversed S, and so lower contrast. More refinement is possible, and the permutations are endless, making Curves a powerful tool for adjusting tonal relationships.

Brightness v. Curves

There are three systems of changing the apparent brightness of an image. The Brightness slider under *Image > Adjustments > Brightness/Contrast* shifts the entire tonal range, with its end-points, with inevitable clipping of highlights or shadows. The Lightness slider under *Image > Adjustments > Hue/Saturation* squashes the range from either the shadow end or the highlight end, with a reduction in contrast and no clipping. Moving the middle parts of the tone curve shifts only the central body of the tonal range, with no clipping.

▼ Final curve
From the previous tests, it was decided that the key improvement would be an increase in contrast limited to the mid-tones that make up the central part of the frame. The curve reflects this, by keying the mid-shadows and mid-highlights to hold the upper and lower parts of the range in place, and then subtly applying an S-shape to the middle.

▲ Increase contrast
The huts look better, but too much lost at both ends.

▲ Decrease contrast
Smoother tonal distribution, but the central area flat.

A different approach to tones

Photoshop's Shadow/Highlight command redistributes tones in a pragmatic way designed to deal with purely photographic issues of backlighting and contrast.

A relatively new and distinct procedure that is photographically oriented separates the range of an image into three zones, and for each one allows a sophisticated lightening, darkening, and change of contrast. Rather than operating on the principle of tonal curves, it uses procedures more akin to sharpening and other filters, by searching for neighbouring pixels across a radius that you can choose. Essentially, it was designed to deal with blocked shadow areas and washed-out highlights, as commonly happens with backlit subjects taken against bright backgrounds (in the former case) and subjects too close to the on-camera flash (in the latter).

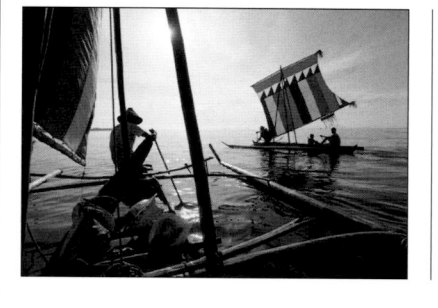

Original
Scanned from a colour transparency, this shot of shell fishermen in the Philippines is high in contrast and atmosphere, but shadow detail has been sacrificed in the exposure in order to hold the highlights.

Adjusted shadows
Since the digital original was made with a drum scanner, there is good detail to work with. With these settings, the shadows open up beautifully.

These are common problems for amateurs, but even so, the advanced algorithms used in this procedure make it useful for more delicate adjustments on a wide range of images.

Because of the corrections for which it was designed, the Shadow/Highlight command assumes more-or-less normal exposure in the mid-tones, and there are three sets of sliders, for the shadows, the highlights, and 'adjustments'. For both the shadows and highlights, you can select the range covered, extending from either end toward the mid-tones (Tonal Width), and this limits the alterations. The Amount specifies the strength of the lightening (in the case of the shadows) or darkening (in the case of the highlights). Finally, and least intuitively, you can set the Radius, which determines how far is searched around each pixel to decide whether it falls into the shadow zone or highlight zone. As this is measured in pixels, it

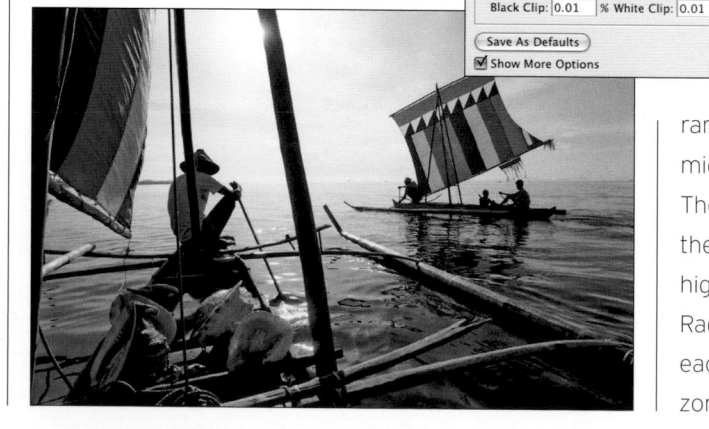

depends on the size of the image and the size of the subject within it that you are trying to adjust. The remaining set of two sliders, under Adjustments, allows you to control the contrast over the mid-tones (the gap left between the shadow and highlight areas that you defined) and raise or lower the brightness in the shadows and highlights.

No clipping is involved, as the black and white points are left unaltered, but like any adjustment, using it to extremes can have odd results. As it tends to be used most for opening up shadow areas, a typical effect is an unrealistic lightness and lack of contrast confined to the shadows. There is often a strong temptation to reveal hidden details, but it needs to be tempered with realism.

▽ Adjusted highlights
A surprising amount of bright sky becomes visible when the highlight settings are adjusted.

Adjusting too far

The unique procedures used in this command can create effects that are strange but difficult to define. The usual adjustments of Levels and Curves are so familiar to everyone that the limits of acceptability are generally agreed. This command, however, is more open to interpretation. Extreme Radius settings, however, can produce halo-like effects.

Radius 10 Radius 50 Radius 100

▷ Mid-tones
Finally, the mid-tones are lowered in contrast very slightly to give a more even distribution to the water.

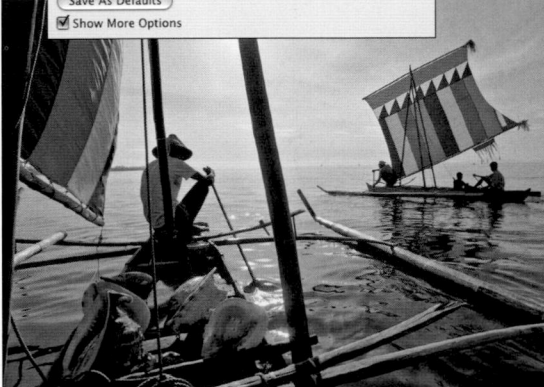

Gradient mapping

An alternative technique for setting both the tonal range and its distribution is to map the image to a preset gradient.

Mapping is a digital imaging technique in which all the pixel values in an image are plotted according to a specific intent. The procedure looks at every pixel and says, in effect, 'If this pixel is such-and-such, we will change it to this new value by referring to this particular map'. This is simpler and more relevant for a black-and-white image than for colour because there is only a single channel – mapping a monochrome image is essentially tone mapping, and it can be a useful way of setting black points, white points, and the way in which the greys in between are adjusted. This is very much a procedural adjustment that works by calculation rather than on-screen interaction. It is precise, measurable, and repeatable, but not intuitive, since it's harder to experiment with.

Photoshop conveniently offers this global tonal control under *Image* > *Adjustments* > *Gradient Map...* using the Gradient Tool as the reference. Simple in theory, but to make finely controlled adjustments you'll need to familiarize yourself with the effects of different gradients. The

Slot canyon
A wide range of tones is contained within this shot of a shaft of sunlight illuminating a narrow canyon, but the exercise will be in how the tones are distributed.

A basic gradient
Open the Gradient Editor and choose the first, basic gradient, a smooth transition from black to white. This performs an automatic monochrome conversion.

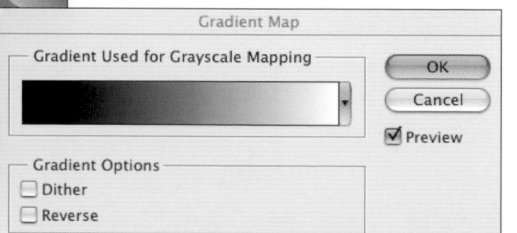

Drag left
Dragging the mid-point slider left shifts the bulk of tones toward white, as shown by the histogram.

◢ Drag right
Dragging the mid-point slider right shifts the bulk of tones toward black.

▷ Adding a tone
Clicking below the bar adds a new stop, and this can be assigned a colour, here a mid-grey. This inserts a grey band into the gradient, with an effect similar to a soft posterization.

◢ Metallic gradient
Loading a preset from the library, in this case a metallic gradient. The cycles of black to white create an effect similar to solarization.

simplest gradient of all is a linear one from black (0) to white (255). By default, this is the gradient you will be offered when you go to *Image > Adjustments > Gradient Map*. Keep the Histogram palette open to watch your changes, and aim to fit the ends of the tonal range neatly into its box.

Any other gradient can be applied, although to be useful in black and white you will need to create it first. The place to do this is the Gradient Editor, accessed by clicking once on the gradient sample in the Gradient tool's options bar. In most cases, you will want one that begins with black and ends with white, but there are infinite adjustments that you can make to the gradient in between. With the standard black-to-white linear gradient as a starting point, in the Gradient Editor click once on either of the colour stops at the ends of the bar to create a diamond-shaped mid-point slider in the middle. Take this diamond and drag it to the left or right. This will display a new gradient skewed towards the highlights (if you drag left), or towards the shadows (if you drag right). The disadvantage of the Gradient Editor is that you can only guess what the effect will be, but in principle, applying a gradient which has its mid-point dragged toward the shadows will shift the mid-tones lighter, and vice versa. Things become interesting, however, if you add another 'colour' to the gradient – for a black-and-white image another tone. Click anywhere below the gradient bar in the Editor and a new stop is created; by this means it is possible to produce some very intricate gradients.

Dodging and burning

Digital tools can mimic the traditional darkroom techniques of increasing and holding back exposure from local areas of a print.

Emulating photographic techniques is one of the ways in which software developers try to improve their products. The aim is to make photographers feel at ease by offering things that they are familiar with from the days of film. Digital dodging and burning falls into this category—comfortable for those nostalgic for the darkroom. Of course it will never replicate traditional techniques entirely, but the principle of adjusting the brightness of local detail is sound, and there are several ways to achieve it within Photoshop.

First, the Dodge and Burn tools in the Toolbox. Traditionally, dodging was performed in a wet darkroom by holding back the exposure from the enlarger lamp, normally using a small, shaped piece of black card or metal. This was at the end of a thin rod, and by moving it constantly during the exposure, the edges of the area being held back were softened and the shadow of the rod was unnoticeable. Dodging larger areas at the edges of the frame could be done by shaping the hands and moving them. Burning was the opposite—adding extra time to selected areas after the initial overall exposure. This usually needed a shaped hole, either cut into a large piece of black card or by cupping the hands.

Digital dodging and burning tools are only partly similar, as they alter the brightness of an existing image rather than alter the exposure, but they do have an added advantage, not possible traditionally, of being restricted to a tonal range: shadow areas, mid-tones or highlights. This gives some control

The plan
Shown here in diagrammatic form, the plan for selectively lightening and darkening involves three areas – darker areas of trees and fields left and right, and the immediate vicinity of the sun.

Burn then dodge
The tool is set soft and large, over 600 pixels, and with a very low Exposure (strength) setting of 6% so that several strokes can be applied. The range is then set to Midtones for a realistic effect, a slightly smaller brush size to suit the shape of the areas, and a Exposure setting of 10%.

Painting a selection
A different approach to the adjustment is to paint a selection in Quick Mask mode, first for the darker areas.

over local contrast, as the examples here show. And of course, you can take as much time as you want, and go back over any excesses.

Given all the other methods of controlling the tonal range in a black-and-white image, dodging and burning is best as a final touch-up technique on small areas (larger areas are more conveniently dealt with by the Shadow/Highlight command). The danger, exactly as with the traditional technique on a silver print, is a falseness through being overused, so that the patch that has been treated stands out against the surrounding tonal range. All too typically, the darkest tones in a dodge appear weak and the lightest in a burn acquire a veil of light grey.

As digital dodging and burning has more to do with result than procedure, there are alternatives. One, is simply to make a selection by brushing over the area in Quick Mask Mode, allowing you to make the area as soft and shaped as you like, and then use Curves to alter the tones up or down. Thinking this through further, as dodging and burning is supposed to alter the exposure, a truer alternative if you shot the image in Raw format would be as follows: prepare two files from the original RAW at different exposures, and place them on top of each other as layers in Photoshop. Gently erase areas of the higher layer for the other to show through (place the lighter one on top if burning is required, or the darker on top to dodge).

Curves
Use Curves to lighten the areas, with a point that makes this biased towards the shadows.

Result
Compare the result with the original. Burning is slightly more successful than the dodging, which lacks contrast.

Selective composite
Another approach is to stack a copy of the image over a version that's been subject to overall lightening, then erase parts of the top layer.

Multi-exposure composites

The ultimate answer to recording a wide range of brightness is to make more than one exposure, from less to more, and then combine them.

Combining images that are in alignment is one of digital photography's most powerful and effective post-production techniques. It works for all kinds of purposes, and one of the most useful is to cover a range of brightness that would normally be too great for a single digital capture. The principle is straightforward – capture different tonal ranges of an identically framed image, from the highlights down to the shadows – although the procedures for making the composite need care and control for the final result to be realistic. The camera, needless to say, has to be fixed on a tripod throughout shooting, and an extra precaution is to use a cable release.

Much depends on how much the brightness range of the scene compares with the dynamic range of the camera. If it only differs by two or three f-stops, aim for one exposure that captures all highlight detail without any clipping, and one that captures all shadow detail without clipping. With a rather higher brightness range, add a third exposure in between the two that captures the mid-tones optimally. The shooting guides to use for these are as follows. For the highlight exposure, use the clipped highlight warning function in the camera's LCD display, and find the setting at which there is no clipping.

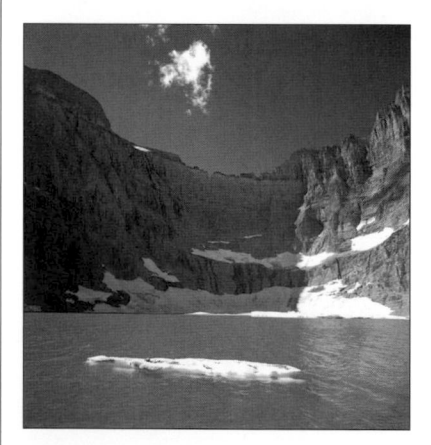

Two exposures
Each of these covers a different, though overlapping, part of the range. The dark version, which holds the highlights in the ice and cloud, is copied and pasted onto the light version, which holds the shadow detail.

Extreme curve
This extreme curve, applied to the darker version, allows only the highlights to show, and these only just.

Result
The technique depends on combining the two layers in Multiply mode, which gives an enhanced type of darkening. The result is a composite that combines both ends of the high range.

For the shadow exposure, use the LCD display's histogram and make sure that its left edge is not squashed up against the left edge of the grid. For the mid-tone exposure, choose the setting at which the main peak of the histogram is centred.

There are different methods of combining these frames, according to taste. For photographers who prefer a less technical, more hands-on approach, paste one version of the image over another, and use an eraser brush over the areas where you want the underlying tones to come through. Thus, if you place the darker, exposed-for-the-highlights image as a layer over the lighter version that contains the better shadow detail, you can erase the too-dark shadows. Varying the size, the hardness, and the percentage of the eraser brush gives a great deal of control.

The better procedural technique, but which needs accuracy to maintain a good transition, is as illustrated here. It uses a strong Curves adjustment and a particular Layer mode to combine just a section of the tonal range. The principle is to use the Curves dialog on the exposed-for-the-highlights version so that only the highlights are displayed, and then to use Multiply as the Layer mode for combining, with this layer on top. On an exposed-for-the-shadows version, the Curves would be adjusted so that only the shadows display, this layer placed beneath, and Screen mode used for the upper one.

▲ **White house**

Another image with a contrast too high for the sensor, photographed with two exposures. Key areas to hold are the darker interior, seen through the window, and the sky and roof reflections.

▼ **Automatic generation**

The Highlight-and-Shadow command in the PhotoMatix plug-in allows the blending to be biased if necessary, here toward the highlights. The composite contains the darker highlights and the lighter shadows.

Blending Point Adjustment

<< darker equi. brighter >>

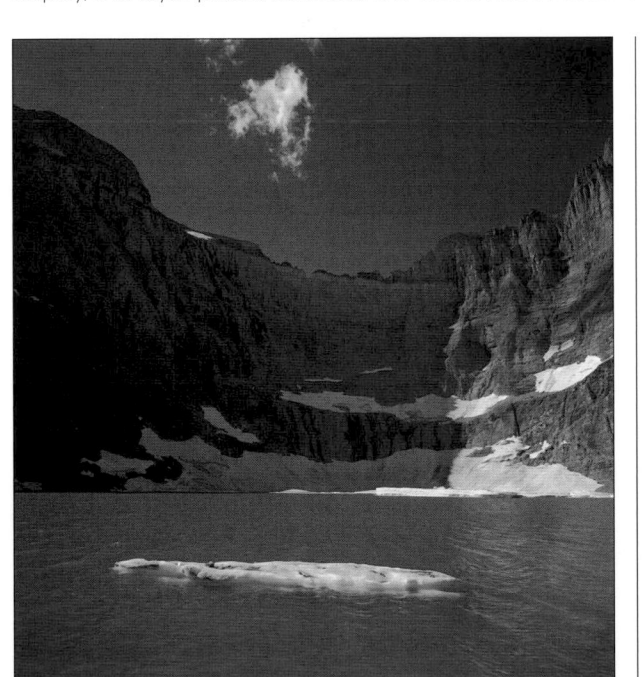

High dynamic range images

A sophisticated technique for covering a wide tonal range is to create an extremely high bit-depth image and map this to the final 8-bit version.

When the range of brightness is extreme - more than 2,000:1 or in excess of 11 f-stops - even the compositing techniques just described hit problems. The real answer is to use a special file format that can cover a high dynamic range, put all the exposures into that, and then use tone mapping to compress the otherwise unviewable result back into a normal format. This is a highly technical and specialized procedure, and the principle is HDRI, or High Dynamic Range Image. The software used here to perform the operation is PhotoMatix, which works in RGB, and so the procedure is conducted before conversion to greyscale, even though the image can be, as here, fully desaturated.

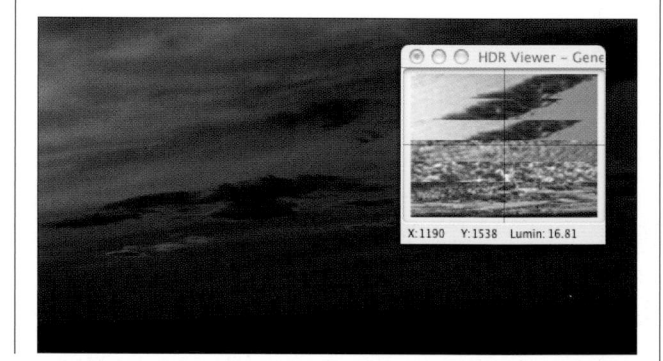

Two versions

Although the dynamic range of this page's paper is too small to convey the effect properly, when viewed on a lightbox, the negative can be seen to contain a wide range of detail. The problem is compressing it so that it can be printed. A dark scan and a light scan now contain all the information that we need.

Generating HDR image

PhotoMatix software allows a choice of response curves when creating the High Dynamic Range image. Here the default is chosen. (There is also a HDR tool in Photoshop under *File > Automate > Merge to HDR*.)

On-screen

The on-screen appearance is very dark and contrasty, but a small window reveals an optimized version of what is under the cursor.

Tone mapping

The next step is to map the full range down to a standard 8 bits or 16 bits per channel.

DIGITAL BLACK AND WHITE

The software is designed to work with digital capture, but it can also, as in this example, handled scanned negatives perfectly well. This was a virtually unprintable medium-format panoramic image that I had shot years ago, in New Mexico. Had I been shooting digitally, the capture would have needed a number of exposures (see box) and the range would have been higher, yet still the HDRI technique would have coped. Nevertheless, the range of the original negative was too high, so even though this was well within the capabilities of the technique, it was still a challenge for the image. The final version has to encompass bright cloud values close to the sun and shadowed foliage on the river banks.

Just two scans were made and used, one for the highlights and one for the shadows. The software first combines these (it can handle more) into a single HRD image, in the Radiance format. The apparent peculiarity of this is that the HDRI contains all that information, but neither the monitor display nor a print can come anywhere close to displaying it. This calls for the next step, which is to map this high range of tones to a normal bit-depth. In other words, compress it and arrange for a pleasant distribution of the intermediate tones.

A multiple exposure sequence

Begin shooting at one end of the range and continue in steps of between one and two *f*-stops. If you start at the shadow end, display the histogram in the camera's LCD and choose the exposure setting that gives just a slight separation between the left edge of the scale and the left (black point) end of the histogram. Vary the shutter speed, not the aperture, to avoid any visible differences in depth of field. Switch the display from histogram to clipped highlight warning, and continue the sequence until there is no clipping at all. You will then have covered the full brightness range of the scene.

▽ **Rio Puerco**
HDRI tone mapping combines a massive range from a difficult shot remarkably well.

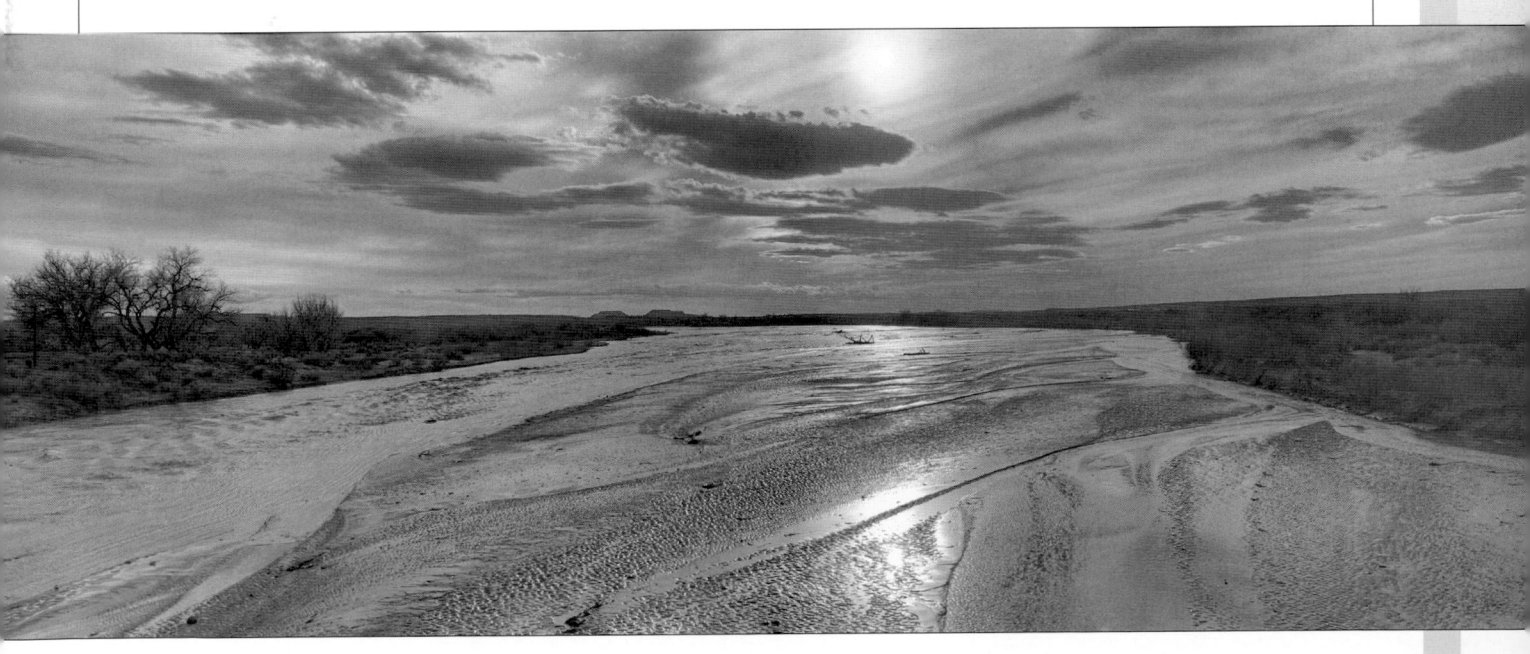

Case study: **refining the tonal range**

In practice, and particularly with images that begin life as unsatisfactory, it may be necessary to try several alternative ways of optimizing the tonal range, and discover by trial and error what works best in each individual case. This example is deliberately chosen as one in which the shooting conditions left much to be desired. The planned subject was an overgrown cross in an old cemetery, shot for a book cover, and the low camera angle was determined not only by needing to have wild vegetation in the foreground, but also by the surroundings, which had to be kept out of view. Clouds were wanted in keeping with the gloomy subject, but an obvious difficulty was going to be rendering them dark while being able to distinguish the vegetation.

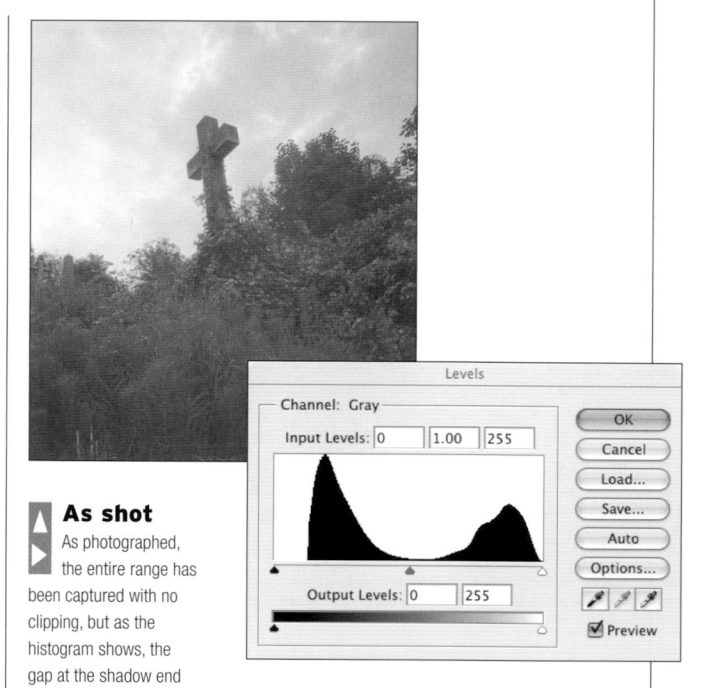

As shot

As photographed, the entire range has been captured with no clipping, but as the histogram shows, the gap at the shadow end is evidence of weak blacks and overall lack of contrast. Fortunately, the image is 12 bits per channel in depth, and so can be edited in 16-bit mode.

Standard black and white points

The normal procedure is to close up the black and white points, which essentially means the shadows, as the highlights are almost perfect. This gives us a satisfactory overall range, but much work remains to be done on the distribution within it.

A controlled curves adjustment

Following the Levels adjustment, we can take the Curves dialog and make a new curve, with two objectives in mind. One is to darken the sky (by dragging the third point to the left); the other is to increase mid-to-dark-tone contrast (creating an S-curve in the upper sector) while holding the dark tones in the upper quarter.

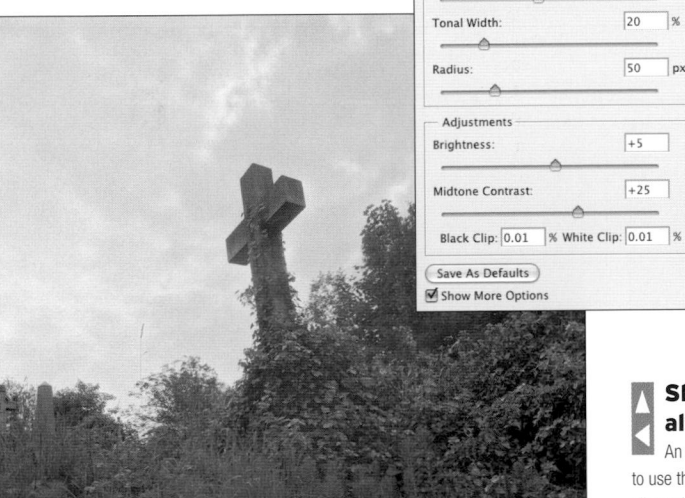

Shadow/highlight command alternative

An alternative approach to the Curves approach is to use the Shadow/Highlight command instead. This allows three zones to be defined – shadows, highlights and mid-tones – and the options chosen are a very slight lightening of the foreground vegetation, a stronger darkening of the sky, and a moderate increase in contrast in the intervening zone. The Radius adjustments are important in order to maintain the contrast detail. The result is fairly satisfactory, but still lacks the punch that was envisaged.

Composited layers

A more complex solution, but which guarantees independent control over foreground and sky, is to adjust each separately and composite them as layers. There are several ways of doing this, and in this case the one chosen is to adjust the blending range of the upper layer. The first step is to make two duplicate layers (the Background layer will eventually be discarded when the process has been satisfactorily completed).

Optimizing the sky alone

On the upper layer, we can now concentrate on adjusting the sky alone, without having to worry about holding shadows in the vegetation. A simple curves adjustment is made, using a highlight point for dragging left.

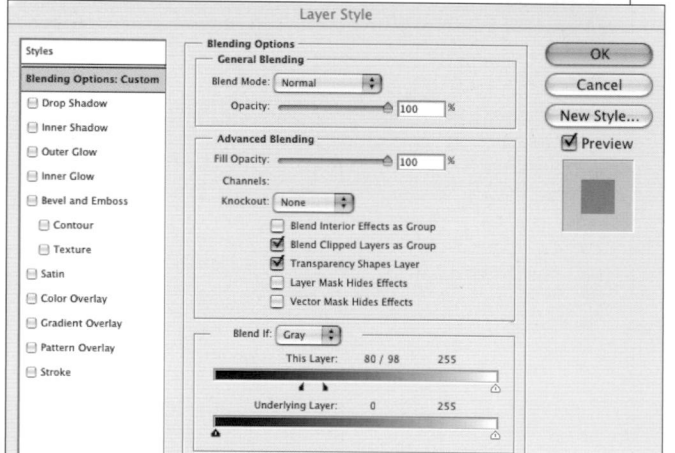

Optimizing foreground alone

For the lower layer, we make a contrast-increasing S-curve that affects the dark-to-mid-tones.

Blending to combine

On the upper, 'sky' layer, we want to remove the too-dark vegetation to allow the lower layer to show through. A quick way of doing this without the need for masking is to drag the black point inward to 'clip' the darker part of the range. Separating the two halves of the slider gives a smoother edge to the blend. The result works except for the fact that some of the vegetation on the skyline has become tonally confused with the sky. This will need some manual retouching.

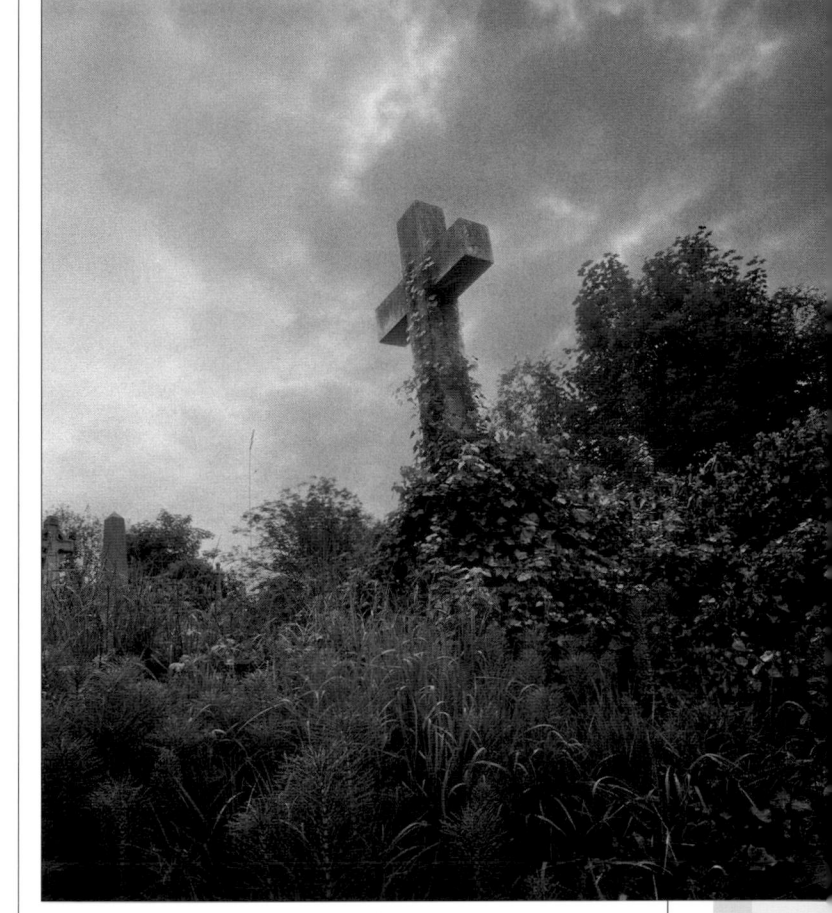

▲▶ Adjusting the skyline

Here we need another layer, a duplicate of the upper 'sky' layer. This is then partly erased to confine the effects to the skyline alone, and then a mild lightening applied through the Curves dialog until it blends in with the rest of the image.

Final

The result of the layer composite was a sombre mood that still retains contrast and detail in both halves. This sky is even more threatening.

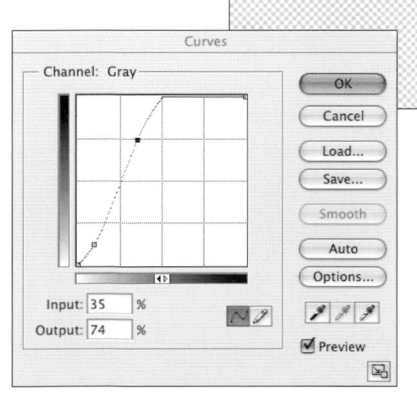

▲◀ Taking the sky to extreme

For the final image, the sky layer is reworked for even greater contrast and darkness in its shadow areas. All the blending procedures are as before.

Noise control

Tackle unwanted noise with a combination of the appropriate camera settings and post-production filters.

Noise is probably the most common artifact in digital capture (artifact being any part of the image that was introduced by the process and not from the original scene). At first glance, (digital) noise looks somewhat similar to film graininess, and indeed it increases with the ISO sensitivity in the same way. Nevertheless, noise has quite different origins, and in close-up can be seen to have a different structure. There are ways of suppressing it during shooting, and of reducing it, later, in post-production. However, because it exists at the finest level of image detail, it is not easy to separate from genuine image detail. If you enlarge a section of noisy image to 100% or 200%, the individual specks are obvious, but so too are the pixels that constitute 'real' detail. In fact, the only distinction between the two is your own knowledge of the scene and judgment. This makes automated noise reduction difficult – it needs to be directed by an experienced eye, otherwise the procedure will remove or soften the detail that you want to keep.

At the stage of shooting, there are ways to avoid excessive noise, which, incidentally, varies between makes of camera according to the design of the sensor and the in-camera processor. The first and most obvious precaution is to use the lowest ISO setting possible. The second is to make use of the

Blind area artifacting

A side-effect of noise reduction is the destruction of apparent detail in busy areas of the image. The filter settings that are appropriate for a low-detail area, such as sky or smooth skin, will remove too much from high-detail areas such as vegetation and hair. This argues for first making a selection of the smoother areas of the image (where noise is in any case more noticeable) and confining the noise reduction to these. Dedicated noise-reduction software may have algorithms that take care of this.

Camera software

The Nikon Capture Editor, supplied with Nikon's cameras, has the advantage of being tuned by the manufacturer for its own range.

Photoshop Raw

Other image-editing applications, like Photoshop, also have noise reduction facilities, but by their very nature have to be more general.

Dfine

This plug-in allows separate operations for luminance and chrominance noise, and has the ability to select zones, and to load a specific camera profile.

We would be happy to send you further information on ILEX books and updates on forthcoming titles.
Please indicate which subject area(s) interest you and return this card to us.

Subject categories:

☐ Digital Photography
☐ Graphic Design
☐ 3D Art and Design
☐ Game Design

☐ Digital Video and Audio
☐ Web Design
☐ Art and Imaging

As we will be sending details by email, please ensure that you enter your full email address clearly below.
All information is subject to the Data Protection Act:

Name: _____

Address: _____

Postcode: _____

Email: _____

Alternatively you can receive full details on ILEX books or join the online forum by registering on
our website at **www.ilex-press.com**

POST CARD

ILEX

FREEPOST NAT10440

LEWES

BN7 2BR

camera's noise-reduction option for long exposures. This exists because there are different kinds of digital image noise, and the most prominent, but correctable, is long-exposure or fixed-pattern noise. Because of individual differences that occur during sensor manufacture, each one has a unique pattern of misfired pixels that is most evident in low light. As its name suggests, it is a fixed pattern, and so can be subtracted by the camera's processor, hence the option on better cameras.

In post-production, noise can be reduced by a variety of processing algorithms, most of which rely on being able to identify pixel-level differences in contrast and smoothing these out with averaging, median, or blurring filters. There is a distinction between luminance noise (dark and light specks) and chrominance noise (coloured specks), and some software uses separate procedures for each. If the end-product of an RGB image is to be black and white, the chrominance noise does not matter. Because noise reduction is a specialized process, it makes little sense to try and tackle it with the ordinary Photoshop tools. Photoshop Raw, as shown, has a noise control, but consider using the camera manufacturer's editing software, on the grounds that the manufacturer is likely to have the best information of the noise problems specific to that sensor. Or there is dedicated software, like PictureCode's Noise Ninja, for which specific camera noise profiles are supplied.

Photoshop Camera Raw

For Raw images, luminance and chrominance noise are filtered separately. If the image is to be converted to greyscale, chrominance noise is less important.

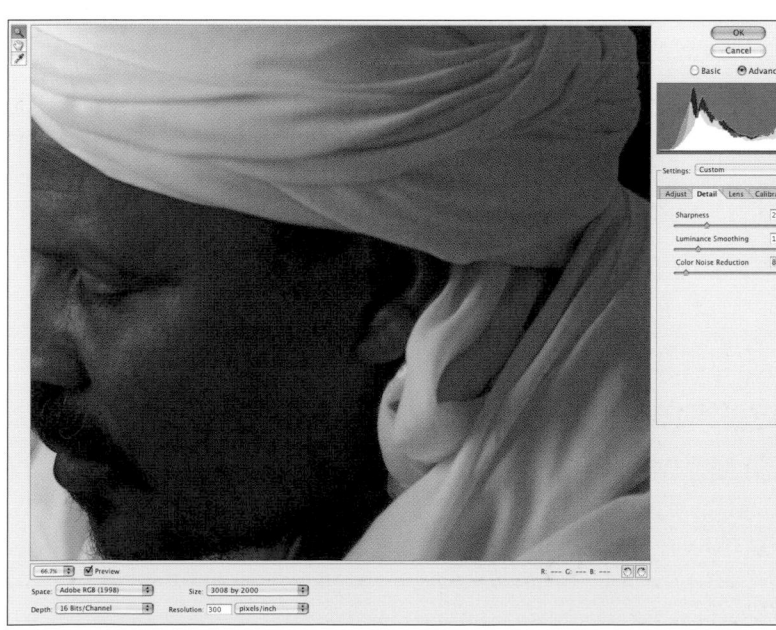

Mosque
Prayers in a dimly lit mosque were, by necessity, shot at 1600 ISO, hence the inevitable noise. The image beneath is the result of noise reduction using Nikon Capture Editor (illustrated lower left).

Upscaling

Special interpolation algorithms can, with care, be used to enlarge digital images without noticeable loss of detail.

Because the end-product in digital black-and-white photography is so often a display print, there is frequently a need to increase the size of the image, and this is surprisingly successful without any apparent loss of detail. The process is quite different from a regular film enlargement, which relies on optics to increase the scale from the inherently large amount of detail packed into a typical film negative. Digitally, enlargement means filling in missing detail artificially, which sounds dubious but with the right software works very well.

Upscaling, as it is generally known, is needed when the combination of final image size and resolution exceeds that of the original file. This bears a little explanation. The dimensions of an image depend on the number of pixels and the resolution at which they are to be displayed. The maximum pixel count is set by the camera's sensor. Thus, 3000 pixels on the longer side by 2000 on the shorter give 6 million (known as 6-megapixels). In three-channel RGB this will deliver a maximum TIFF file of 18 MB. A typical monitor has a resolution of 72 pixels per inch, so that while the 3000 x 2000 pixels is typically crammed onto a sensor measuring only about an inch across, this will display perfectly well at a size of 106 x 71 cm (42 x 28 inches), much larger than most monitors.

For printing, however, whether offset repro or desktop inkjet, the recommended resolution is 300 ppi (pixels per inch, sometimes called dpi or dots per inch when printing). For the example image just mentioned, that means a maximum of 25 x 17 cm (10 x 6½ inches). In other words, if you want to print tabloid size (A3) or larger, the image will have to be upscaled. The digital process for doing this is interpolation, which is also used in such other procedures as color adjustment and sharpening. In upscaling, the entire image is 'stretched' over a larger number of pixels, meaning that there are gaps to be filled. If the area is doubled, for instance, there will be an equal

PhotoZoom
Formerly known as S-Spline, this software uses adaptive interpolation so that the most sharpening is given to those parts of the image that need it.

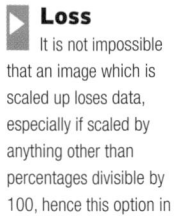

Loss

It is not impossible that an image which is scaled up loses data, especially if scaled by anything other than percentages divisible by 100, hence this option in Genuine Fractals.

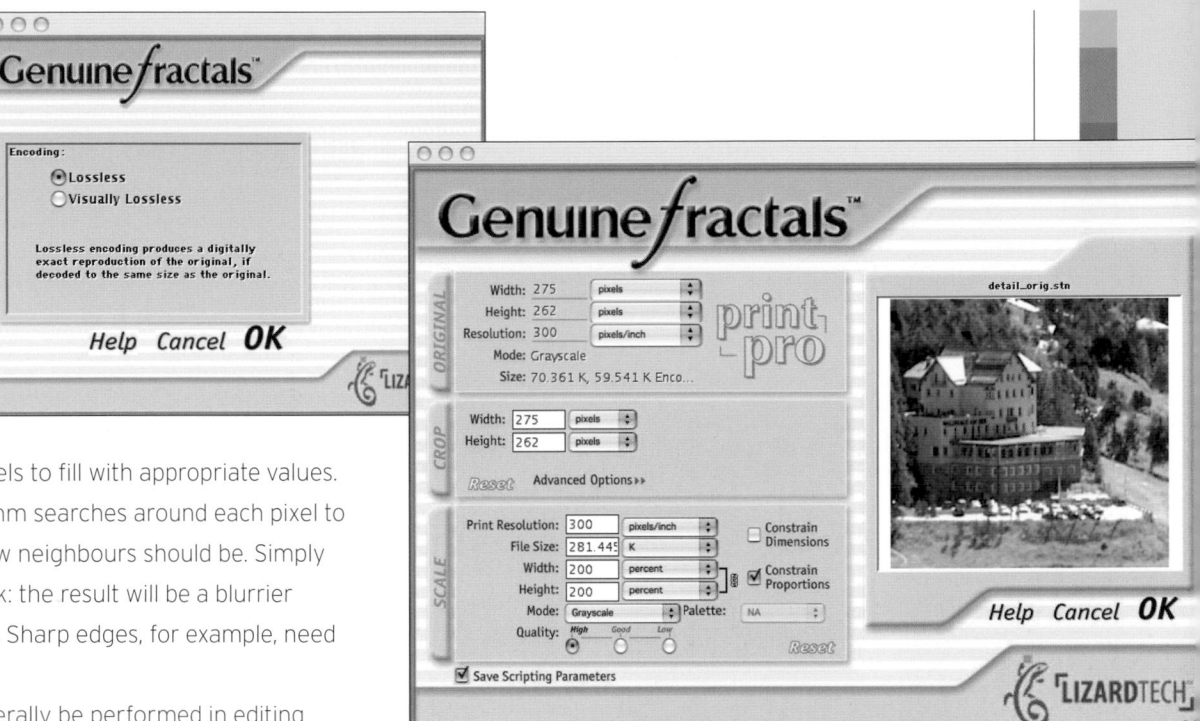

number of 'empty' pixels to fill with appropriate values. Effectively, the algorithm searches around each pixel to determine what its new neighbours should be. Simply averaging will not work: the result will be a blurrier version of the original. Sharp edges, for example, need to be maintained.

Upscaling can generally be performed in editing software, or by the printer driver, and for modest increases there may be little to choose between them. At amounts above 150%, however, it is worth making comparative tests, and also looking at specialist upscaling programs. Huge increases are often claimed, but the success of these depends on what quality you are prepared to accept, and at what viewing distance the final image will be seen. I would hesitate to go beyond 300%. The standard algorithm of choice, widely available and used by default in Photoshop, is Bicubic. The other two offered in Photoshop (*Preferences > General > Image Interpolation*) are Nearest Neighbor and Bilinear, and worth looking at only for comparison with Bicubic. More complex algorithms are available in other software, one of the most widely used being PhotoZoom, shown here. Its algorithm, S-Spline, assesses the detail across an image and applies different methods to different areas. It can also apply sharpening which, if you are preparing a copy (always a copy) of an image for enlarged printing, saves a step.

Another approach is to convert the image to scalable image format and then output this larger – Genuine Fractals is an example of this. Some specialist upscaling software needs the three RGB channels to work on; bear this in mind when choosing at what stage to upscale a digital image.

Genuine Fractals

A Photoshop plug-in that offers a different way of encoding images from the usual pixel-based methods. Upscaling is one of its useful by-products. Its file format is resolution-independent, which allows larger images to be output without noticeable loss of detail. The effects are comparable with PhotoZoom.

Copying in black and white

Making an accurate record of flat artwork calls for a precise adjustment of the tonal range so as to preserve the often minute details.

Paradoxically, copying for reproduction in black and white usually demands more care than when a colour image is the final output, and this is particularly true for flat artwork in which the base is white, as in a document or a wood-block print. The reason for this is that the variety of hues in a colour image can easily mask errors in lighting and exposure. Black and white's much more restricted palette draws attention to things like vignetting, uneven lighting and the background tone of the 'white'. Nevertheless, there are ways of dealing with any problem in image editing.

With a full-colour original, such as a painting, it helps to have a measure of the actual colours, and professional copyists use a colour target close to the original or held in front of it for a reference shot. Colour accuracy is not, of course, as important for a black-and-white reproduction, so this step is not essential. What replaces this as a matter of judgment is deciding what tonal values to assign to the different colours, just as with regular photography. There is often a tendency to exaggerate tonal contrast for a more dramatic effect, and in reproducing original artwork this is not really appropriate. Copying may not be a particularly creative activity, but it does demand proficiency and remaining faithful, perceptually, to the original. The example here of a full-length portrait shows the kinds of decision that need to be made.

Original
This oil portrait was photographed under reasonably accurate lighting – 3200K quartz-halogen, with a 3200K white balance setting. Colour accuracy is important even in black and white, in order to decide the channel mix.

White point
The white point, as set using the Levels tool (right).

Color Picker

Select target highlight color:

OK
Cancel
Custom

H: 0 ° L: 97
S: 0 % a: 0
B: 96 % b: 0
R: 245 C: 5 %
G: 245 M: 3 %
B: 245 Y: 4 %
 K: 0 %
F5F5F5

☐ Only Web Colors

KODAK Gray Scale

Levels

Channel: RGB

Input Levels: 0 1.00 255

OK
Cancel
Load...
Save...
Auto
Options...

Output Levels: 0 255

☑ Preview

Points
Using the picker, the black and white points are set to the ideal values for the ends of the grayscale that has been included in the shot—45 and 245 (see also pages 84-85).

More technically demanding is simple black on white flat artwork. Here, the essential is to reproduce the white as brightly as possible without blowing it out through over-exposure. At the same time, the black parts of the artwork need to be rich and dense, but without 'bleeding', which is to say keeping finely drawn or etched lines separate. At image capture, the extremes of black and white can make the camera's histogram difficult to read, as they will each tend to be at an end of the scale. More useful is the highlight warning display on the LCD, letting you adjust the exposure so that the image is as bright as possible without clipping.

There are two lighting issues. One is to make it even across the original, for which it's normal to use at least two lights, aimed as shown in the example here. Four are even better, although more cumbersome to set up. A workable alternative is direct sunlight, uncontrolled though it may sound. One advantage of the sun is that because of its distance there is no illumination fall-off. But with this, the second lighting issue comes into play – reflection. Very few surfaces are completely matte, and even a textured white paper will show hot-spots if the angle of lighting is too frontal. A low angle, whether from the sun or artificial lights, is usually best.

Final
Using a channel mix of 80% red, 20% green, and 0% blue, as tested on the colour swatches, the painting now has an equivalent perceptual contrast to the optimized colour original.

Curves
A standard contrast-enhancing curve is now applied, and the image is ready for greyscale conversion. The result of a standard conversion is shown above.

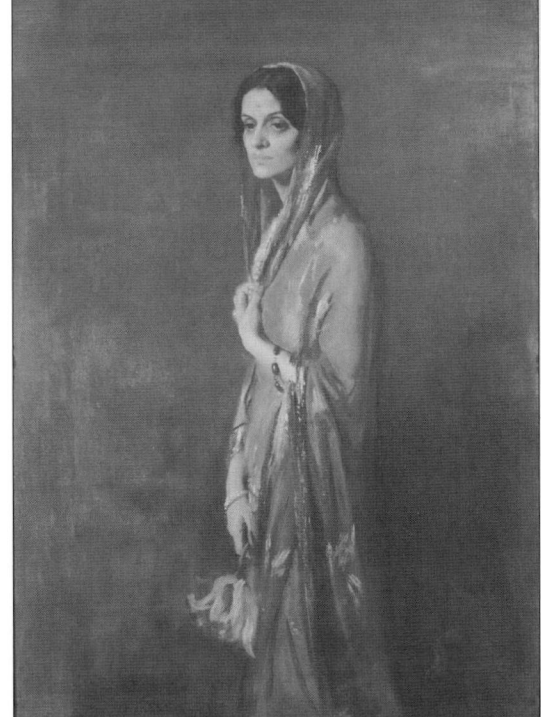

Scanning negatives

The advantage of scanning a black-and-white negative for digital printing over normal silver halide printing is the wide range of digital tools available for editing and optimizing the image.

In the changeover from film to digital, there comes the stage when it makes sense to archive the negative files, not only for filing and digital storage but also so that they can be entered into the digital workflow of post-production and desktop printing. Slide scanners have the option for handling black-and-white negatives, and this involves displaying and capturing inverted tones to produce a positive scan, and using a single greyscale channel rather than the three RGB channels. This, of course, makes scanning faster, a real convenience with high-resolution scans.

Scanning software offers many of the same optimization tools that Photoshop has, including Histogram and Curves. Thus there are two stages at which you can make these adjustments, but, as with digital capture using a camera, it is important to acquire

Basic scanning sequence

1. Load the preview in as large a window as possible, and rotate 90° if necessary.
2. Crop accurately. If you choose to leave a margin of the rebate (the unexposed area around the edge), be aware that this will affect the histogram display.
3. Set the file size and output resolution. In fact, the resolution, measured in dpi, is less important, as it can be changed later without affecting the image. The file size, however, in megabytes, determines the size at which you can print the image. At 300 dpi, a 8Mb monochrome scan will print to letter (A4) size (17Mb for 16 bits per pixel).
4. Set as high as possible a bit-depth to capture the maximum tonal information. That is, more than the regular 8 bits per channel.
5. Set the white and black points, without clipping highlights or shadows.
6. Adjust the brightness, using either the curve or a slider, based on the appearance of the image on-screen.
7. Set the amount of sharpening to either low or none (sharpening ought to depend on the final size of use, and is usually best left until immediately before printing).
8. Scan and save.

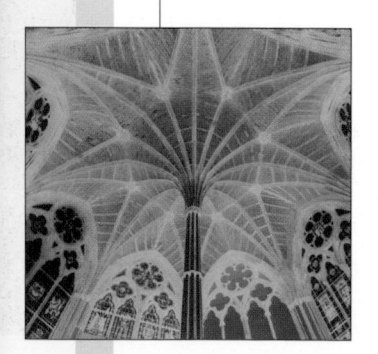

◀ **Chapter House**
The original 6 x 6cm negative of a stone ceiling in London's Westminster Abbey. Most of the detail is evidently in the shadow areas.

 The scan
Using a Nikon slide scanner, the settings are selected as Neg (Mono), 6 x 6 and Grayscale. The illumination (Analog brightness) is set so that the highlights just fall within the range, leaving a very small gap at the left (shadow) end.

as much of the information as possible at the scanning stage. In particular, this means setting the black and white points correctly, and the objective is to capture as wide a tonal range as possible without clipping either end. Much depends on the scanner software. If there is any uncertainty about clipping, err on the side of caution and set the black and white points at a little distance from the ends of the histogram. Of course, if you make no adjustments at all, then you will not have made use of the full dynamic range of the scanner, and any later optimization will, in effect, stretch out the more limited tonal range of the image. Clearly, it pays to scan at the highest bit-depth possible, for the same reasons as shooting Raw format with the camera (see page 76). A slight difficulty with scanning negatives is that the D-Max and D-Min of the original film are very far from black and white. Examine a properly exposed black-and-white negative on a lightbox and you will see that the densest areas (maximum exposure) are grey, while the film rebate (no exposure) is a pale grey because of the tone of the acetate film base. When you load a negative into the scanner, the histogram as it first appears will show significant gaps left and right, and they do need to be closed up. The more adjustment you leave to Levels in Photoshop, the less of the subtle tonal gradation you will be able to hold.

◢◣ **Photoshop changes**
The positive scan before optimizing (above) then after Levels adjustment (right). As the scan settings were chosen carefully, there is very little closing up to do in Photoshop.

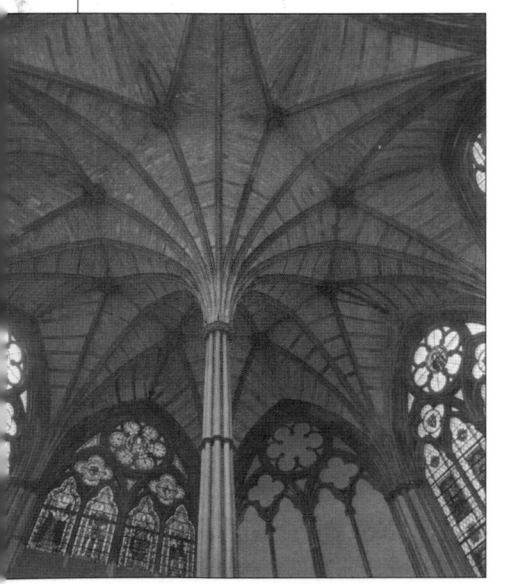

◀ **16-bit**
This is a 16-bit scan, retaining significantly more information than the 8-bit versions shown at the top of the page. Radical changes can be made to it at little cost to the overall quality.

▶ **Moody final**
From the 16-bit original, this adjusted image still has subtle tonal grades. It has also been sharpened for press.

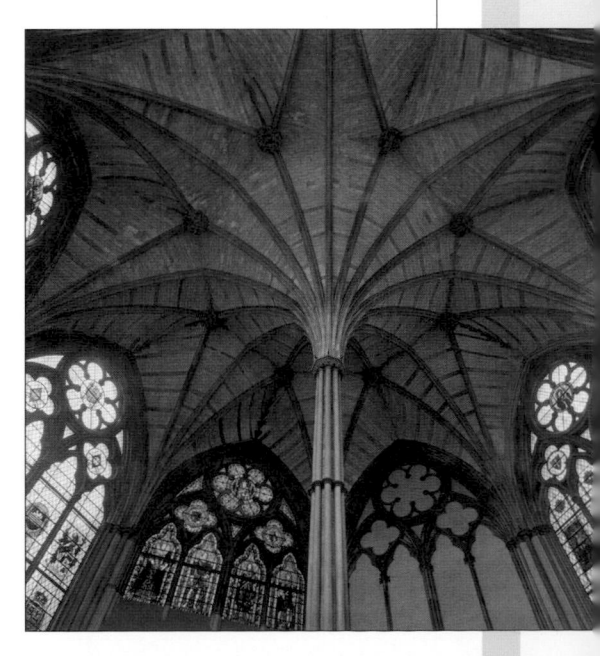

Scanning positives

Continue the archiving process by scanning colour transparencies in a slide scanner and prints in a flatbed model.

A scanner provides the same opportunities as digital capture for finessing the conversion of a colour scene into black and white, including the choice of grey tones for individual colours. The basic scanning procedure is exactly the same as for film negatives, as just described, except that the mode is positive and RGB. Having made all the adjustments recommended in the box 'Basic scanning sequence' on the previous pages, also adjust the colour balance and saturation. This makes it important to assess the colour of the slide first, on a colour-corrected lightbox, before placing it in the scanner. Look for neutrals and memory colours in the slide, and make a mental note of them. Neutral areas, such as concrete and shadows on white, are particularly valuable, as they can be measured with the scanner software's sampling tool. If you make regular use of a slide scanner, you should in any case calibrate it.

When only a black-and-white print survives of an image, flatbed scanning is both a means of safeguarding the image and a first step in retouching

Dust and scratches

Always clean the film to be scanned, to remove dust and particles. If there are embedded particles in the film, consider washing the film. Many scanners have an option for finding and removing dust and scratch artifacts, although some that use a separate infrared channel during the process will work only with colour slides, not black-and-white silver negatives.

Settings
The image is cropped to within the mount, the size and resolution set to the desired amounts (the maximum at 300 dpi), and the Curves used to lighten the mid-tones.

▲ Mode
With a slide scanner, the procedure is essentially the same as for a negative. The input here is Kodachrome, and the output Grayscale.

blemishes. However, while a good print carries the advantage of being a considered expression of the raw negative, and has been optimized to the satisfaction of the printer/ photographer, the much greater disadvantage is that its dynamic range is much less than that of the original negative. As we saw on pages 18–19, the dynamic range of a print varies between about five f-stops for matte paper and seven to eight f-stops for glossy, but the range for black-and-white negative film is in the order of 11 f-stops, around 2,000:1. If you have the negative and a fine print, scan the negative and use the print as a guide for optimization.

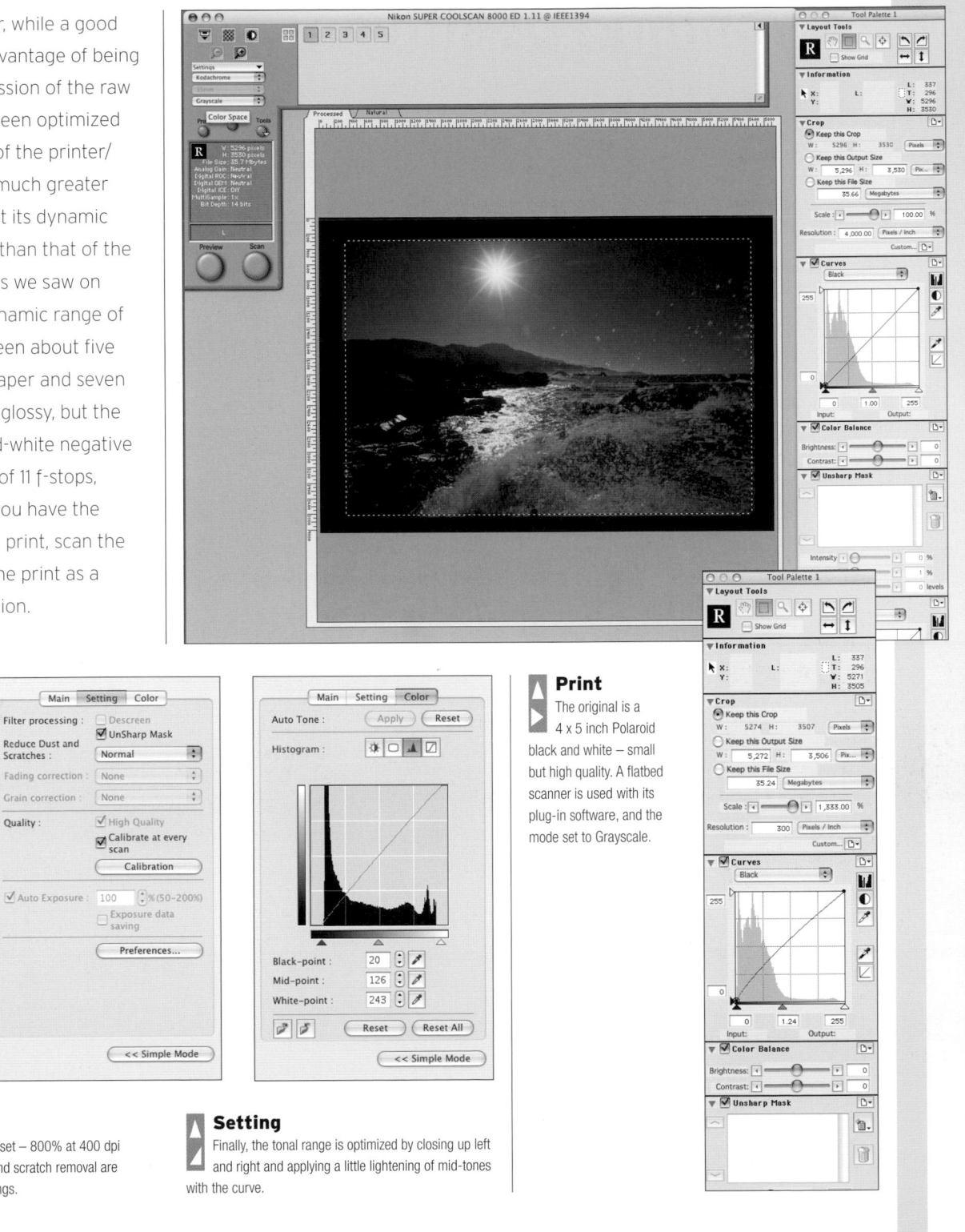

Print
The original is a 4 x 5 inch Polaroid black and white – small but high quality. A flatbed scanner is used with its plug-in software, and the mode set to Grayscale.

Size
Scale and resolution are set – 800% at 400 dpi Sharpening (USM) and dust and scratch removal are activated at their default settings.

Setting
Finally, the tonal range is optimized by closing up left and right and applying a little lightening of mid-tones with the curve.

Image **Editing** & **Effects**

As usual with digital imaging, it makes sense to draw a line between procedures that are designed to produce the best image quality possible, and those that change the character of the photography. In black and white, as in colour, image editing with Photoshop and other software can achieve just about anything that you can imagine, so to avoid getting bogged down in unnecessary procedures it's important to decide at the outset what you want from the final image. The last chapter was essentially concerned with just getting it right. Here we go further, and look at different ways of interpreting the photograph that has already been shot.

Much of this derives from techniques and styles that have already been developed in traditional silver-halide black-and-white photography, and the largest group of these involves putting some colour back into the image, which may at first seem strange. Yet it comes directly from the world of traditional photography, and is an acknowledgment of the delicacy of this medium – that barely perceptible shifts in hue away from pure black and pure grey can enhance the atmosphere created by a print. This addition of hue, is far from the natural, 'full' colour of a normal RGB image, and can be extremely subtle – a version of monochrome that simply adds another dimension in which to distinguish between greys, blacks, and whites. Toning, as it has long been known in traditional printing (despite being a different and potentially confusing meaning of the word), is an after-treatment that can add coolness or warmth to what started as a neutral print, as well as permanence

to a silver print. Duotones are a sort of offset printing version in which coloured inks are assigned to different parts of the tonal range, with tritones and quadtones being more complex versions. The comparison between these original ways of reproducing monochrome and the modern digital methods should not be taken too literally. The processes are quite different, and the colour effect is created before printing. What has been borrowed is the special sensibility of delicate differences in the 'colour' of monochrome. Throughout black-and-white photography, the small differences, the shades of distinction, play a more important role than they can in colour photography.

These effects can also go beyond color shift, to include various degrees of stylization, including the application of simulated grain and artificial aging. Grain, of course, does not exist in a digital photograph, although there is a near equivalent in the noise that occurs in low light and with high sensitivity settings. Aesthetically, noise is generally poorly regarded, being a true artefact (that is, an unwanted addition to the image) rather than a part of the process, as is film grain. Graininess has a certain attractiveness in the texture it gives, in much the same way as a textured paper gives a tactile quality to a print, and there are digital ways of simulating it. This, and the many other stylizing filters on the market, are not to everyone's taste, as they move away from the photograph as image toward the photograph as object. Nevertheless, they exist, and are worthy of examination.

Mood and atmosphere

Fine-tuning brightness and contrast can alter the character and lighting of a scene for a personal interpretation.

In black and white, more than in colour, there is no such thing as a perfectly 'correct' print. Instead there is the individual photographer's idea of how the image should look, what Ansel Adams called 'visualization'. Here is how he described his ideas for one of his most famous images (Clearing Winter Storm, Yosemite National Park, 1940): 'Although the scene was of low general contrast, my visualization of the final print was quite vigorous. The subject had a very dramatic potential.' Or consider the work of English photographer Bill Brandt, who favoured glossy grade 4 paper for intense blacks and brilliant whites, and once said, 'I try to convey the atmosphere of my subject by intensifying the elements that compose it.' Other photographers have aimed for lower contrast in order to reveal everything from shadow to highlight with the subtlest of distinctions.

Just because the mood of an image is a less tangible quality than, say, its composition, makes it no less important to think about. The technical issues of digital imaging understandably occupy a lot of attention because they are new, complex, and detailed, but there is a tendency for them to push to one side those creative qualities that are less easy to pin down. Setting black and white points, and other ways of optimizing, are technical procedures that

▲ **White Sands**

White Sands, New Mexico is a favorite location for black-and-white landscape photography because of the constantly changing graphics of shadows on the brilliant gypsum sand. In this high-key treatment, the mood is open and bright, with no shadow tones.

ought to follow on from your ideas of how an image should look, and not determine it.

Consider the following descriptions as applied to black-and-white photographs: bright and open, mysterious, threatening, subdued, airy, cheerful, soft, brittle. All are valid, even though open to personal interpretation, and the language is far from technical. It describes the overall effect and not the process. Nevertheless, the means for creating these types of atmosphere suggest themselves readily enough in monochrome, as the table illustrates. Here is yet another instance in which discarding the dimension of colour from images tends to focus attention on the nuances of the tonal range. Arguably, mood and atmosphere are better served in black and white than in colour.

▼ White Sands

A quite different atmosphere ignores the whiteness of the sands and concentrates on graphic relationships, using the full range with strong blacks.

▶ Chapel of St John

This vaulted Norman chapel in the heart of the Tower of London was photographed without artificial lighting to capture its natural atmosphere, a mixture of mysterious and deep shadow details among the stone pillars and arches, and the flooding light from the far end.

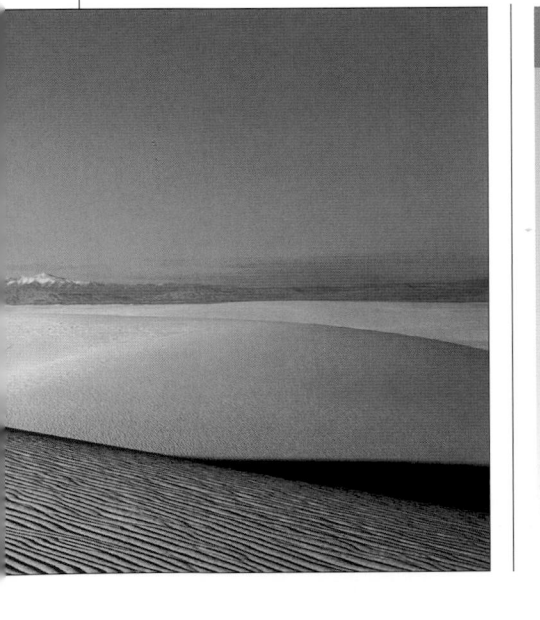

Qualities and effects

Technical qualities	Mood effects
Most of image falls into mid-to-light tones, large areas of highlight, no blacks, limited shadows.	High key, bright, cheerful but also possibly slightly mysterious through the sense of not being able to see everything. Luminous.
Most of image dark, with few highlights. The concentration of graphic activity is in the shadow areas.	Low key, rich and dense, can be threatening, possibly mysterious.
Image largely in the second quarter of the tonal range (dark-to-mid), with no true blacks and very few light tones.	Murky, crepuscular, with possibly industrial and even pollution overtones.
Shadows and highlights clipped or almost clipped, and much of the image close to these ends of the scale, with limited areas of mid-tone grey.	High contrast, stark, lunar, chiaroscuro, sharp and brittle.
Most of image concentrated in the mid-tones, with few if any dark shadows and bright highlights.	Low contrast, dull, subdued.
Image largely in the third quarter of the tonal range (mid-to-light), with few dark areas but no really bright highlights.	Soft, delicate, misty.

Case study: **defining the mood**

In black and white, more than in colour, there is no such thing as a "correct" print. Instead there is the individual photographer's idea of how the image should look, what Ansel Adams called 'visualization'. He described his ideas for one image (Clearing Winter Storm, Yosemite National Park, 1940), thus: 'Although the scene was of low general contrast, my visualization of the final print was quite vigorous. The subject had a very dramatic potential.' Or consider the work of English photographer Bill Brandt, who favoured glossy grade 4 paper for intense blacks and brilliant whites, and once said, 'I try to convey the atmosphere of my subject by intensifying the elements that compose it.' The scene here was a mountain stream coursing through the Isle of Skye in Western Scotland. How to interpret a landscape like this?

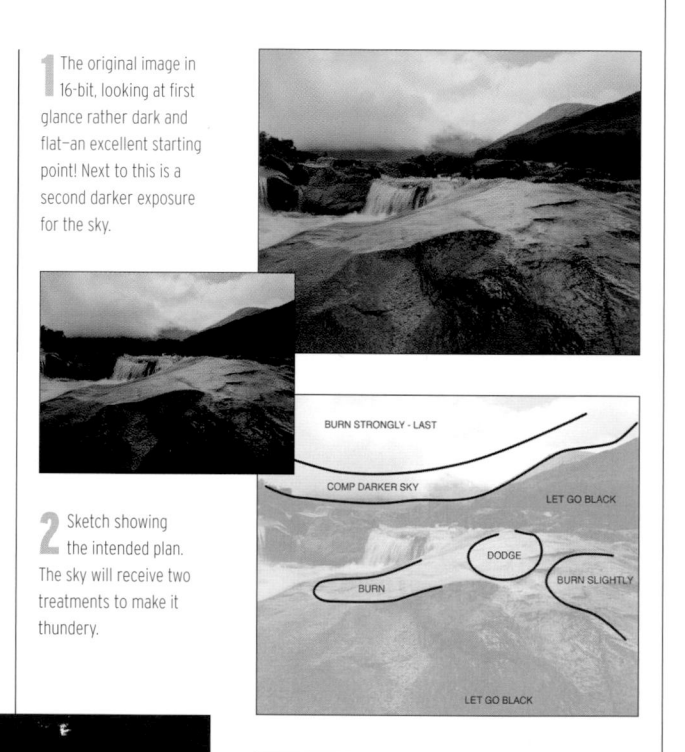

1 The original image in 16-bit, looking at first glance rather dark and flat–an excellent starting point! Next to this is a second darker exposure for the sky.

2 Sketch showing the intended plan. The sky will receive two treatments to make it thundery.

BURN STRONGLY - LAST

COMP DARKER SKY

LET GO BLACK

DODGE

BURN

BURN SLIGHTLY

LET GO BLACK

Levels

Channel: Gray

Input Levels: 1 1.00 225

OK
Cancel
Load...
Save...
Auto
Options...

Output Levels: 0 255

☑ Preview

3 The first action is to make the tonal range fit neatly within the full scale, by setting the white and black points. Holding down the Alt key (or Option key) at the same time as moving either slider reveals the point at which the highlights/shadows will be clipped. The actual setting is a little back from these.

New Snapshot

Name: Snapshot 1 OK

From: Current Layer Cancel

6 A snapshot is taken of this upper layer for later use by the History brush. Then the layer is deleted, and the darker sky carefully brushed in with the History Brush.

Adobe Photoshop

Delete the layer "Layer 1"?

No Yes

Brightness/Contrast

Brightness: -20 OK

Contrast: +10 Cancel

☑ Preview

4 Brightness and contrast are then adjusted to taste – here, that means darker and more contrasty.

Brush: 1242 Range: Midtones

Master Diameter 1242 px

Hardness: 0%

Layers Channels Paths

Normal Opacity: 100%

Lock: ☐ ✎ ✛ ⬚ Fill: 100%

👁 ✎ Layer 1

👁 *Background* 🔒

5 Although no highlights have been clipped in the original, the range of tones in the sky is still weakly defined. There is more information in the second, darker exposure, here given more contrast. As the camera was on a tripod, there is perfect register between the two images, and the darker is copied and pasted on top of the working image.

7 The final step is dodging and burning, using these tools in Photoshop in much the same way as in traditional darkroom printing, but with the considerable advantage of being able to see the effect as it is applied – and to undo the strokes if necessary. The Burn tool is set to a very large brush size and only 15% opacity (for fine control). The upper part of the sky is given seven passes of the brush. A slight amount of dodging and burning is then given to the foreground rocks, as shown in the sketch, to give a better visual match to the retouched sky.

Toner effects

Traditional toning baths for silver-halide prints, which add a gentle colouration, can be replicated in image editing using several different methods.

In silver-halide printing, toner solutions became popular in the 19th century as a means of increasing the range of expression in a print through changing the colour from black. The subtlety of the effects varied with the kind of toner and the process (longer development times typically produced stronger colouring when the print was later put in the toning bath). There was, in addition, an archival effect. Aesthetically, toning had its proponents and its critics, but in general, it seemed to be most successful when used subtly. Toners work on emulsion, which means that in appearance their effect is

▲ St James's Park

A telephoto view of Whitehall and Horse Guards Parade, in London.

▶ Selenium effect

A slight increase in blue, an even smaller reduction in red, and a gentle increase in contrast replicates selenium toning.

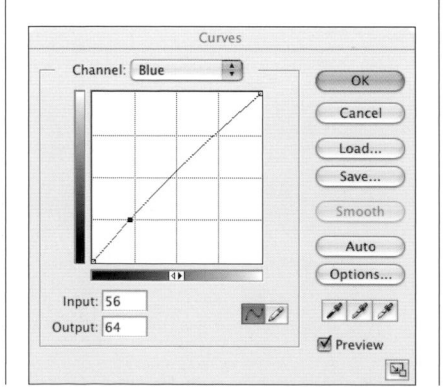

Curves

Channel: Blue

Input: 56
Output: 64

OK
Cancel
Load...
Save...
Smooth
Auto
Options...
☑ Preview

Curves

Channel: Red

Input: 125
Output: 128

OK
Cancel
Load...
Save...
Smooth
Auto
Options...
☑ Preview

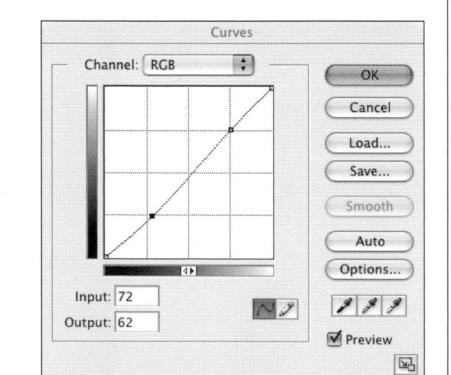

Curves

Channel: RGB

Input: 72
Output: 62

OK
Cancel
Load...
Save...
Smooth
Auto
Options...
☑ Preview

usually strongest in the mid- or mid-to-dark tones. It is least obvious in the highlights (where there is little to work on) while very dark shadows approach black in any case and reveal little colour.

All of this can be imitated digitally during image editing, and if you like toning effects it helps to have some familiarity with the traditional range of toners. The most common was sulphur toning, which delivered a pronounced sepia effect. The method used is bleach-and-redevelop, in which a first bleach bath converts the metallic silver into a silver salt, which is then altered into brown silver sulphide by means of a second bath of sodium sulphide. The problem is the extreme overall effect, which is by no means to everyone's taste. Selenium toning has a less obvious and, for most people, a more pleasing result, with a subtle cooling of the print. Ansel Adams, for example, used it extensively in combination with papers that had a cool emulsion colour, working for a cool purple-black image by using a cold-toned developer and a slight toning in selenium.

▲ **Balance**
This control usefully separates hue changes across the tonal range, making it easy to concentrate the sepia in the darker tones and add a yellowing in the lighter.

▶ **Curves**
Curves are used to do essentially the same thing – increase reds with a bias towards the shadows and reduce blue (that is, increase yellow) toward the highlights.

Analyzing traditional tones

An alternative and more factually based approach to toning is to work from traditionally prepared and tone prints to extract the colour response.

We can cast the net wider than pure toning baths to include traditional and specialized printing processes, on the grounds that the appeal of these effects lies in the subtle addition of colour, whatever the chemistry. This suggests a more pragmatic way of reproducing the effects digitally – first prepare the prints of an identical target, then scan these and analyse the response. The difficulty is that some printing techniques, such as palladium and cyanotype, are highly specialized, and there are few skilled practitioners. The problem was solved by Jan Esmann of PowerRetouche, by recruiting help from experts in each printing and toning process. The prints were analysed for tonal range and for the variations of colour within that range.

His Toned Photos plug-in has nine presets, including Platinum, Palladium, Cyanotype and Kallitype. The results vary in colour, the way it is distributed across the tonal range, and also saturation and the breadth of the range.

Roots
A gallery at one of the Angkor temples encased in the roots of a giant silk-cotton tree. The ancient atmosphere might benefit from an old-fashioned look, as if it had been photographed when first discovered.

Power Retouche

The Toned Photos plug-in contains a number of presets that automatically convert from a colour original into a traditional type of print. Part of the conversion allows for the difference in paper.

Ta pro

Van Dyck

Silver

Silver gelatin

Platinum

Sepia

Kallitype

Light Cyan

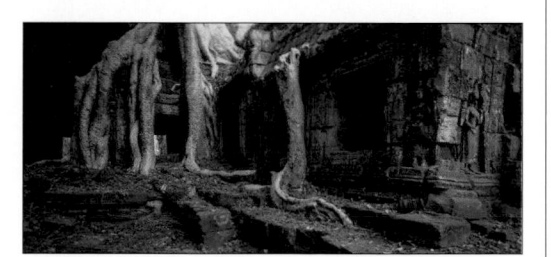

Palladium

Cyanotype

Mimicking film response

For photographers unhappy to be weaned off a favourite black-and-white emulsion, there are convincing digital imitations.

Many black and white film photographers have a favourite emulsion, although how real the claimed differences are between brands is moot. There certainly was a major distinction between old orthochromatic (relatively insensitive to red CK) films and modern panchromatic, but from one modern brand to another the differences are slight. They are mostly in the dynamic range and the shape of the characteristic curve. One way to simulate a particular emulsion's response curve is simply to download the response curve from the manufacturer's website (for those that are still in business). Then tweak the Curves graph of an image in Photoshop to approximate this, and save it as a preset for later use. This is very much a matter of judgment, but given the very fine shades of difference, this is probably as good a way as any. Another approach is to photograph a greyscale, scan this and analyse the tonal response. But the scanning probably introduces much greater differences than exist in the first place. One third-party software company has actually gone to the trouble of analysing the tonal performance and spectral sensitivity of different black-and-white emulsion brands and produced one-click 'Filmtype presets' – this is the Black and White Studio plug-in from PowerRetouche, and a definite recommendation if you want your digital imagery to look like Tri-X, for example. It certainly saves considerable effort, and is just one of

▲ **Ava**
The starting point for adding a grain effect is this misty view of an old watch-tower in Burma. The smooth grey tones will show any grain distinctly.

▼ **nik Color Efex Pro**
This plug-in, part of the nik Multimedia Color Efex Pro! suite, has Grain as one of five sliders.

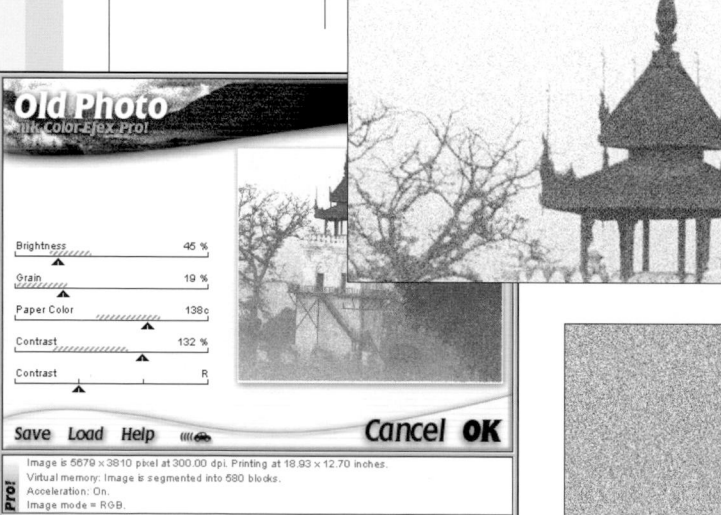

◄ **Make your own**
One option, if you have a great deal of time, is to make your own noise and exaggerate it or soften it with Curves.

many effects that use traditional black-and-white photography as a starting point (see pages 124–125).

Another aspect of black-and-white film imagery that retains a certain esthetic appeal is grain. The loose equivalent in digital capture is noise, but the similarity is superficial, because the reasons for each are quite different. Noise in a digital image has almost no saving graces, and is much more closely related to the noise in an audio signal – an artefact that interferes with the content. Grain in film, despite looking similar (except in close-up) and being also associated with increased ISO sensitivity, does have some justification. It derives from the clumping of processed crystals in the emulsion, and so is intimately a part of the process, as much as brushstrokes are to a painting. This, at least, is the argument for those photographers who like its presence, and in the days of film there were identifiable differences between brands of emulsion in the grain structure they displayed. This is not the place to argue the merits of graininess, but as it has its adherents, simulating it digitally is valid. The visible grain in a silver image is not, incidentally, a view of the individual crystals, but of much larger clumps.

Original

APX 100

100TMX

HP5

T400CN

Delta 100

400TX

PanF

Woodland

This converted black-and-white shot of bluebells in woodland has considerable detail, and will need a strong grain effect to make a difference. With this technique, we create our own grain with a noise filter.

Hippo

An ox-pecker perched on the brow of a hippopotamus provides a test-bed for seeing the subtle differences between the tonal responses of different black-and-white negative films.

Controls Film

Lens Color-filters

None

Add Filter

Strength 100

Film Spectral Sensitivity

Filmtype presets

Wavelength

Magenta - 400

Blue - 440

Cyan - 475

Green - 510

Yellow - 560

Orange - 618

Red - 645

Panchromatic
Orthochromatic
• Perceptual Luminance
100TMX TMAX (Kodak)
T400CN (Kodak)
400TX Tri-X (Kodak)
APX 100 (Agfa)
HP5+ (Ilford)
Delta 100 (Ilford)
PAN F+ (Ilford)

Duotones

This established graphic arts tool can be re-purposed to both improve the monochrome printing performance of a desktop inkjet printer, and add subtle colours.

Duotones were developed for the printing industry, both as a way of adding a spot colour to an image and as a solution to the problem of the narrow range of greys that most printing presses are capable of. An 8-bit monochrome image has 256 levels from black to white, but a typical press can manage only about 50. A duotone using a black and a grey significantly increases the dynamic range for the press. All of this is of limited interest to most digital photographers, but the tools for creating duotones (and tritones and quadtones), conveniently available in Photoshop, can be put to the unintended use of increasing the range of expression in desktop inkjet printing. These printers can't actually use duotones in the way they were intended, but the image can be adjusted in several interesting ways. Moreover, even good inkjet printers such as the Epson range (see page 146) do a relatively poor job when printing a single-channel greyscale image. The reason is easy to understand. Whereas a colour RGB image has 16.8 million levels (256 x 256 x 256), a greyscale image has just 256, and if the

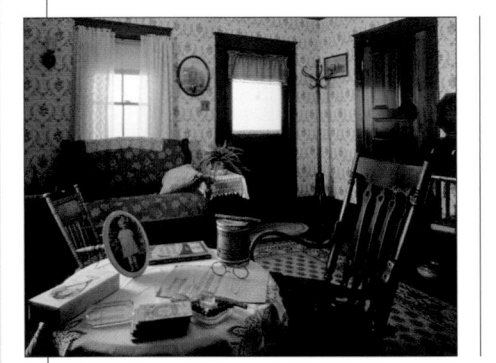

▲ A 1930s living room
An Italian-American living room installation in a museum is the starting point. The shot has an historical atmosphere, and may well suit a duotone treatment.

▲ Convert to monochrome
First create the monochrome effect that you prefer, by using desaturation, the channel mixer or any of the other conversion methods described on pages 74–95.

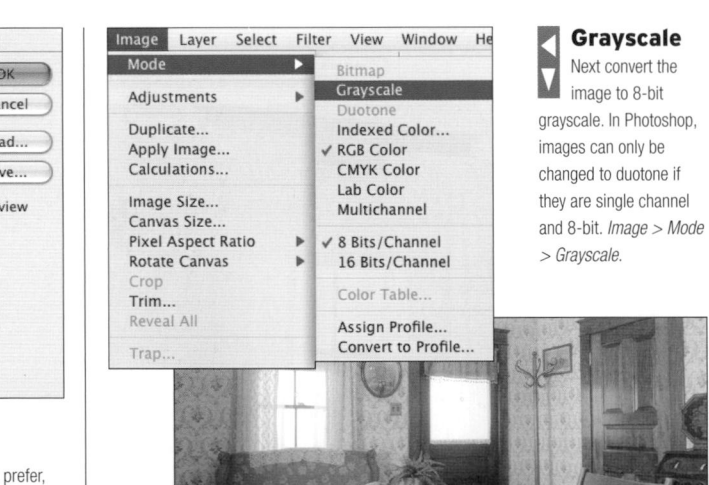

◄ Grayscale
Next convert the image to 8-bit grayscale. In Photoshop, images can only be changed to duotone if they are single channel and 8-bit. *Image > Mode > Grayscale.*

printer is using just its black ink, it cannot create 256 separate shades of grey by means of its dithering procedure. Printing in full colour mode allows the printer to use all of its inks, and the dynamic range is improved, but at the cost of unpredictable colour casts. Duotones are a way around this impasse.

In a sense, duotones replace channels, with the added advantage that each ink that you specify has a readily available Curves dialog that allows precise adjustments of its tonal range. We'll deal with this aspect of duotones on the following pages. For now, the first step, having made the conversion to Duotone in Photoshop, is to assign the inks, and normally the first one will be black. Graphic arts professionals need to specify an exact ink, hence the drop-down list of presets available in the Color Options dialog, offering a range of process and Pantone colours. This precision is not necessary for desktop inkjet printing, because your printer uses its own set of inks, so when selecting these colours you can make the choice solely on appearance. There is also another way of choosing a colour: using the standard Photoshop Color Picker, also available from the Color Options dialog.

If there is a problem with duotones, it is the infinite choice of colours and settings, so to begin with ignore the curve boxes that appear at the left of each ink in the Duotone Options dialog, and concentrate on the ink colours. Preferences are largely a matter of personal taste.

◭ First ink
For ink 1, create a pure black in the Picker and use this as a starting point. You can go back and change the colour at any time.

▽ Second ink
For ink 2, use the Picker again and choose any other colour, in this example, blue-green. Click the Preview box off and on to see the scale of the change.

▽ Two inks
Two inks are available. Click the second square of Ink 1 to access the Color Options dialog. This offers two ways of choosing an ink colour. One is from the presets available under Book. The other is via the normal Color Picker. Click Picker.

◭ Duotone dialog
Open the Duotone Options dialog window by going to *Image > Mode > Duotone*. Choose Duotone under Type and make sure the Preview box is ticked so that you can see the results of any changes you make in real time.

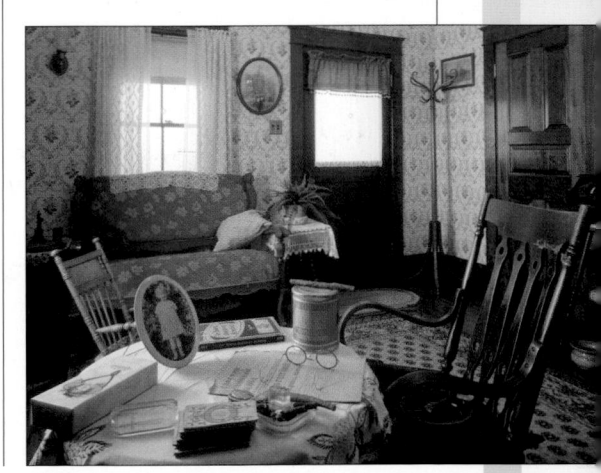

Manipulating duotone curves

Arguably the most powerful use of duotones is in assigning the different colours to discrete parts of the image's tonal range, by means of curve adjustment.

Simply adding one colour to black, as on the previous pages, is interesting but largely misses the opportunities offered by duotones. Each ink/colour has attached to it a curve, on the left in the Duotone Options dialog. Clicking on this opens up the Duotone Curve window, with the graph on the left and percentages on the right. By now, you should be familiar with the adjustment of a curve: it is the same here as the regular Curves dialog, without the black and white point tools but with a finer grid mesh to allow more precise positioning of points along the curve. Whatever the tonal range of the image, it appears by default as a straight 45° line. As you click to add and move points along this line, the percentage boxes at right show how much ink will be applied to that point on the curve.

Original
This shot of an opulent 19th-century Swiss interior is ideal for our purposes.

Select a preset
Load the Photoshop Presets (in the folder structure *Duotones > Gray/Black Duotones*), and choose any of the presets. In this example, we use "424 bl 4."

Ink 1
Click on the curve box for ink 1, then drag the curve to lighten the application of black to the highlights.

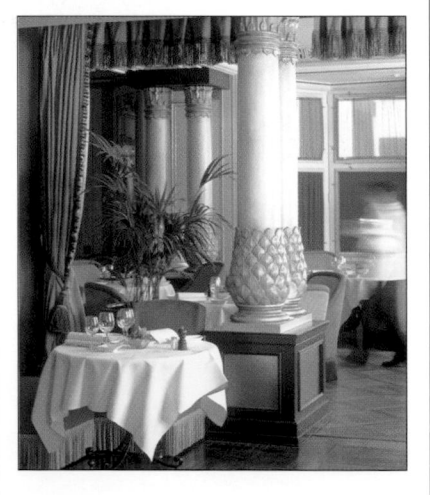

Greyscale
Convert the original to greyscale using the technique on the previous page. We can now experiment with the Photoshop library of preset tones.

Ink 2
Next click the curve box for ink 2. Drag the top right corner down, then add another point on the curve and drag it upward. This shape reduces blue-green in the shadows.

Curve adjustment is at the heart of duotones, but getting a feel for the effect of altering them takes time. The basic approach is to assign each ink/colour to a different part of the overall tonal range, and the most usual is to use black for the shadows (to ensure a rich, dense lower end to the scale) and the other colour for the mid-tones and highlights. Even so, where to begin is a common problem. Fortunately, Photoshop offers preselected colours which can be accessed by clicking Load in the Duotone Options dialog. These are particularly useful if you are beginning to experiment with duotones, because each has a different combination not only of ink colours but also of curve settings. A glance at a number of presets will show you how infinitely adjustable, and complex, the combinations can be, even with only two inks. Probably the best advice to start with is to take an image with which you are familiar, and load different presets from the Grey/Black Duotones library, one at a time, to familiarize yourself with the effects of different curve shapes. Don't hesitate to re-manipulate the loaded curves to see what happens. Once you have a reasonable grasp of how the curves work, do the same with the PANTONE Duotones and Process Duotones libraries. This adds the dimension of colour, and a delicate application of this to certain tonal areas can give a surprising improvement to the appearance of the tonal range.

A final step, but only for when you are comfortable with making the choices for a duotone, is to move on to tritones and quadtones. These dramatically increase the range of options. As we'll see, using four inks, each with adjusted curves to assign them to different but overlapping parts of the tonal scale, can produce the complexity of effect that was once the prerogative of advanced toning in selenium and other chemicals.

Cool gray 9
A 'Cool Gray 9'. As with each choice, go to the Duotone Curve dialog for each ink, one at a time, and look carefully at how it has been constructed.

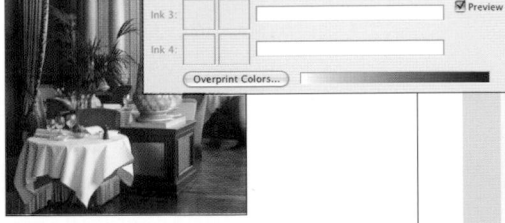

Other presets
Go back to the Duotone Curve dialog for each ink, and adjust the curves to achieve your desired results.

Case study: **tones to suit**

With all of these possibilities, and more permutations with tritones and quadtones, there is such an embarrassment of choice that it is difficult to get started in applying tones to an image. One method is simply to experiment until you hit on a pleasing combination of tones and their curves, though this will waste time and is a less than focused approach. Another, more logical, is to decide first on what quality of the image you want to enhance by means of a delicate colour shift, and why. If you can answer this question to yourself, then the procedure for selecting tones becomes more structured. Ultimately, though, the justification for using duotones, tritones, or quadtones is personal taste, and if you prefer to work by gut reaction rather than analyse the reasons, that is entirely your choice. Here we take three images, each with the potential for enhancement through tones, and use different starting points in order to arrive at the desired effect.

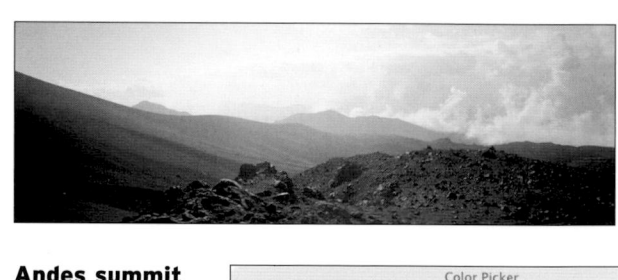

▲ Chapter House

This famous vaulting in Westminster Abbey makes a suitable subject for applying subtle tones, partly because it is an historical subject, and partly because there is a gentle gradation of the darker values of stonework that can be enhanced with a slight distinction in colour.

▶ A preset quadtone

For this exercise, which will involve the least effort, I want to find an existing multitone in the Photoshop library that will do the job. Specifically, I want colours with an antique flavor, and colours that will contrast across the tonal range. In the PANTONE Quadtones library I settle for this one, which conventionally has black at the base of the tonal range, then blue and purple for the mid-to-dark tones, and a contrasting 'old' green for the lighter tones.

Andes summit

For this second exercise in applying tones, I want to construct a simple duotone from scratch. The image chosen is a high-contrast mountain panorama.

Load

tones

Name
Duotones
Quadtones
📁 Gray Quadtones
📁 PANTONE(R) Quadtones
🔲 Bl 75% 50% 25%
🔲 Bl 430 493 557
🔲 Bl 431 492 556
🔲 Bl 541 513 5773
📁 Process Quadtones
Tritones

Duotone Options

Type: Quadtone

Ink 1:	Black
Ink 2:	PANTONE 541 CVC
Ink 3:	PANTONE 513 CVC
Ink 4:	PANTONE 5773 CVC

OK Cancel Load... Save... ☑ Preview

Overprint Colors...

▶ Final result

Although a glance at the quadtone colours would suggest a stronger, more richly coloured effect, the result is extremely subtle. Importantly, there is a crossover across the tonal range from purplish to greenish.

▶ Separating the colours

The curves for each ink/colour show that the black is strongly restricted to the shadow tones, the next two rather less so, while the inverse curve for the green ensures that its ink will be subtly separated from the others.

Duotone Curve

0:	0	%	60:		%
5:		%	70:		%
10:		%	80:		%
20:		%	90:		%
30:		%	95:		%
40:		%	100:	80	%
50:	10	%			

OK · Cancel · Load... · Save...

Duotone Curve

0:	0	%	60:		%
5:		%	70:		%
10:		%	80:		%
20:		%	90:		%
30:	50	%	95:		%
40:		%	100:	90	%
50:		%			

OK · Cancel · Load... · Save...

Duotone Curve

0:	0	%	60:		%
5:		%	70:		%
10:		%	80:	40	%
20:		%	90:		%
30:		%	95:		%
40:		%	100:	95	%
50:	5	%			

OK · Cancel · Load... · Save...

Duotone Curve

0:	0	%	60:		%
5:		%	70:		%
10:		%	80:		%
20:		%	90:		%
30:		%	95:		%
40:		%	100:	80	%
50:	25	%			

OK · Cancel · Load... · Save...

Duotone Curve

0:	0	%	60:		%
5:		%	70:		%
10:		%	80:		%
20:		%	90:	91.9	%
30:		%	95:		%
40:		%	100:	100	%
50:	35.6	%			

OK · Cancel · Load... · Save...

Duotone Curve

0:	0	%	60:		%
5:		%	70:		%
10:		%	80:		%
20:		%	90:		%
30:		%	95:		%
40:		%	100:	43.1	%
50:	40	%			

OK · Cancel · Load... · Save...

◀ Separating the colours

I use the Curves dialog for each ink/colour to 'place' it in the appropriate part of the image's tonal range. A concave and a convex curve is a typical solution, but here I make a more extreme separation and confine the blue more to the highlights by dragging the upper right end-point down.

▽ A distinct duotone

The uncomplicated result has blacks clearly in control of the shadows, and blues in the mid-tones. Note that the upper highlights have little colour by virtue of their brightness.

◀ Colour choice

I will use black for the darkest tones, as is normal to keep the overall range full, but for the lighter tones I have chosen blue, which will suit this high mountain view. The aim is to maintain a distinction between the colours.

Angkor lake

The original was shot just before dawn at a 10th-12th-century ceremonial lake at the ruins of Angkor Wat in Cambodia. A very formal composition, and the intention in making a multitoned image is to give it a sense of an early, 19th-century print. So, toning is appropriate in the black-and-white conversion, and the sandstone sculptures have a deep brownish-red patina, which suggests what the base colour should be.

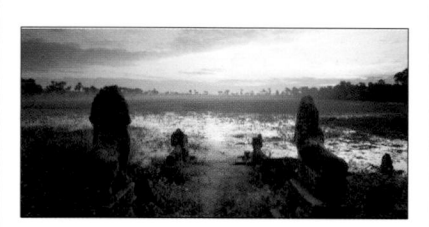

Black-and-white conversion

First, we need to convert to black and white before moving on to a tritone or quadtone. To lighten the shadows on the foreground sculptures, I choose 100% in the red channel. This is then converted to greyscale, from which the Duotone option becomes available.

▶ Tritone preset ◀

In this example we will choose a tritone preset, then adapt it. I find this an interesting one: black as usual keying the image, but a red in the shadow areas and a coolish grey in the lighter areas. On applying it, we can see that yes, it has a distinct split between shadows and highlights, but to my taste has too cold a sky.

Load

Name		Date Modified
▶ 📁 Duotones		13/02/20
▶ 📁 Quadtones		13/02/20
▼ 📁 Tritones		13/02/20
▶ 📁 Gray Tritones		13/02/20
▼ 📁 PANTONE(R) Tritones		13/02/20
	📄 Bl 50% 25%	18/09/20
	📄 Bl 165 red orange 457 brown	18/09/20
	📄 Bl 172 orange 423 gray	18/09/20
	📄 Bl 313 aqua 127 gold	18/09/20
	📄 Bl 334 green 437 mauve	18/09/20
	📄 Bl 340 green 423 gray	18/09/20
	📄 Bl 437 burgundy 127 gold	18/09/20
▶ 📁 Process Tritones		13/02/20

Michael Freema...
Macintosh HD
LaCie TERA_1
Desktop
michaelhfreeman
Applications
Documents
Movies
Music
Pictures

Find... Find Again

New Folder Cancel Load

Duotone Options

Type: Tritone

Ink 1: ▨ ▨ Black

Ink 2: ▨ ▨ PANTONE 172 CVC

Ink 3: ▨ ▨ PANTONE 423 CVC

Ink 4: ▨ ▨

Overprint Colors...

OK Cancel Load... Save... ☑ Preview

Duotone Curve

0:	0	%	60:		%
5:		%	70:	45	%
10:		%	80:		%
20:		%	90:		%
30:		%	95:		%
40:		%	100:	95	%
50:		%			

OK Cancel Load... Save...

Duotone Curve

0:	0	%	60:		%
5:		%	70:		%
10:		%	80:		%
20:		%	90:		%
30:		%	95:		%
40:	9.4	%	100:	80.6	%
50:		%			

OK Cancel Load... Save...

Duotone Curve

0:	0	%	60:		%
5:		%	70:		%
10:		%	80:		%
20:		%	90:		%
30:		%	95:		%
40:		%	100:	90	%
50:	65	%			

OK Cancel Load... Save...

▶ Quadtone with yellow

Rather than replace the cool grey third ink, I prefer to add an ink/colour by turning this into a quadtone. Having done this, I click on the fourth colour, and choose a warm yellow from the Pantone series. Then, to bias this colour toward the brighter sky, I construct this curve, which confines it and keeps it from spreading into the mid-bright tones occupied by the cool grey.

Custom Colors

Book: PANTONE® solid coated

OK
Cancel
Picker

PANTONE Yellow C
PANTONE Yellow 012 C
PANTONE Orange 021 C
PANTONE Warm Red C
PANTONE Red 032 C
PANTONE Rubine Red C
PANTONE Rhodamine Red C

L: 87
a: 2
b: 114

Type a color name to select it in the color list

Duotone Options

Type: Quadtone

OK
Cancel
Load...
Save...
☑ Preview

Ink 1: Black
Ink 2: PANTONE 1925 C
Ink 3: PANTONE 423 CVC
Ink 4: PANTONE Yellow 012 C

Duotone Curve

0:	0	%	60:		%
5:		%	70:		%
10:	12.5	%	80:		%
20:		%	90:		%
30:		%	95:		%
40:	24.4	%	100:	38.8	%
50:		%			

OK
Cancel
Load...
Save...

▼ Final image

The result is a subtle but distinct association of colours that adds to the sense of age. Importantly, there is a progression, largely upward, from black through reddish brown to neutral (which by comparison appears cool), to yellowish highlights.

Stylized black and white

Among the stable of imaging effects suites are a number designed specifically for monochrome, to create unusual or atmospheric graphic treatments.

This is a huge area of image conversion, although away from the basic standards of a balanced, optimized photographic image. To make this kind of alteration there are many filters both within Photoshop and as third-party plug-ins. Purists committed to 'straight' photography will abhor these treatments, but for others they have their uses. There is a distinction, which may or may not be useful, between stylizations that are traditionally connected to the photographic process (such as solarization, posterization, and lith film) and those that convert images to other art media (such as crayon, pen and ink, and charcoal). The Photoshop Filter menu is a place to begin at no extra cost, in particular the Sketch, Artistic and Brush Strokes sub-menus. Third-party software, as plug-ins or stand-alone applications, offer more sophisticated and adjustable conversions, as the examples here show.

Alpine flowers
This is the colour original, chosen due to its clear shapes and distinct lines.

Poster edges
From Photoshop's Artistic filter set, this filter performs a posterization (see the following pages) and adds an edge effect that converts edges into lines, like a drawing.

Bas Relief
One of the Sketch filters, this treatment offsets highlighted edges on one side of the image with darkened edges on the other side.

Spatter
In the Brush Strokes set of Photoshop filters is this effect that mimics spattering, with characteristically ragged edges.

▲ Stairs
▲
◀ A filter within nik
Multimedia Abstract
Efex Pro!, this creates a
stair-stepping effect
across the luminosity of
an image, at the same
time making adjustments
based on hue.

▲ Solarize
▲
▶ Also part of nik
Multimedia Abstract
Efex Pro!, this filter
simulates the traditional
solarization darkroom
effect achieved by a brief
exposure to light.

▶ Duplex
This filter from nik
Multimedia Color Efex
Pro! simulates the duplex
print process by creating
a single-hue image with
the colour values across
the image changed for a
stylized look.

Posterization

Used on an appropriate image, this traditional technique for simplifying the continuous tonal range of a photograph into a small number of distinct, flat tones can produce an interesting graphic stylization.

Posterization is both an imaging fault and a way of deliberately stylizing photographs. It works by clumping a range of tonal values into one single value, hence the name, for an early and widely used graphic technique for making posters – with flat blocks of colour or tone. As a fault, you can see it in action by making strong changes to an 8-bit image and viewing the results in Levels, where a characteristic 'toothcomb' effect is evidence of clumped values with gaps in between. For intentional creative effect, Photoshop offers a dedicated filter, under *Layer > New Adjustment Layer > Posterize*. The skill in using it successfully lies in choosing not only the number of levels to which the image will be reduced, but also in choosing the 'breaks' – the divisions between the tonal ranges that determine the edges of the new posterized tones. A successful break helps to identify the content of the image rather than confuse it.

The first step is to find an image suitable for posterization. Because the process drastically simplifies the tonal range, graphically simple images nearly always work the best, and it may even help to retouch some areas of

Basilica
Images with clear shapes and simple tonal areas posterize the most successfully. This late evening view of a church overlooking Marseilles harbor still has enough tone in the sky to separate it.

Convert to black and white
A channel mix favouring red strongly lightens the building and darkens the sky for good separation. This is done as an Adjustment Layer.

Posterize Adjustment Layer
A posterizing layer is added, and four levels selected.

the image, such as the background, to improve the simplicity. The next step is to convert the image to greyscale while retaining all three channels, and the Channel Mixer is ideal for this. As with most special effects, the final outcome may be difficult to predict, so it's advisable to maintain some flexibility—hence a Channel Mixer Adjustment layer is recommended. You can easily go back to this layer to alter the mix. Note that while the Posterization filter can be applied to a colour image, this restricts the number of posterized levels to at least six—the minimum number of levels for the posterization command is two, but this is then applied to each colour. Converting to greyscale first removes this restriction.

Above the Channel Mixer layer, create a posterizing layer (*Layer > New Adjustment Layer > Posterize*). This offers a choice of the number of levels, with a minimum, obviously, of two. As an adjustment layer, this is easy to return to and alter the number, but tends to be more successful graphically with a small number of levels. Four is often a good number to begin with.

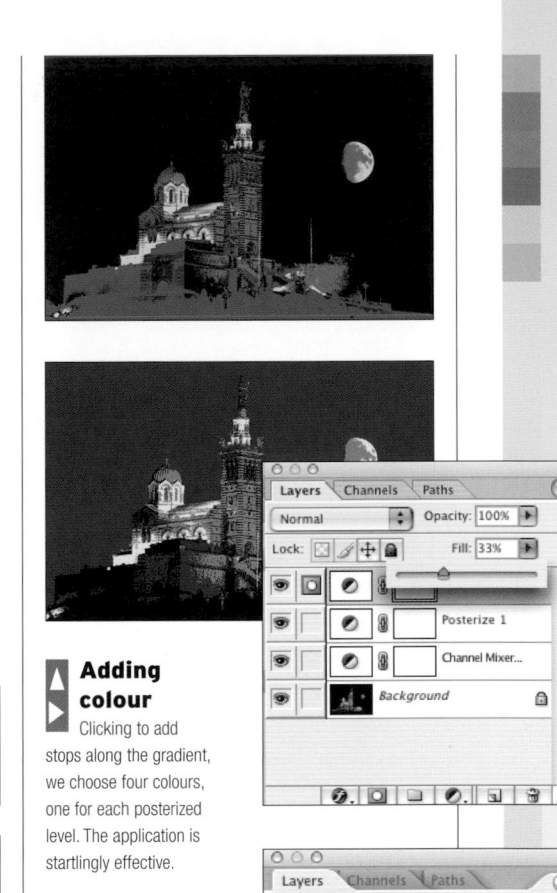

Adding colour
Clicking to add stops along the gradient, we choose four colours, one for each posterized level. The application is startlingly effective.

Muted color
To modify the bright colours, the fill opacity of the Gradient layer is reduced, here to 33%.

Change the Channel Mix
Now that the effect can be judged, we can change our minds if we like. Return to the Channel Mix layer and adjust it for a paler sky, by enhancing the blue channel and reducing the red.

Gradient Layer
We begin the process of adding colour by opening the Gradient Editor in an Adjustment Layer, to which colours can then be added. We start with a default greyscale map.

Adding age

One specific class of image distress is an antique effect designed to imitate an early silver halide print or other, old-fashioned print processes.

A very specific way of stylizing images in black and white is to give the impression of age. This is a kind of pastiche, and calls for some justification. Like all stylization, it runs counter to the ethos of the well-tuned fine print, and is generally the reverse of optimization, with a final result in which highlights are lost and the overall contrast reduced, in addition to colour shifts.

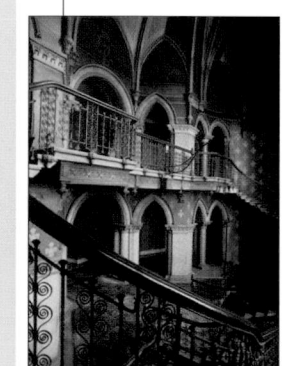

◀ **St Pancras Hotel**
The image used for antiquing is an interior view of a Victorian railway hotel, abandoned for many years.

There is third-party imaging software designed specifically for this, and the examples here are three plug-in filters from nik Multimedia and one from AutoFX Software. With rather more effort, and several distinct steps, similar effects can be created using Photoshop filters and commands. The typical symptoms of aging are fading, loss of highlights, and paper discoloration. Alternative ways to suggest an antique flavour to a print are to reproduce old-fashioned styles of presentation, such as vignetting and decorative borders.

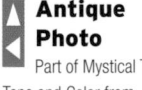

▲
◀ **Antique Photo**
Part of Mystical Tint, Tone and Color from AutoFX Software, this filter includes colour cast, soft-focus effect, fading and sepia tinting.

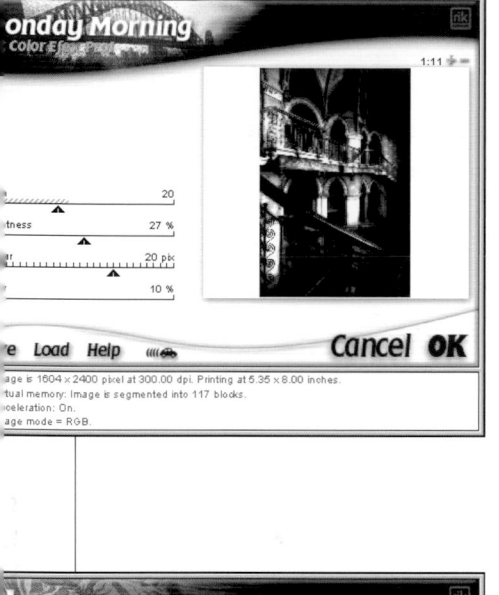

onday Morning
Color Efex Pro!

1:11

20
thness 27 %
20 pix
10 %

e Load Help

Cancel **OK**

age is 1604 × 2400 pixel at 300.00 dpi. Printing at 5.35 × 8.00 inches.
tual memory: Image is segmented into 117 blocks.
celeration: On.
age mode = RGB.

Old Photo
nik Color Efex Pro!

1:11

Brightness 50 %

Grain 15 %

Paper Color 100c

Contrast 100 %

Contrast R

Save Load Help

Cancel **OK**

Image is 1604 × 2400 pixel at 300.00 dpi. Printing at 5.35 × 8.00 inches.
Virtual memory: Image is segmented into 117 blocks.
Acceleration: On.
Image mode = RGB.

▲ Old Photo
This filter in the
Color Efex Pro! suite
allows any of the RGB
channels, or all, to be
used for the conversion,
and also includes a paper
tinting control.

▲ Monday Morning
In addition to colour and brightness adjustment, this
filter, part of Color Efex Pro!, has a Smear control to
give a softening effect similar to soft-focus, and a grain
control (also see pages 126–7).

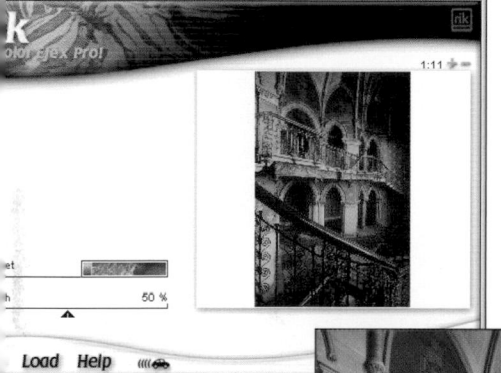

k
Color Efex Pro!

1:11

et
h 50 %

Load Help

s is 1604 × 2400 pixel at 300.00 dpi. Printing at 5.35 × 8.00 inc
al memory: Image is segmented into 117 blocks.
leration: On.
 mode = RGB.

▲ Ink
In the Color Efex
Pro! suite from nik
Multimedia, this filter
changes the colour set
in the image to make it
appear as if it were
printed on old
photographic paper.
Further desaturation is
then applied for a
monochrome effect.

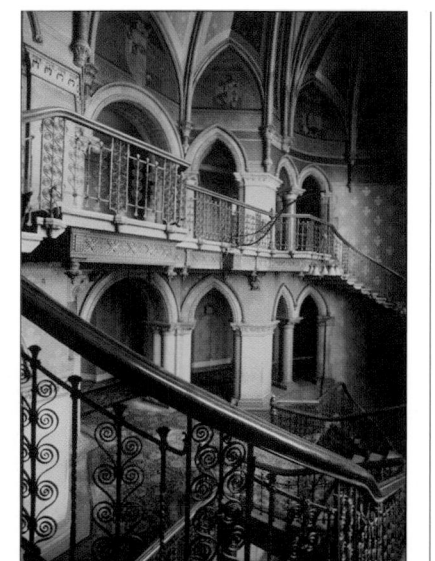

Hand-colouring

Digital post-production brings a new convenience and a wider range of treatment to an old-fashioned process—that of adding colour washes to a monochrome print.

Hand-colouring was an early technique for introducing colour into a monochrome image, unsophisticated in principle although demanding in painting skill. It now has a new lease of life in digital post-production, with several alternative techniques to choose from. Traditional hand-colouring uses light washes of watercolour or dye, and so has most effect on highlight areas and least in the shadows. In other words, it works on the opposite end of the tonal scale to traditional toning solutions, and for this reason one approach was first to apply a light toning and then to brush in colour. The digital equivalent naturally has no such constraints, but if the aim is to replicate the hand-coloured effect, it helps to be familiar with its nuances.

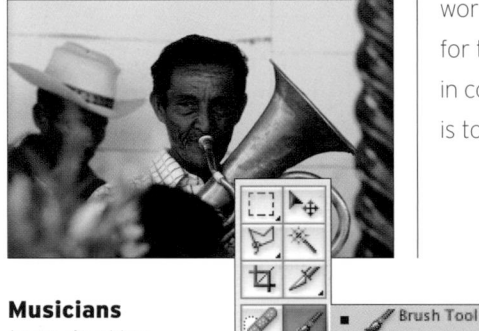

Musicians
A group of musicians playing at a Colombian party provides the basic image.

First desaturate
This initial step prepares for one of three alternative techniques. For purposes of comparison, reference and reverting, this is done on a duplicate layer.

Brush Tool	B
Pencil Tool	B
Color Replacement Tool	B

△ Painting
This is the basic approach, with a low (20%) opacity to give the desired muted effect, and a brush size and hardness that is constantly altered to suit the area of the image being painted.

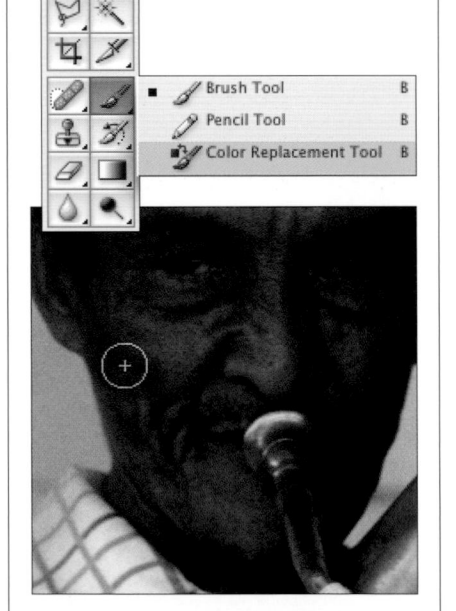

Brush Tool	B
Pencil Tool	B
Color Replacement Tool	B

△ Colour Replacement
This tool has advantages over simple brushing in that the tolerances can be set so that the colour is automatically confined to one area of tone. Here, the brush is set to once-only Sampling, Contiguous, and a Tolerance of 20%.

▷ Hand-coloured
The final result of hand-colouring, which is muted and concentrates mainly on the instrument and face, leaving most of the image black and white.

Hand-colouring was never a realistic alternative to full-colour photography, but instead added a subtle and less saturated overlay. An interesting and effective variation on this is partial colouring, as in the example here, in which the monochrome background helps to enhance the coloured area by contrasting with it.

There are endless ways of adding colour—or rather of controlling the colouring to give this style—but three of the most practical are painting on a new layer, undercolour exposure, and the Color Replacement tool. The first method is uncomplicated but relies entirely on your skill with a brush. Open a new layer (New Layer in the Layers palette). Then choose the foreground colour and brush size and hardness, and paint, changing colours and blending modes as necessary.

Undercolour exposure makes use of the original full-colour RGB image to create partial colouring. The principle is to prepare a less saturated and stylized colour base using procedural rather than hand-brushing techniques, then to create a greyscale overlayer (say a Channel Mixer Adjustment layer), and to erase - or, better still, mask out - specific parts of this by hand.

The third alternative is interactive brushwork using the Color Replacement tool. The value of this tool, designed for work on colour images, is that it allows you to choose the parameters under which the colour is applied. In addition to percentage tolerance, this goes beyond the usual brush options to include contiguous and discontiguous - the former confines colouring to areas that adjoin the first application.

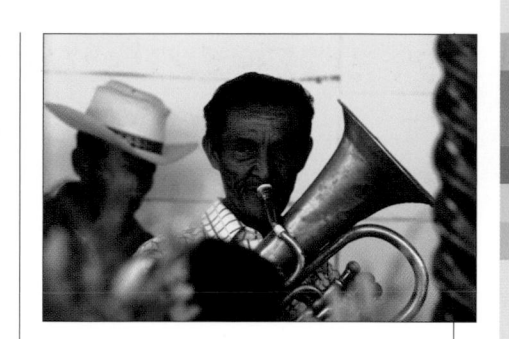

Undercolour
In this technique, an overall muted colour is used as the base. First, the image is slightly desaturated.

Monochrome layer
A Channel Mix Adjustment Layer is created above the Background.

Layer Mask
Painting on a layer mask has the effect of revealing the colour Background image.

The **Print**

A fine print has always been the ultimate goal in black-and-white photography – more so than with colour photography, in which the processes involved in printing have always been more limited and less easy to manage by oneself. Digital imaging, far from diminishing this through such new possibilities for display as on-screen presentations, digital projection, and websites, has actually made the fine print easier and more interesting to achieve. The only thing missing is the ritual of the wet darkroom, which undeniably has a kind of alchemical appeal but which is also messy, time-consuming, and not easy to predict. It can certainly add to the experience of creating images, and is very insistent as 'process', but these are features that most people nowadays would consider to be drawbacks in photography.

Digital desktop printing, by contrast, is clean, visible and immediate. The only chemicals are inks and pigments, which are preloaded as cartridges or tube-fed from sets of bottles (known as continuous ink systems). Conveniently and comfortably, everything takes place under normal lighting, which bypasses the need to set aside and seal off one room dedicated to printing. Nor is there any need for plumbing, or for the disposal of chemicals. The only delay is in the time it takes for the paper to move past the printing heads, and even this is a matter of time rather than uncertainty, because provided that the monitor, editing software and printer have been set up correctly, what you see on the screen is what you will get as a print.

As in so much else digital, a rapid spurt of technological development has not only breached the barriers of acceptable quality and cost, but has taken printing performance to new levels that would have been hard to imagine in a purely silver halide world. Now the quality of both inkjet and dye-sub printers makes printing to professional and museum standards an affordable reality, and this makes a huge difference in the access photographers have to this ultimate form of the image. Because the physical space of a darkroom is no longer required, printing becomes as easy as any other stage in the digital process. And convenience is not the only benefit, because perhaps the most exciting thing about digital printing is that you can keep it as part of a closed loop. Whether in the studio or at home, you can manage every stage of post-production yourself, and the rapid feedback you receive from the printer makes it easy to fine-tune the print. Moreover, with inkjet printing, which has become the de facto standard, it is now possible to print on almost any type of paper. No longer are you restricted to the glossy, semi-glossy and matte varieties that were the staple of silver halide printing. Manufacturers of inkjet-dedicated paper now offer far more choice, and beyond that, more adventurous photographers are experimenting with the countless different varieties of non-dedicated paper. Handmade paper from the most obscure sources imaginable can be fed into most inkjet printers for ever more individualistic prints.

Desktop printers

Two digital printing technologies, inkjet and dye sublimation, offer a huge range of desktop printing possibilities in black and white as well as in colour.

The advances in printing technology, principally in inkjet, but also in dye-sublimation, have radically altered the options for producing high-quality display prints. Inkjet technology involves spraying minute droplets of ink through a set of nozzles, and is now the standard for desktop printing. Dye-sublimation printers use wide ribbons for successive contact printing of inks via a thermal transfer method, and have the advantage of producing prints that have the same look and feel as traditional glossy silver-halide prints, although only proprietary paper can be used. For black and white printing there are special monochrome cartridges, and the result is a true continuous-tone image, without the dithering used by inkjet printers. Nevertheless, inkjet printing will probably remain the standard for its flexibility of size, choice of inks, and choice of papers. Indeed, any paper can be run through an inkjet printer, and for special effects there is plenty of room for experiment.

Dye sublimation

This is a thermal transfer process in which cartridges supply sheets of ribbon containing dye to the size of the print. Heating elements in the print head are activated as the ribbon passes over it, causing the dyes to vaporize and soak into the paper. The paper has to pass to and fro in register for successive dye transfer, which in the case of black and white printing means using blacks and greys. As the ribbon is for one-time use, and special paper is needed, dye-sub printing tends to be expensive.

Canon Selphy

The most common form of dye sublimation printer on the market these days is the compact photo printer. The technology was once widely used in computer colour proofing too, but the cost has proved prohibitive when compared to inkjet technology.

Inkjet inks

A standard set of inkjet inks for a Canon printer. Different printers take different cartridges. Some, like these, are sold separately. Others come in a combined unit that you must discard when one ink runs out.

Inkjet technology

Many desktop machines are now designed specifically for photography, with a larger number of heads and high-resolution output. A stepper motor moves the print head assembly, with its nozzles, one for each ink colour or tone, one line at a time over the paper. Dithering results in a mix of inks, and output resolutions of 1440 dpi and 2880 dpi are common. When comparing resolutions, remember that at the smallest level an ink dot can either be on or off (black or white, cyan or white, etc), so this sort of resolution isn't directly comparable to the 300dpi most printing houses prefer, or the resolution your computer screen works at.

Canon Pixma printer

This modern inkjet shows how far the technology has come in a few years, while still remaining versatile. This printer has two paper trays and even the ability to print onto CD or DVDs (in some regions), as well as producing excellent photographic prints using its two black inks.

100%

500%

Dithering

Inkjets make the appearance of continuous tones using dithering – arranging patterns of dots on the page with varying degrees of density. A close look at any section of output reveals these patterns, sometimes known as halftones.

1000%

Contact sheets

Almost all browser and image-editing programs now offer options for creating that mainstay of black-and-white image selection, the printed contact sheet.

Contact sheets have always had a special role in the editing process of traditional black-and-white photography – more than their simple physical convenience might suggest. Editing in this case means the selection of images for final printing from the shooting sequence, with a printed contact sheet providing a kind of summary of the photographic session. Naturally, with black-and-white negative film, a set of positive 'thumbnails' was the only way to read details such as the expression on a face, but even though this is no longer an issue in digital imaging, a printed sheet remains a valuable and highly recommended intermediate step. Viewing digital images on a monitor is convenient in some ways, but has the drawbacks that it ties you to the computer (even a laptop) and is only really satisfactory in a darkened room.

Photoshop
The Contact Sheet II dialog, with its interactive display of the layout according to the rows and columns chosen, and the quantity of information that will be displayed.

Most browsing and image-editing software has the facility to produce contact sheets for printing. They are not, of course, actual contacts of anything, and can be sized and ordered as you wish, with whatever embedded information you care to display. It's worth taking time to review the options for customizing these prints so that they suit your working method. Naturally, as a preparation for black and white printing, it helps to print out the images in greyscale, even though they will have been shot in colour. The two most likely choices for creating contact sheets are your camera's browsing application and Photoshop, though there is a wide choice of other software available. The two examples shown here, from Nikon and Photoshop, illustrate the options, which include image size, layout, and the amount of embedded information. In deciding on which application to use as a regular method, note that the images may be created from thumbnails (fast operation but low quality) or downsized from the originals (excellent quality but slow).

A preview of conversion methods

As the layout and ordering of contact sheets is completely flexible – and usually a batch processing operation – consider printing them with variations of one image across each row. For example, the three 'default' greyscale conversion mixes in Photoshop are Grayscale (bias toward the green channel), Desaturate (an even mix of channels), and Channel Mixer (100% red channel as it opens). In this example, the images from a take have been batch processed to create these copies, arranged 4 across with the colour original first.

Nikon View
Camera manufacturer's software used for printing contact sheets directly from the Browser. Here, there is a fixed choice of rows and columns, from which 4 x 4 Up has been selected.

Photoshop contact sheet
A specimen contact sheet, with images displayed right way up (this takes more space with a mixture of horizontals and verticals).

Printer calibration

In order to achieve precision in black-and-white neutrality, and predictable delicacy in toned prints, professional calibration is highly recommended.

Calibration, as we've already seen, refines the accuracy of capture (the camera) and display (the monitor) to a precise degree, and if excellence of image quality is important, it should be a part of the workflow. While it's true that colour reproduction, through its complexity, needs this more than black and white, the subtleties of the tonal range in greyscale tend to attract close attention. To complete this necessary control over image quality, the printer also should be calibrated.

To an extent, desktop printers have some degree of built-in calibration, in that each machine has a generic profile that can be accessed by the computer to which it is connected. Nevertheless, printers work in quite a different way from the other devices involved, and the process of translating an RGB image that has been optimized for a monitor leaves plenty of room for unwanted changes to creep in. They use process colours that are complementary to RGB, which is to say cyan, magenta and yellow, plus other inks including black, grey and pale process colours. In addition, the printed image is reflective, which lowers its contrast range and introduces the paper's colour into the highlights.

There are also issues peculiar to black and white printing, involving print density and neutrality. A black-and-white image displayed on an 8-bit monitor (almost all monitors are) has 256 distinct levels of tone, and even though this is much less than the 16.7 million of a full-colour RGB image, it is perfectly sufficient for the human eye. Unfortunately, most inkjet printers as supplied with their cartridge inksets have only one black ink, and the dithering process used by the printer cannot produce the 256 tones from just this. Printing in full colour mode solves this problem, but in attempting to create a monochrome image from five or seven differently coloured inks, some unexpected colour bias is likely, and this is also likely to suffer from metamerism (the hue appears to be different

▼ Test target

The first stage of calibration is printing a test target. Here the TC9.18 target is being printed from a Epson printer. The Lyson ink tanks to the right are what's known as a continuous flow system, whereby much larger external tanks can be used in place of the manufacturer's (often expensive) own-brand inks.

◁ **Spectrolino**
Once the ink is dry,
the printed target is placed
on the GretagMacbeth
Spectrolino/Spectroscan
and measured.

under different types of lighting). Of course, if you are actively looking for a hint of colour in the print, such as with duotones and colour gradient mapping, it is easier to direct the bias than to achieve perfect neutrality.

A custom profile necessarily involves professional help, because the measurement of a test print calls for a spectrophotometer, which is expensive and needs a skilled operator. The principle is that you print out a test target using known Photoshop and printer settings. The profile-maker then measures this and the software analyzes how it differs from the known values, and produces an ICC profile to correct. The examples here were prepared by Udo Machiels of Atmos Designs in the United Kingdom. If your printer is profiled for a full-colour inkset, it will usually work well enough in printing black and white, but may still not be achieving perfect neutrality. One solution, already mentioned, is to deliberately tone the image, so that at least you know in which direction the colour will shift. Otherwise, consider a monochrome inkset or a small gamut inkset, but note that monochrome inksets do not lend themselves to calibration. An additional professional solution is to use RIP software, which is expensive but can produce outstanding results. One such software is Colorbyte's ImagePrint, which enables absolutely neutral tones. Another is isphoto's Shiraz RIP, a more complex and professional application that allows you to build your own linearization and CMYK profiles.

Profiling sequence

The typical procedure is as follows:
1. Print a standard test target, using standard printer settings.
2. Allow the inks to stabilize.
3. The print is measured with a spectrophotometer in conjunction with profiling software.
4. The profiling software compares this measurement with the known values of the target and constructs an ICC profile that compensates for the difference.
5. Load the profile onto your computer and select it for all printing.

Ink and paper

Pigment and specialist monochrome inksets greatly increase the potential of high-quality inkjet printing, as does the huge range of papers.

For inkjet printers there is now tremendous scope for choosing inks and papers to suit your particular needs. While printer manufacturers supply their own ink cartridges, there are third-party alternatives that are not only less expensive but can offer advantages in quality. If you plan to print regularly and often, one of the best small investments is in a CIS (Continuous Ink System). This is a set of bottles of ink that are arranged alongside the printer on a tray. A tube from each feeds ink to cartridges that replace the originals at the print head. The great advantage of Continuous Ink Systems is that they are much cheaper to operate than the printer manufacturer's own cartridges – sometimes by as much as ten times. Ink levels in the bottles can be checked visually and topped up when necessary individually. Whether you opt for CIS or regular cartridges, there is a choice between pigment and dye inks, from different manufacturers. Dye is standard, and tends to work better on glossy and satin finished paper, but lacks archival qualities. Pigment inks are thicker and the better ones are definitely archival, and better suited to matte paper. There is also available a selection of monochrome inksets that use a mixture of blacks and greys.

One of the greatest advantages of inkjet printing is that it works independently of the paper, which unlike silver-halide printing and dye-sub digital printing does not need to be pre-treated. Coating or sizing does help, but in practice you can run any paper at all through a desktop inkjet printer. Specialist art suppliers carry hand-laid paper from different sources, and if you are looking for a more textural, even painterly effect in your prints, it is worth experimenting with these. Within the range of conventional inkjet papers, there are now many manufacturers, offering different finishes and different paper weights.

Monochrome inks

Using special monochrome inks brings out better detail in greyshades. The upper image was printed using ordinary process colour, and the lower using Lyson Quad Black inks. Notice that the contrast is stronger and the definition sharper.

Consumables
Using good quality materials, both inks and paper, is vital to making a good print. All inkjet inks are prone to a degree of fading, especially magentas, but these effects can be minimized by using archival quality products.

Lyson Daylight Darkroom
These subtly different graduated bars are printed using Lyson's Daylight Darkroom inks. These replace the normal tanks in the printer with variants of black from which Mac or PC software can create prints in monochrome.

Monochrome inksets

Using four intensities of black ink in place of the normal CMYK colours is one way of achieving a tonal gradation that matches traditional silver-halide printing. In the examples on this page, from Lyson, the Quad Black inks are available in three versions: cool, neutral and warm tones. Flush the printer heads if changing from a CMYK inkset. For perfect accuracy, consider installing a true monochrome print driver.

Mounting and display

The presentation of the finished print is the final step in serious black-and-white photography, and needs the same level of attention as all of the post-production stages.

Prints are intended for display, and while there are many and varied ways of doing this, from sandwiching between sheets of acrylic to printing directly onto aluminum, there still remains one commonly used traditional procedure. In this, the print is attached to a mounting board, covered with an overmat into which a window has been cut, protected by a sheet of glass, and framed. There are good protective reasons for doing this, and there is a sufficient variety of finishes available in the two most visible components – the frame and the overmat – to allow idiosyncrasy. The three overriding concerns are that the print is held flat, is protected and can be hung in an easily viewable position.

There are fewer comparisons with the mounting of paintings than might be imagined. In principle, a photograph is much less a physical object than is a painting, which is both unique and has tangible surface qualities. A photograph is always, by definition, a reproduction – put another way, it is a window to a scene. This argues for a plain, simple presentation, the more so for a monochrome image. Anything but the mildest, most natural-looking colour becomes a distraction. The mounting and display of a black-and-white print should concentrate attention on the print area, not complement it. Any exceptions to this take the print away from pure photography and more into mixed media – which is, of course, completely valid, but not the subject here.

The mounting board has the job of supporting the print, and can be natural (traditional museum board is 100% cotton fibre) or synthetic (foamboard with a polystyrene core), and can be self-adhesive or plain. If plain, there are several alternatives for fixing the print to the board. If the paper is thick, it can be held in place by corners or hingeless strips that have adhesive-free edges (and digital prints usually have an advantage in flatness over silver prints in that they do not suffer warping through having being soaked). If you choose to mount the print fully and permanently to the board, the choices include dry-mounted adhesive film, mounting tissue and cold-mounted adhesive rolls. Depending on which you use, you may also need a dry-mounting press or tacking iron. However, with fairly thick paper that is already flat, the overmat will help to keep it secure on the mounting board.

▼ **Mounting board**
Mounting board is available in a variety of different colours, textures and thicknesses.

The overmat serves a number of functions, protecting the surface of the print by keeping it separated from the glass, holding the edges of the print flat against the mounting board, and providing an aesthetic 'window'. The usual material is museum board similar to that used for mounting. By far the most difficult and skilled job in the entire mounting process is cutting the window in the overmat, as the inner edges receive a lot of attention when the print is viewed. They must be straight and neat, and by convention they should be at a 45º angle, which calls for a special mat cutter. Pre-cut overmats can be bought, but then you will have the restriction of having to crop the image to fit. An alternative to an overmat is a separator, typically of hollow rectangular-section acrylic, that fits around the edges of the mounting board and keeps the print from touching the glass.

For simplicity, frames are typically very simple in both section (usually square) and material, with aluminum and wood being the most popular. A cleanly mitred joint at each corner needs skill, and it is normal to buy these ready-cut as kits. As most prints are made to conventional sizes this is normally no inconvenience. Both glass and acrylic are alternatives for the front of the frame. A non-glare finish helps cut reflections, and conservation glass specifically cuts UV penetration – which will cause fading. Acrylic cuts out almost all UV. The finished frame can be hung with picture wire attached to either ring hangers or corner clips on the frame.

Lighting is the final consideration. With a glass-framed print, the most important precaution is to avoid reflections at eye level. Low-reflectivity glass helps, naturally, but the position of light sources needs to be considered. A slight downward angle to the framed print (which is normal anyway) prevents picking up the reflections of ceiling lights. Also, try to ensure that prints do not face windows. Ideally, illuminate each print with its own spotlight, placed high so that there is a good angle between the beam and the normal line of sight, and with the beam masked down as precisely as possible to the edges of the image. The two methods of masking are miniature adjustable barn doors, and a shaped four-sided mask placed close to the focal point of the light beam (if the spotlight is at an angle to the print, the shape will be trapezoidal). Increasing the illumination on just the print both raises its prominence on the wall and reduces environmental reflections in the glass.

Pre-cut frames
There are a variety of pre-cut shapes on the market.

Bevel cutter
This is FrameCo's 101 Bevel Cutter, which holds the blade at a 45º angle for you, while you drag it along the rule.

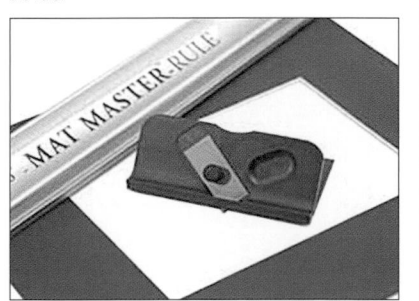

Glossary

aperture The opening behind the camera lens through which light passes on its way to the CCD.

artifact A flaw in a digital image.

backlighting The result of shooting with a light source, natural or artificial, behind the subject to create a silhouette or rim-lighting effect.

bit (binary digit) The smallest data unit of binary computing, being a single 1 or 0.

bit depth The number of bits of colour data for each pixel in a digital image. A photographic-quality image needs eight bits for each of the red, green, and blue channels, making for a bit depth of 24.

bracketing A method of ensuring a correctly exposed photograph by taking three shots; one with the supposed correct exposure, one slightly underexposed, and one slightly overexposed.

brightness The level of light intensity. One of the three dimensions of colour in the HSB colour system. See also Hue and Saturation

byte Eight bits. The basic unit of desktop computing. 1,024 bytes equals one kilobyte (KB), 1,024 kilobytes equals one megabyte (MB), and 1,024 megabytes equals one gigabyte (GB).

calibration The process of adjusting a device, such as a monitor, so that it works consistently with others, such as scanners or printers.

CCD (Charge-Coupled Device) A tiny photocell used to convert light into an electronic signal. Used in densely packed arrays, CCDs are the recording medium in most digital cameras.

channel Part of an image as stored in the computer; similar to a layer. Commonly, a colour image will have a channel allocated to each primary colour (e.g. RGB) and sometimes one or more for a mask or other effects.

CMOS (Complementary Metal-Oxide Semiconductor) An alternative sensor technology to the CCD, CMOS chips are used in ultra-high-resolution cameras from Canon and Kodak.

colour temperature A way of describing the colour differences in light, measured in Kelvins and using a scale that ranges from dull red (1,900K), through orange, to yellow, white, and blue (10,000K).

compression Technique for reducing the amount of space that a file occupies, by removing redundant data.

contrast The range of tones across an image, from bright highlights to dark shadows.

cropping The process of removing unwanted areas of an image, leaving behind the most significant elements.

depth of field The distance in front of and behind the point of focus in a photograph, in which the scene remains in acceptable sharp focus.

diffusion The scattering of light by a material, resulting in a softening of the light and of any shadows cast. Diffusion occurs in nature through mist and cloud cover, and can also be simulated using diffusion sheets and soft-boxes.

edge lighting Light that hits the subject from behind and slightly to one side, creating flare or a bright 'rim lighting' effect around the edges of the subject.

feathering In image-editing, the fading of the edge of an image or selection.

file format The method of writing and storing information (such as an image) in digital form. Formats commonly used for photographs include TIFF, BMP, and JPEG.

fill-in flash A technique that uses the on-camera flash or an external flash in combination with natural or ambient light to reveal detail in the scene and reduce shadows.

filter (1) A thin sheet of transparent material placed over a camera lens or light source to modify the quality or colour of the light passing through. (2) A feature in an image-editing application that alters or transforms selected pixels for some kind of visual effect.

focal length The distance between the optical center of a lens and its point of focus when the lens is focused on infinity.

focal range The range over which a camera or lens is able to focus on a subject (for example, 0.5m to infinity).

focus The optical state where the light rays converge on the film or CCD to produce the sharpest possible image.

fringe In image-editing, an unwanted border effect to a selection, where the pixels combine some of the colours inside the selection and some from the background.

frontal light Light that hits the subject from behind the camera, creating bright, high-contrast images, but with flat shadows and less relief.

f-stop The calibration of the aperture size of a photographic lens.

gradation The smooth blending of one tone or colour into another, or from transparent to coloured in a tint. A graduated lens filter, for instance, might be dark on one side, fading to clear on the other.

greyscale An image made up of a sequential series of 256 grey tones, covering the entire gamut between black and white.

haze The scattering of light by particles in the atmosphere, usually caused by fine dust, high humidity, or pollution. Haze makes a scene paler with distance, and softens the hard edges of sunlight.

histogram A map of the distribution of tones in an image, arranged as a graph.

The horizontal axis goes from the darkest tones to the lightest, while the vertical axis shows the number of pixels in that range.

hot-shoe An accessory fitting found on most digital and film SLR cameras and some high-end compact models, normally used to control an external flash unit.

HSB (Hue, Saturation, Brightness) The three dimensions of colour, and the standard colour model used to adjust colour in much image-editing software.

hue The pure colour defined by position on the colour spectrum; what is generally meant by 'colour' in lay terms.

ISO An international standard rating for film speed, with the film getting faster as the rating increases. ISO 400 film is twice as fast as ISO 200, and will produce a correct exposure with less light and/or a shorter exposure. However, higher-speed film tends to produce more grain in the exposure, too.

lasso In image-editing, a tool used to draw an outline around an area of an image for the purposes of selection.

layer In image-editing, one level of an image file, separate from the rest, allowing different elements to be edited separately.

light tent A tent-like structure, varying in size and material, used to diffuse light over a wider area for close-up shots.

luminosity The brightness of a colour, independent of the hue or saturation.

macro A mode offered by some lenses and cameras that enables the lens or camera to focus in extreme close-up.

mask In image-editing, a greyscale template that hides part of an image. One of the most important tools in editing an image, it is used to limit changes to a particular area or protect part of an image from alteration.

megapixel A rating of resolution for a digital camera, directly related to the number of pixels forming or output by the CMOS or CCD sensor. The higher the megapixel rating, the higher the resolution of images created by the camera.

midtone The parts of an image that are approximately average in tone, falling midway between the highlights and shadows.

monobloc An all-in-one flash unit with the controls and power supply built-in. Monoblocs can be synchronized together to create more elaborate lighting setups.

noise Random pattern of small spots on a digital image that are generally unwanted, caused by non-image-forming electrical signals.

pixel (PICture ELement) The smallest units of a digital image, pixels are the square screen dots that make up a bitmapped picture. Each pixel carries a specific tone and colour.

plug-in In image-editing, software produced by a third party and intended to supplement a program's features or performance.

ppi (pixels-per-inch) A measure of resolution for a bitmapped image.

reflector An object or material used to bounce available light or studio lighting onto the subject, often softening and dispersing the light for a more attractive end result.

resampling Changing the resolution of an image either by removing pixels (lowering resolution) or adding them by interpolation (increasing resolution).

resolution The level of detail in a digital image, measured in pixels (e.g. 1,024 by 768 pixels), lines-per-inch (on a monitor) or dots-per-inch (in a half-tone image, e.g. 1,200 dpi).

RGB (Red, Green, Blue) The primary colours of the additive model, used in monitors and image-editing programs.

saturation The purity of a colour, going from the lightest tint to the deepest, most saturated tone.

selection In image-editing, a part of an on-screen image that is chosen and defined by a border in preparation for manipulation or movement.

shutter The device inside a conventional camera that controls the length of time during which the film is exposed to light. Many digital cameras don't have a shutter, but the term is still used as shorthand to describe the electronic mechanism that controls the length of exposure for the CCD.

shutter speed The time the shutter (or electronic switch) leaves the CCD or film open to light during an exposure.

SLR (Single Lens Reflex) A camera that transmits the same image via a mirror to the film and viewfinder, ensuring that you get exactly what you see in terms of focus and composition.

snoot A tapered barrel attached to a lamp in order to concentrate the light emitted into a spotlight.

soft-box A studio lighting accessory consisting of a flexible box that attaches to a light source at one end and has an adjustable diffusion screen at the other, softening the light and any shadows cast by the subject.

spot meter A specialized light meter, or function of the camera light meter, that takes an exposure reading for a precise area of a scene.

telephoto A photographic lens with a long focal length that enables distant objects to be enlarged. The drawbacks include a limited depth of field and angle of view.

TTL (Through The Lens) Describes metering systems that use the light passing through the lens to evaluate exposure details.

white balance A digital camera control used to balance exposure and colour settings for artificial lighting types.

zoom A camera lens with an adjustable focal length, giving, in effect, a range of lenses in one. Drawbacks include a smaller maximum aperture and increased distortion over a prime lens (one with a fixed focal length).

Index

Acknowledgments

The author would like to thank the following for all their assistance in the creation of this title: Filmplus Ltd, Lyson, Nikon UK, REALVIZ, and nikMultimedia.

Useful Addresses

Adobe (Photoshop, Illustrator)
www.adobe.com

Agfa www.agfa.com

Alien Skin (Photoshop Plug-ins)
www.alienskin.com

Apple Computer www.apple.com

Canon www.canon.co.uk

Corel (Photo-Paint, Paint Shop Pro)
www.corel.com

Digital camera information
www.dpreview.com

Epson www.epson.com

Extensis www.extensis.com

Formac www.formac.com

Fractal www.fractal.com

Fujifilm www.fujifilm.com

Hasselblad www.hasselblad.se

Hewlett-Packard www.hp.com

Iomega www.iomega.com

Kingston (memory) www.kingston.com

Kodak www.kodak.com

Konika Minolta www.konicaminolta.com

LaCie www.lacie.com

Lexmark www.lexmark.com

Linotype www.linotype.org

Lyson (paper and inks)
www.lyson.com

Macromedia (Director)
www.macromedia.com

Microsoft www.microsoft.com

Nikon www.nikon.com

Nixvue www.nixvue.com

Olympus
www.olympusamerica.com

Paint Shop Pro www.corel.com

Pantone www.pantone.com

Photographic information site
www.ephotozine.com

Photomatix www.hdrsoft.com

Photoshop tutorial sites
www.planetphotoshop.com
www.ultimate-photoshop.com

Qimage Pro
www.ddisoftware.com/qimage/

Ricoh www.ricoh.com

Samsung www.samsung.com

Sanyo www.sanyo.co.jp

Sony www.sony.com

Symantec www.symantec.com

Umax www.umax.com

Wacom (graphics tablets)
www.wacom.com